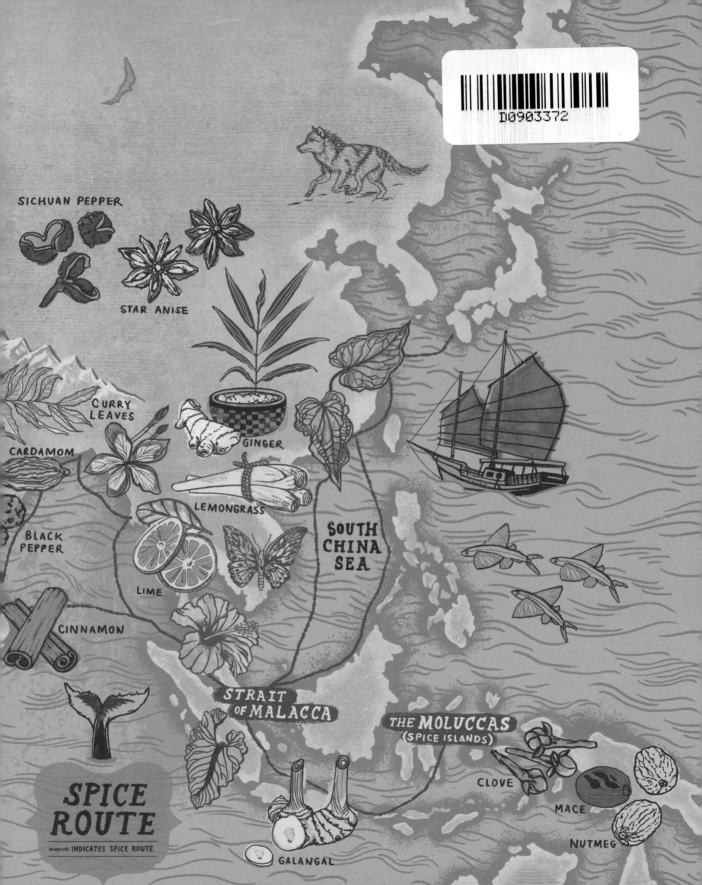

"Eleanor Ford is a cook and a historian, a culinary detective and, as she says, a gastronomic archaeologist. What a deep dive this is into the world of spice. It's a culinary history, a spice library, anatomy and miscellany. And then the recipes! Recipes which allow the reader to travel from Asia to the Middle East along the spice route, taking in so much flavor and so much context on the way." Yotam Ottolenghi

"A fascinating and evocative journey along the spice routes, the 'central nervous system of the world.' The author's blend of history, geography, taxonomy and enticing recipes offers a fresh look at these small, potent ingredients that bring magic to our kitchens." Fuchsia Dunlop, author of *The Food of Sichuan*

"I am completely enraptured with *The Nutmeg Trail*. It is the perfect balance of being fascinating and mouthwatering at the same time." Georgina Hayden, author of *Taverna*

"A tantalizing treatise on the intoxicating world of spice. Eleanor has coupled essays on the history and cultural significance of spices with very enticing recipes. I cannot wait to read, meander and cook my way along the ancient spice routes that Eleanor has so cleverly traced in this beautiful book." Helen Goh, recipe columnist

"In *The Nutmeg Trail*, Eleanor Ford takes us on a mouthwatering culinary voyage to the fabled 'spiceries,' those semimystical islands of the East Indies. A heady blend of history, adventure and deliciously authentic recipes, this book will make you hungry!" Giles Milton, author of *Nathaniel's Nutmeg*

"A fascinating, transporting read, packed full of intriguing recipes I can't wait to try."
Felicity Cloake, *The Guardian* food columnist

"*The Nutmeg Trail* offers a historical account of the spice trade with invaluable advice on the use of culinary spices—how to prepare and combine them, when to introduce them, and what delights to expect. Mouthwatering."
John Keay, historian and author of *The Spice Route*

"A fragrant, intoxicating and mesmerizing voyage into the history and global spread of spice. With recipes every bit as delectable as the prose."
Tom Parker Bowles, food writer and critic

FRAGRANT THINGS, FLOWERS, UNGUENTS,
DIAMONDS, APHRODISIACS, THOSE
WHO ENJOY SUMPTUOUS FOOD, BATHS,
LOVERS, SILK AND NUTMEG ... ALL THESE
BELONG TO THE REALM OF VENUS.

Varāhamihira (translated and abridged
from sixth-century Sanskrit)

WE CAME TO WARMER WAVES, AND DEEP
ACROSS THE BOUNDLESS EAST WE DROVE,
WHERE THOSE LONG SWELLS OF BREAKER SWEEP
THE NUTMEG ROCKS AND ISLES OF CLOVE.

Tennyson, *The Voyage*

MYRISTICIVOROUS (ADJ):
FEEDING UPON NUTMEGS

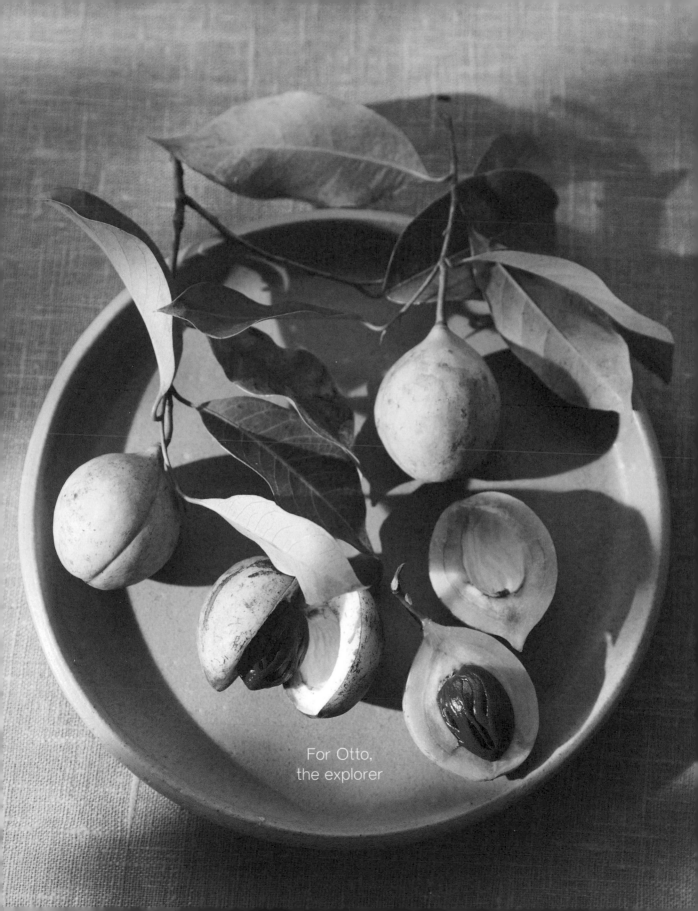

For Otto,
the explorer

THE NUTMEG TRAIL

RECIPES AND STORIES ALONG THE ANCIENT SPICE ROUTES

Eleanor Ford

APOLLO
PUBLISHERS

CONTEN

How spice changed
the world 6

Cultural diffusion along
the spice routes 10

Golden nutmegs: the rise
& fall of spicy excess 16

Cooking with spice 20
choosing, using & layering
— a journey of flavors

A note on the recipes 44

TS

THE FIRST SPICE 46
Ginger's fire & thunder

BLACK GOLD 68
A family of peppercorns
 The kebab empire 90

FRAGRANT & FLORAL 98
Petals, barks & other delights
 Layers of spice & rice 116

THE FIERY IMPORT 124
Chilies arrive in Asia
 Chilies in this book 129

LIME LEAVES & LEMONGRASS 152
Fresh spice pastes

EARTHY NOTES 178
Cumin loves coriander
 Curry & conquerors 183

SPICE CRESCENDO 206
Heady flavors & complex blends
 Redrawing the world 226

Spice miscellany 240 ★ Timeline 242
Sources & further reading 248
Acknowledgments 249 ★ Index 250

HOW SPICE
CHANGED
THE WORLD

Sailors would catch the scent of spice on the wind before they could see land. A string of emerald isles, as remote as any you can imagine, was once the only place on earth that nutmeg grew. The Banda Sea stretches through the Indonesian province of Maluku, 1500 miles east of Jakarta. Here, lying just south of the equator, are ten tiny volcanic islands ringed by turquoise water. Indeed, one called Gunung Api or "Fire Mountain" is a volcano in its entirety, which has been known to splutter and stream molten lava, causing the surrounding sea to boil. The ocean winds, salty tropical rains and fertile volcanic soil combine to create the perfect habitat for the evergreen nutmeg trees that gave the Banda Islands their moniker, the Spice Islands.

At the heart of the dusky yellow nutmeg fruit is the prized seed at the center of the spice trade. Around it grows a lacy red wrapping, mace, a sister spice with a floral edge. Along with cloves, another Maluku native, and a clutch of other Indian Ocean spices,

these exotic commodities, now commonplace the world over, once elicited such lustful excitement that a sea trade developed that changed the course of history and the food of today.

What unites Indian garam masala, Lebanese seven spice, French quatre épices, Moroccan ras el hanout and Middle Eastern baharat? It is nutmeg, which lends its bittersweet, fragrant warmth to them all. From its remote island home, this wrinkly seed has found its place at the center of the world's best-known spice blends. You can detect nutmeg enlivening Chinese five spice, Ethiopian berbere, Jamaican jerk seasonings, even Coca Cola's secret recipe. National dishes are transformed by it: American apple pie, German Christmas cookies, Greek moussaka. It is clear that this unassuming seed holds us all in its thrall.

Nutmeg is not alone. Sweet curls of cinnamon bark found their way from Sri Lanka into perfumed pilafs in the Middle East. Cumin crossed from the Mediterranean to become the essential base note in almost every Indian curry. Indian peppercorns joined salt as the stalwarts of the Western dining table and star anise traveled south from China to give its licorice accent to broths across Southeast Asia.

Spice's legacy is sweeter than its history. The saga is eventually one of greed, monopolies, empire and colonization. After all, fortunes were made, blood spilt, maps redrawn and the New World discovered all because of a desire for spice.

From our very earliest history, people have traveled the spice routes. So broad reaching as to seem intangible, these maritime trading trails and the later overland routes, known as the Silk Road, acted as the central nervous system of the world, enabling the human-propelled flow of goods. At first, this was short distances from home ports, but in time the immense rewards of trade lured sailors to brave longer journeys. Four thousand years ago, Asian spices had found their way to the Middle East. It was not only spices; bolts of silk, ivory and tortoiseshell, delicate porcelain, metals, bullion and cases of jewels crisscrossed the world, bringing great profits to those prepared to risk the treacherous seas. With them traveled knowledge and ideas: science, religion, language, craftsmanship, expertise, cookery. Traders broke up long journeys, staying in entrepôts where they would pick up customs, exchange ideas and influence local cuisines.

The value and allure of spices only grew, their exotic strangeness bestowing mystical, medicinal and spiritual values. They were

stirred into potions, added to food, used as tonics and aphrodisiacs and burnt into clouds of incense to sweeten the air and carry prayers heavenward.

Spice merchants wove fantastical tales of dragons, phoenixes and fearsome serpents to create a sense of mystery around the origin of their wares. Prices escalated and at one time, nutmeg was worth more than its weight in gold.

With commodities in such high demand, there was great wealth to be had for those who controlled them. Trade that had been largely peaceful for millennia under the Malays, Chinese, Phoenicians, Romans, Greeks, Persians, Arabs, Jews and Indians descended to devastating battles when the Europeans started seizing control from the fifteenth century. Encounters between the Portuguese, Dutch, Spanish, French and British spiraled into monopolies, imperialism and war. The spice trade laid the foundation for the modern world. It opened the first era of globalization, an Age of Discovery, and was the trigger for colonialism.

Our collective memory weighs heavy from the suffering inflicted in the name of spice. I want to acknowledge the human cost of the trade; colonialism led to the negation of cultures, exploitation of economies and oppression of many peoples' autonomies. It is important to recognize the wounds of the past and the scars left behind, for spices have a cost that is still being paid today, both in terms of literal extraction and broader societal damage.

Cooking with spice cannot be neutral, not only literally, but because the weight of history, collaboration, domination, mysticism, social status and desire is rooted in every cardamom pod and blade of mace.

Spices have brought humans great pleasure and health, but also aroused intense greed and barbarity. This book journeys into both culinary imperialism and international collaboration, exploring how, all across the world, centuries of trade and cultural diffusion changed the way we are, the way we think and the way we eat. Because of the spice trade, ingredients came together in new ways, and the same ingredients, when married with different techniques and traditions, gave rise to new, intriguing, exciting, often electrifying flavors. Every cuisine is constantly in a process of assimilation and revision, and so our food is intricately interwoven with our history.

It is a story as bittersweet as nutmeg.

CULTURAL DIFFUSION ALONG THE SPICE ROUTES

Using recipes as our maps, we are embarking on a culinary journey that weaves through history and halfway around the world, following the ancient trails of maritime trade known as the spice routes.

Our voyage starts in the Indonesian Spice Islands for nutmeg and cloves, taking us to China for ginger, Sri Lanka for cinnamon and India for cardamom and black pepper, via the Middle East and northeast Africa to Europe, where we find cumin, coriander and saffron. Each ancient port is linked by the ribbon of spice and with it have traveled ingredients and cooking techniques that have been assimilated, adapted, refined and reinvented over and over. We will be exploring how centuries of spice trade and cultural diffusion have changed the world's cuisine.

The spice routes led to an early and enduring mingling of Asia and Europe, East and West.

They knitted together a shared history.

Focus is often placed on only a short period, for the Age of Discovery and rampaging colonial conquest from the fifteenth century AD onward tend to fire the historical imagination. Yet the peaceful trade and the gentle spread of ideas and knowledge that took place over many millennia prior make a quieter and equally compelling story.

Spice trade sprang from desire and opportunity. Seafaring was a historically dangerous endeavor, yet throughout antiquity people were enticed into unknown waters by the allure of the exotic and the prices such rarities could fetch. Across thousands of years, trading links from Indonesia fanned out through Asia and met with those spreading from the Middle East. Spices traveled from one end of the earth to the other. They came to hold great value, used in food, religion and medicine, and so the Indian Ocean was coursed by Chinese, Malayan, Pharaonic, Phoenician, Graeco-Roman, Arab, Jewish, Indian and European merchant seafarers all united by a common temptation.

The vast network of sea routes that developed, linking East and West, made up part of the trade system, along with the land-based Silk Road. Sometimes it is referred to as the Maritime Silk Road. Fogged with romance and cliché, this concept is a European conceit and comes with an assumption of the primacy of its own region as consumer. In reality, there has never been a simple passage leading from the steamy spice forests of Asia to kitchens in the West. Instead, we see an ever-changing web of trade with flow in all directions, some spices traveling great distances and some hardly traveling at all but finding a home in local cuisines.

A few spices made their journey exclusively overland—musk, cassia and licorice trekked with camel caravans across Central Asia—but these are the exception. As the most sought-after spices grew on impenetrable forest islands, the trade was largely conducted by sea. This lent the routes to frequent realignment, and journeys that initially skipped along the skirts of Asia, interspersed with occasional land passages, gradually edged away from the shores as maritime technology improved.

That these grand spice routes existed at all can't be traced through archaeological evidence. Their legacy lingers on in a less tangible form, in the sharing and blending of ideas. With every ship that set sail packed with valuable cargo, fresh knowledge was carried over the seas to the next port.

One of the ways this is most evident is in the food cultures that have developed in concert with each other throughout history.

I have worked hungrily as a culinary detective, finding clues from recipe names, methods and tastes to trace their stories and ancient links. This book has become a project of gastronomic archaeology.

At the most basic, we have the movement of ingredients. Tracing early plant migration requires guesswork, but we can deduce that deliberate spice trade started around 2000 BC. From Austronesia to India traveled crops, including bananas, coconuts, rice, sandalwood, betel nut and ginger, along with harvested spices, like nutmeg, mace and cloves. In return, India and Sri Lanka sent peppercorns, cinnamon, aubergines (eggplants) and turmeric to Malaysia and Indonesia. From further west came Mediterranean coriander, cumin, saffron, wheat, lentils and chickpeas, while rice is thought to have been brought to Greece by returning members of Alexander the Great's expedition to India in the fourth century BC. Tamarind was introduced to Asia from Africa, possibly by Arab traders or perhaps by Ethiopian merchants who were trading with India and Sri Lanka between 100 and 600 AD. Much later, the arrival of Portuguese and Spanish explorers in the 1600s brought New World plants into the culinary game: tomatoes, potatoes, allspice, cashews, corn and papaya. The greatest gift of all was chili from Central America, which was warmly embraced in Asia and quickly replaced indigenous peppers as the key source of heat.

With the movement of goods and people came an exchange of thought. We can, for instance, trace shared philosophies around healthy eating along the aromatic trails. A concept of balancing "cold and hot foods" is found in Chinese yin and yang, Indian Ayurveda, traditional Iranian medicine and the Salerno Regimen from the Italian Middle Ages. The expansive region once home to the

spice routes has such threads of commonality found across languages, epics, religions and cultural customs. In particular, we can see lasting influences from the processes of Sinicization, Indianization, Islamization and colonization that happened through various epochs.

The Chinese influence on Southeast Asian cuisine and its subsequent Sinicization is substantial. It is most obvious in Vietnam, which fell under Chinese rule, but traders were in the Philippines by the eleventh century and settled in Java by the sixteenth, leaving behind Hokkien recipes as footprints. Use of China's star anise spread, its flavor compounds particularly good at enhancing meaty braises. Rice forming the center of meals was a Chinese practice, as was the much-adopted technique of stir-frying and a now near-universal love of noodles. It is often difficult to untangle local from Chinese dishes as many food businesses in Southeast Asia were owned by Chinese, and intermarriage created groups such as the Sino-Thai, Sino-Lao and Nyonya, who laid their own culinary traditions.

Indianization refers to the influence spread by south Indian traders, pilgrims and artists, notably in Southeast Asia from around 200 BC until the fifteenth century. Dance, sculpture, music, Buddhism and Hinduism rippled gently outward from India. With them went new ways of processing the ingredients that were once introduced in the opposite direction: coconut came back in the form of coconut milk curries, spices came back now in complex blends, such as the fragrant mixture used in the Aubergine and toasted coconut curry (page 214).

With the rise of Islam, new ideas about food coursed along the trading pathways like blood through veins. Eating was recognized as a pleasure and a generous insistence on hospitality was woven into the religion.

Cooking techniques traveled from the Middle East, Indians in particular falling in love with Persian tastes, including browned onions, almond and pistachio sauces, saffron-scented rice and fragrant biryanis.

Over the centuries, Muslim traders, both Arab and Indian, spread dishes such as kebabs and kormas across their trade routes.

European colonization left behind fewer cooking techniques; its influence was more from the ingredients introduced. However, we can see some legacies, such as Dutch baking in Indonesia, French baguettes in Vietnam, British tomato soup in India and vinegar-spiked Portuguese braises in Macau.

There are certain hubs along the spice routes where cross-pollination was amplified. Take the "great market" at Bantam on the island of Java, where Indonesian, Indian, Chinese, European, Arab and Turkish traders came together to exchange exotic birds and fruits, jewelry and weapons, honey and rice, drugs and spice.

Seventeenth-century British traders from the East India Company would offer woolen cloths, mirrors and silver bars in return for nutmeg so fresh it would leave fragrant oils on their fingertips, to be packed into westward ships with peppercorns, silk yarn, indigo and bales of Chinese tea. Other ports of early coexistence and conviviality include Venice, Alexandria, Istanbul, Cochin, Colombo, Hong Kong, Macau and Singapore.

Geographical bottlenecks served to funnel trade through key entrepôts, creating cosmopolitan centers along the trail where merchants would hang around waiting for the change of season that brought a turn in trade winds. Between China and India lies a string of islands that acts as both a barrier and bridge for the two powerful regions. Known to us today as Malaysia, Indonesia and the Philippines, the ancient Greeks termed it the "Golden Peninsula" in a nod to the wealth both locals and traders made from the strategic position, especially the Strait of Malacca. Another bottleneck is the route into Europe—either through the Persian Gulf or rounding the Horn of Africa to enter the Red Sea—both of which required spices to leave boats for a stretch of overland travel. The section of the African coast where ships docked on the passage to India was long known as the "Cape of Spices."

When the notion of a dish arrives in new lands, brought by lingering traders or immigrants seeking a taste of a faraway home, fusion and evolution quickly follow. Communities have always borrowed ideas and then grafted them onto local traditions, whether the idea in question is a religion or a recipe. Take Thai curries with their rainbow names—red, yellow, green—which show a union between local aromatic herbs and spices brought in with Indian traders.

Migration creates a merging of "them" and "us," new cooking born out of necessity and innovation entwined with nostalgia.

As Madhur Jaffrey says, "A new fish in a new land demands a new technique and perhaps a fresh set of spices." Culinary traditions evolve, sparking creativity as ingredients are adopted and recipes are adapted.

The story of food can sometimes be the story of humanity, and nowhere does that seem more true than in the case of the spice routes. There have been periods of dominion and conflict, but mostly of cooperation and exchange. From Yemeni martabak in Indonesia to Portuguese-inspired vindaloo in India, we are left with a grand legacy of adopted dishes that reveal admiration for other cultures and act as lasting bonds, reaching across distant seas.

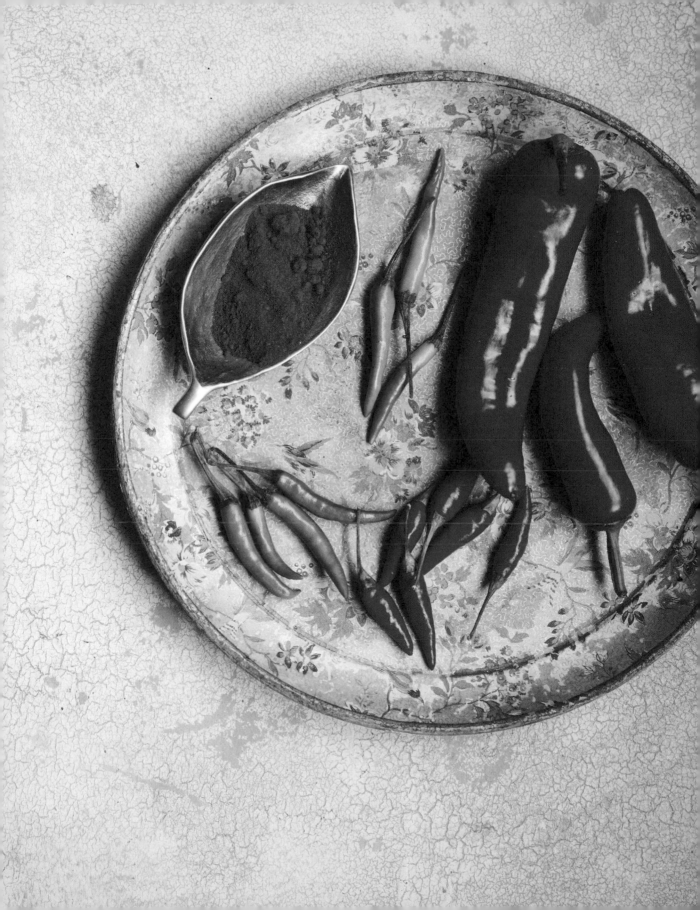

GOLDEN NUTMEGS: THE RISE & FALL OF SPICY EXCESS

An air of glamor, romance and otherworldliness hangs around spices. With no single land of origin, a spice mix always requires a journey and, until recent history, it was an epic one. The further they traveled, their exotic appeal and costs both escalated. What was special in Asia became extraordinary by the time it reached Europe. Prices fluctuated over the eras in response to changes in trade, but they were always high and at times astronomical, considered as precious as gold or silks.

So great was the value that, like treasure, spices were used variously as rents and ransoms, bribes and offerings. Ancient burials saw bodies embalmed with cinnamon oil; plagues warded off with necklaces of nutmeg; cardamom burnt to summon gods; and fiery ginger used to ignite carnal desire. Spices held a prominent place in food, health and worship, with a good dose of magic laced through it all.

Poets of every age have drawn on spice's inexorable link with fantastical lands, using them as

symbols of the sublime and as shorthand for erotic sensualism.

They come laden with powerful association. In pagan times, gods themselves smelled of spices and it was long thought they arrived on earth from paradise. The peppery yet floral West African seeds "grains of paradise" were so named as a brilliant marketing ploy in medieval times.

Savages and monsters were intrinsic to the lush, spice-scented dreamworlds of medieval literature. Arab spice traders in the fifth century BC wove tales of the fearsome cinnamologus birds who build their nests of cinnamon twigs on sheer cliffs from which the merchants had to wrestle them free. A large part of the attraction was the mystery, that spices came from an unknowable and dangerous world.

The truth was almost as astonishing.

If we take our hero, nutmeg, the journey started at the easternmost extremities of Indonesia on just ten obscure islands in an ocean of tens of thousands.

Golden, apricot-like fruit were broken open to reveal a pip of nutmeg snared in a vermillion web of mace.

From here they would make their way into the ocean on local outrigger boats or Chinese junks. Sailing across the Indonesian archipelago, they would pass either north to China or through the Strait of Malacca and on to India. This voyage was being made from 300 BC, and by the fourteenth century the pips were being taken on as far as England. Arab dhows would pick up nutmegs destined for an

onward journey and take them across the Indian Ocean to the spice ports of the Middle East, where they would be packed onto caravans to continue the journey across the deserts. Those bound for Europe would either move from Byzantium into Eastern Europe or be loaded onto ships once more in the Mediterranean Sea, passing through Alexandria to Italy. From Venice, they might round the Iberian Peninsula to be delivered to the ports of Western Europe, ready to be grated into warm ale. In the long chain of middlemen, only the first few handlers knew the origins of their goods, only the last few knew the destinations, and no one could see the system in its entirety.

As the furthest link, Europeans always paid the highest price for their spice. There were two peaks of spicy excess in the West. The first came in ancient Rome, where direct trade with India allowed prices to dip enough for spice to enter cooking rather than be reserved for ceremonial splendor.

Banquets were elaborate, pleasure-soaked affairs dripping with jewels, gold leaf and immoderations of spice. In the world's first known cookbook, *De Re Culinaria*, c. first century AD, pepper, ginger or cardamom feature in most recipes and boiled, spiced flamingo was on the menu.

As Rome fell, so did the spice trade. The spice lands retreated once more beyond the horizon and costs soared. For a thousand years of the Dark Ages, practicality trumped pleasure and spices all but fell out of culinary use in Western Europe.

With the dawn of the High Middle Ages and Europe reaching an economic and cultural height, spices returned with full pomp. Spiced wines and ales were back in favor and medieval cooks dreamed up countless wonderful, spice-suffused dishes. A popular sauce across Europe during this period was cameline, so called for its camel-like hue. With a base of sweet wine vinegar-soaked bread, it was heavy with cinnamon, ginger, cloves and saffron. Medieval European cookery drew influence from Persian cuisine, with its heady combination of scented sweet and sour. Indian Mughal cuisine had a similar palette and the

visiting Englishmen who ate at the Mughal courts in the sixteenth century would have found a familiarity to their food at home.

There are dishes throughout this book that show these bifurcating and returning culinary roots, as cuisines were expanded and ingrained through multiple generations of travel and tradition.

That spices could only be used by the very wealthy was much of their hold. Pepper, once the most sought-after seasoning, became so affordable and commonplace in the early seventeenth century that a pepper pot sat on every table. The nobility duly lost interest and turned instead to the "fine spices" of nutmeg, cloves and cardamom. Still gathered by hand from wild jungles, they were inherently limited enough to remain a status symbol. A silver nutmeg grater carried on one's person served as a suitable display of standing and refinement.

From heights so dizzying that the European Age of Discovery was seeded by spice, a steep fall was inevitable. Spices lost their luster in large part because their mystique was eroded. Jack Turner in his fascinating book, *Spice: The History of a Temptation*, writes, "The discoverers chipped away at the great edifices of medieval ignorance and fantasy, dragging the realms of spice and gold into the prosaic light of day; into the unromantic focus of the profiteer and venture capitalist."

The mysterious lands were now studied and mapped. Spices were transplanted and grown widely, losing their rarity, and so were stripped also of their value, symbolism and significance. By being so brutally successful in acquiring spices, the legacy of the discoverers was to render them familiar and, more fatal still, attainable. Tastes moved on and new products took over the decadent attraction once reserved for spices: sugar, tobacco, coffee and chocolate.

Spices are no longer the scents of royal courts, maybe not even of paradise. Accessibility has gradually dispersed the elitism, allowing these wonderful flavors to reach nearly every palate. This is a boon for our global food culture, yet hasn't diluted our passion to keep expanding our spice racks.

We continue to seek out new tastes and complexities, and spiced food remains among the most sought-after culinary treasures. Reminders linger of a time when the price of a dull, brown nutmeg outstripped gold.

In the twenty-first century, vanilla beans overtook silver gram-for-gram when Madagascan storms decimated crops. And saffron tops caviar to be one of the world's most illustrious and expensive ingredients. Spice still knows how to hold us, and keep us wanting more.

COOKING

WITH

SPICE

WHAT IS A SPICE?

At their simplest, spices are the parts of plants most densely rich in flavor, which can enliven and elevate food. They are the dried seeds, barks, roots, rhizomes, fruits, arils, flower buds and resins from plants that grow mostly in tropical climates.

Ask a cook and they will tell you about the aromas that have to be teased out through cooking and that spices are decidedly not herbs, the fresh and leafy parts of plants grown more locally. They will know that spices' aromas and flavors are volatile and fat soluble, the spices best freshly ground and their flavors extracted by sizzling in oil, and how they can be used to

build layers of flavor to excite all the senses.

Ask a botanist and you'll hear about the essential oils, oleoresins, terpenes and other compounds, which each bring specific aromas and tastes. These chemical stores in plants have functions to help them survive and reproduce. Often the very things humans are drawn to—the pungency, bitterness, heat or numbness—are actually defense mechanisms for the plants, their armor to repel predators. In the curious case of cinnamon, the resinous bark of the Cinnamomum tree, its warm, woody scent is created when the plant is being eaten to communicate to nearby trees to prepare their defensive chemicals.

A historian's definition will focus on spices' relative geographical scarcity, which made them expensive, elitist and highly sought after. In quest of spice, man first acquired an understanding of earth's geography, and soon after a taste for mastery of it. For both anthropologists and writers, the story of spice has been laden with mythology, symbolism, ritual, romance, seduction, temptation, bloodshed, exploitation and extraction.

Etymologically, the word "spice" derives from the Latin "species," meaning merchandise of special value. A sense of their extraordinariness is embedded in their name. Other rare and valuable items were once included, like ivory, opium, leopard skins, perfumes, lapis lazuli and jewels. In time, the species became more specific and only culinary additives qualified, though for a while tea and sugar were considered spices. Others once treasured, such as long peppers, still fit in the category but have fallen from favor. Today, the smaller clutch in common usage still serve to enrich our lives and enhance our cuisine.

ANATOMY OF SPICE

ROOTS & RHIZOMES

Ginger
Galangal
Turmeric
Licorice

LEAVES

Curry leaf
Lime leaf

FLOWERS

Clove
Saffron
Rose

PODS

Cardamom
Star anise
Vanilla

BARKS

Cinnamon
Cassia

RESINS

Asafoetida
Mastic

FRUITS

Pepper
Sumac
Tamarind
Amchoor
Allspice
Caraway
Chili
Sichuan pepper

SEEDS

Nutmeg
Cumin
Coriander
Fennel
Mustard
Nigella
Fenugreek
Cacao

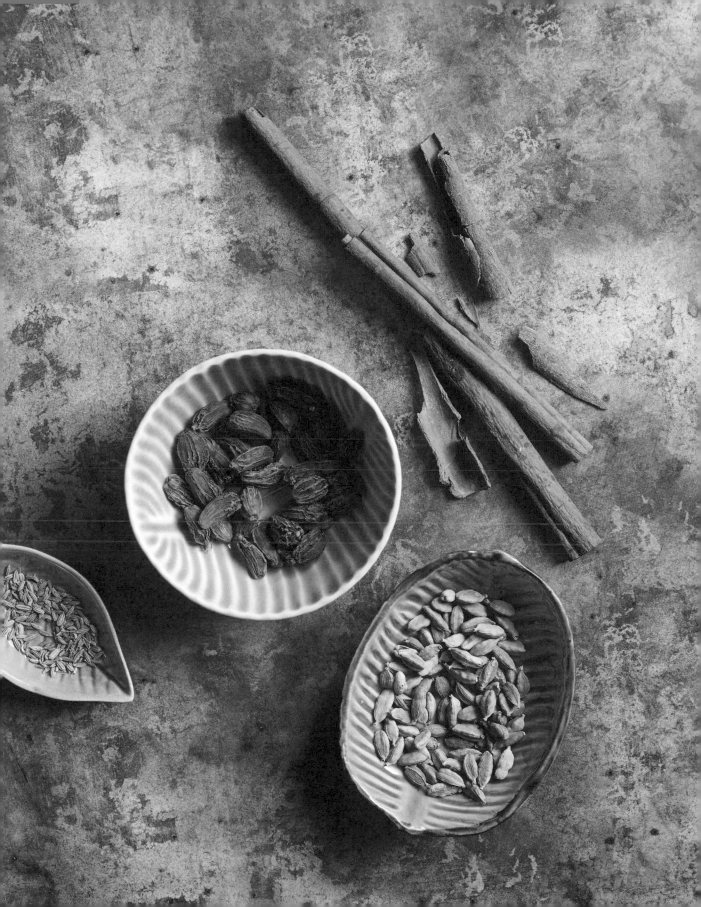

A STARTER SPICE LIBRARY

ALLSPICE

Berry native to the West Indies and Central America, so named because it combines the tastes of many spices. Warm, medicinal and peppery. Crack and toast before grinding to amplify the flavors.

CARAWAY

The "seeds" are actually the dried fruit of a Central European plant. Earthy, aniseedy, woody. Heat will bring out the flavor, but too much and they risk turning bitter.

CARDAMOM

Seed pods of a plant from the ginger family. Green cardamom is native to southern India and tastes of eucalyptus; black cardamom is from the Himalayas and is smoky and more resinous. Indian black pods are smaller than the Chinese (sometimes known as red cardamom) and smokier due to the drying method, but the two can be used interchangeably. There are also African "cardamoms" with a shared medicinal note. Lightly bruise pods before adding whole or for more intensity, grind the seeds. Pre-ground cardamom, often used in Middle Eastern cookery, is muted and less medicinal so needs to be used in greater quantity.

CHILI

American fruit that spread across the world in only fifty years after being "discovered" by Columbus. Fiery and fruity. Each variety has its own profile from mild and sweet to incendiary. The seeds and their surrounding membrane hold most of the heat, so remove for less pungency. Notable chili powders include cayenne, Kashmiri, pul biber, Urfa and paprika.

CINNAMON & CASSIA

True cinnamon is the fragile bark of Sri Lanka's cinnamon tree, while cassia is a coarser bark from China with a coarser flavor to match. In the USA, most of the jars brazenly labeled "ground cinnamon" actually hold cassia. Warm, sweet and woody. Oil will help disperse the flavor in cooking.

CLOVE

Dried flower buds of the evergreen clove tree originating from five islands in Indonesian Maluku. Sweet, warm and medicinal. The flavor compounds are oil soluble so fat in a dish will help tease them out.

CORIANDER

Seeds of the coriander plant native to the Mediterranean. Floral, woody and citrusy. Untoasted it is more floral; toast and the seeds become nuttier and earthy.

CUMIN

Seed of umbrella-shaped flowers native to Egypt and the eastern Mediterranean. Earthy, woody and pungent. Toasting is essential to bring out the flavor. If you buy ground cumin it will have already been toasted.

CURRY LEAF

Leaves from a tree in the citrus family native to the Himalayas. Musky, lemony and sulfurous Buy fresh on the stem and freeze for a better aroma than dried.

FENNEL

Celadon seeds of either the sweet or bitter fennel from the Mediterranean. Aniseedy, herbal and bittersweet. Gently cracking or grinding will help release the essential oils.

FENUGREEK

Angular seeds from an eastern Mediterranean plant. Earthy and musty with notes of brown sugar. Toast for coffee-like flavors and to remove bitterness or soak overnight to bring out an emulsifying gel.

FLOWER ESSENCES

Heavily perfumed extracts from edible flowers, including rose, orange blossom, jasmine, pandan (kewra), and ylang-ylang. Lend desserts exquisite intrigue and can be sprinkled over pilafs.

GALANGAL

Fibrous, ginger-like rhizome of Java's galangal plant. Peppery, medicinal and pungent. It works to enhance other flavors and is best used fresh.

GINGER

Fleshy, underground rhizome native to tropical Asia. Hot, herbal and citrusy. Peel just before use to retain the fragrant oils. Dried is hotter than fresh, but the spicy heat is tamed by cooking.

JUNIPER

Dark berries of a prickly European shrub. Piney, resinous, woody. The dominant aromatic in gin and well suited to meat braises.

LEMONGRASS

Stems from a grass family grown across the Asian tropics. Citrusy, fragrant and herbal. Bruise and (if long enough) tie the stems in a knot to expose the oil glands inside before dropping into the pot.

LIME LEAF

From the Asian makrut (also known as kaffir) lime tree. Citrusy, floral and perfumed. Choose fresh or frozen over dried; finely shred (pulling out the central vein first), or simply scrunch to release the flavors and infuse into cooking.

MACE

Ruby red aril that encases the Indonesian nutmeg seed, dried to auburn blades. Sweet, warm and more floral than nutmeg. Add whole blades to cooking early and ground mace later to keep it sweet and fragrant.

MUSTARD

Seeds from a plant in the cabbage family. White/yellow mustard is Mediterranean, while brown is Himalayan and black Middle Eastern; the latter two can be used interchangeably. Hot, sharp and peppery. The seeds must be cracked either by heat to make them nutty or crushed to transform from bland to pungent.

SAFFRON

Precious crocus stigmas native to the Mediterranean. Honeyed, bitter and floral. Grind then steep in warm water to release all the treasured aromas held within.

SICHUAN PEPPER

Fruit of a Chinese shrub. Numbing, tingling and floral. The black glossy seeds inside can be discarded as the prickly husk holds all the power.

STAR ANISE

Pretty pods of a Chinese tree closely related to magnolia. Sweet, licorice-like and medicinal. Slow-cook to draw out the flavors or toast and grind for nuttiness.

SUMAC

Rust-colored, late-summer berries from the Mediterranean. Tart, fruity and astringent. Sprinkle over food before serving to bring brightness.

TAMARIND

Pulp from the pods of the tamarind tree native to eastern Africa. Sour, sweet and fruity. Unlike citrus, keeps its sourness well in cooking.

TURMERIC

Yellow rhizome thought to be native to India. Earthy, bitter and spicy when fresh. Needs the high heat of fat to disperse the flavors.

VANILLA

Dark, plump pods of the vanilla vine, native to Central America. Sweet, floral and musky. Keep the heat gentle so as not to lose its nuances.

NUTMEG

Seed of the evergreen tree from the volcanic Banda Islands of Indonesia. Bittersweet, peppery and warm. When very fresh, you can squeeze out the essential oils with your fingers. Use at the end of cooking as the flavor is powerful but ephemeral.

PEPPER

Berries from the Indian pepper vine. Underripe berries can be preserved as green peppercorns or dried to black; if the outer layer is stripped you get the less aromatic white peppercorns. Hot, pungent and citrusy. Grind just before use for maximum flavor.

ROSE

Buds and petals of the rose bush, likely native to China, while the exceptionally fragrant damask rose is from the Middle East. Floral, sweet and musky. The delicate flavor can quickly become overwhelming so use judiciously.

EXPANDING YOUR COLLECTION

In the recipes that follow, I have largely featured spices that can be found in most spice libraries. Here are some lesser-known treasures that the curious cook might want to seek out.

AJWAIN/AJOWAN

Oval seeds of a Middle Eastern plant related to cumin and caraway. Herbaceous, pungent, bitter. Important in Afghan, Pakistani and Gujarati cooking.

AMCHOOR

Dried mango fruit, often powdered. Tart, citrusy, amarine. Key component of India's chaat masala.

ANARDANA

Dried seeds and surrounding ruby-red arils of pomegranates. Fruity, sour and sweet. Ground and used as a souring agent for Indian curries and Persian stews.

ANDALIMAN PEPPER

Fruit of a Sumatran shrub similar to Sichuan pepper. Aromatic, numbing, citrusy. Ground into Padang sambals and spice pastes.

ANISE

Seed from the summer-blooming anise plant, native to the Middle East. Licorice-like, woody, sweet. Excites the tongue's sweetness receptors, making it thirteen times sweeter than sugar, which is put to use in liqueurs, from French pastis to Turkish raki.

ANNATTO

Angular Caribbean seeds from a plant in the achiote family known as the lipstick tree. Peppery, citrusy, earthy. Used as an orange coloring by the early Aztecs, and the habit traveled to the Philippines.

ASAFOETIDA

Dubbed both "food of the gods" and "devil's dung," the ground resin from a stinky plant that grows in the mountains of Central Asia. Oniony, sulfurous, sour. Gives depth to Indian vegetarian cookery.

BARBERRY

Jewel-like berry native to western Africa and southern Europe. Tart, zingy, fruity. Adds bursts of brightness to cooking in the Caucasus and Middle East.

BLACK CUMIN

Seed from a plant in the cumin family. Smoky, earthy, sweet. Used in northern India, Pakistan, Afghanistan and Tajikistan; good in biryanis. Note this is different to nigella, which, confusingly, is also sometimes dubbed black cumin.

BLUE FENUGREEK

Seed from the mountainous region of the Caucasus. Earthy, nutty, mild. Essential to Georgian cooking and the national spice blend khmeli suneli.

CACAO NIBS

Broken pieces of the cacao seed kernels native to the American tropics. Earthy, bittersweet, sour. Don't melt like chocolate (made from the same seed), so can add a nutty crunch to sweet bakes.

CAROB

Pods of an eastern Mediterranean tree. Astringent, sweet, chocolatey. A source of food in times of famine as the tree fruits in poor soil; easy to transport, and spread widely by the spice trade.

DILL

"Seeds" that are actually the ripe fruits dried on the stalk of the Mediterranean plant. Herby, woody, bitter. Flavors pickles and vinegars in Eastern Europe, Russia and the Caucasus.

DRIED LIME

Fruit native to Southeast Asia, brought to the Middle East by Arab traders and the practice of drying them started in Oman. Tart, musky, citrusy. Infused into broths and Persian chickpea stews.

FRANKINCENSE

Resin from the Boswellia tree of the Arabian Peninsula and northern Africa. Perfumed, piney, musty. Used to scent Omani lentils and ice cream.

GRAINS OF PARADISE

Nubby seeds of a West African plant from the ginger family. Peppery, floral, herbaceous. Once fashionable in Europe but now used mainly in African meat soups and stews.

GRAINS OF SELIM

Pepper-like seed pods of an African tree. Bitter, musky, sweet. Valued in African spice rubs but fell from favor in Europe after the Middle Ages.

LEMON MYRTLE

Leaves of an Australian evergreen tree related to allspice and clove. Citrusy, herbaceous, peppery. The group of plants also includes aniseed myrtle and cinnamon myrtle, the flavor hints in their names. All prized by aboriginal Australians in cooking and medicine.

LICORICE

Dried root from a Mediterranean and west Asian plant in the pea family. Intense, aniseedy, sweet. Particularly favored in Scandinavia, though also used in India and China.

LONG PEPPER

Elongated fruit from the pepper family. Hot, fragrant, pungent. Used in Indonesian and Malaysian cooking, as well as some North African spice mixes and Nepalese pickles.

MAHLEB

Kernel of the tart mahaleb cherry from the Mediterranean. Fruity, bittersweet, floral. Perfumers appreciate it as much as bakers in Greece, Turkey and the Middle East.

MASTIC

Resin "tears" of the Mediterranean tree from the sumac family. Floral, piney, woody. Used to churn a faintly chewy ice cream enjoyed in Greece, Turkey and Lebanon.

NIGELLA

Black teardrop seeds of a plant native to Europe, Turkey and the Middle East. Oniony, bitter, herbaceous. Now cultivated largely in India, where it is added to pickles and scattered over breads.

PANDAN

Also called pandanus or screw pine, these long, reedy leaves act as the vanilla of Asia. Fragrant, floral, grassy. Can be scrunched, knotted and dropped into custards, rice or Sri Lankan curries.

PINK PEPPERCORNS

Not a pepper but the dried berry of the South American Baise Rose plant. Sweet, peppery, fruity. Delicacy suits desserts.

SANSHO PEPPER

Japanese berries not related to pepper. Citrusy, numbing, warm. A classic flavor for yakitori in Japan.

SWEET FLAG

Rhizome from a reed native to the mountain marshes of India. Bittersweet, pungent, gingery. So popular in the Middle Ages it was almost harvested to extinction, now used in Indian and Arab sweets, absinthe and some colas.

TASMANIAN PEPPERBERRY

Both leaves and berries are harvested from the Australian plant also known as mountain pepper. Hot, peppery, herbal. Once used as a colonist pepper substitute and now exported to Japan to flavor wasabi.

TEPPAL

Indian relative of Sichuan pepper. Woody, numbing, tingly. Used in south Indian fish and vegetarian cookery.

WATTLESEED

Little brown seeds from the Australian wattle. Nutty, roasted, woody. Used in both sweet and savoury dishes, but not widely outside of Australia.

Some spices that once held global importance have all but been forgotten beyond their places of origin, most notably the African "peppers." There are resiny grains of Selim, the floral yet hot grains of paradise, and the more herbaceous Benin pepper. A close relation is cubeb or tailed pepper from Indonesia, which has an insistent, piney bitterness. All were traded widely in Europe and the Middle East in the medieval period, but eventually India's pepper took the upper hand and still reigns supreme as the most grown and used aromatic.

One spice vanished entirely. Silphium was obtained from the deliciously scented resin of a North African plant and was a favorite of ancient Greeks, who would partner it with vegetables, lentils and offal in vinegary sauces. It was so loved that its heart-shaped seeds were imprinted on money and may even have inspired the enduring association of the symbol with romance. First-century Romans were the last people to ever taste silphium for it was wiped out, perhaps by over-farming or the increasing aridity of the Sahara. Our best guess is that it may have been close to asafoetida, another resin spice, though silphium didn't seem to share the pungent aroma that puts off some cooks. It was said to bring an oniony depth to cooking, but we can only imagine the other wondrous flavors it imparted.

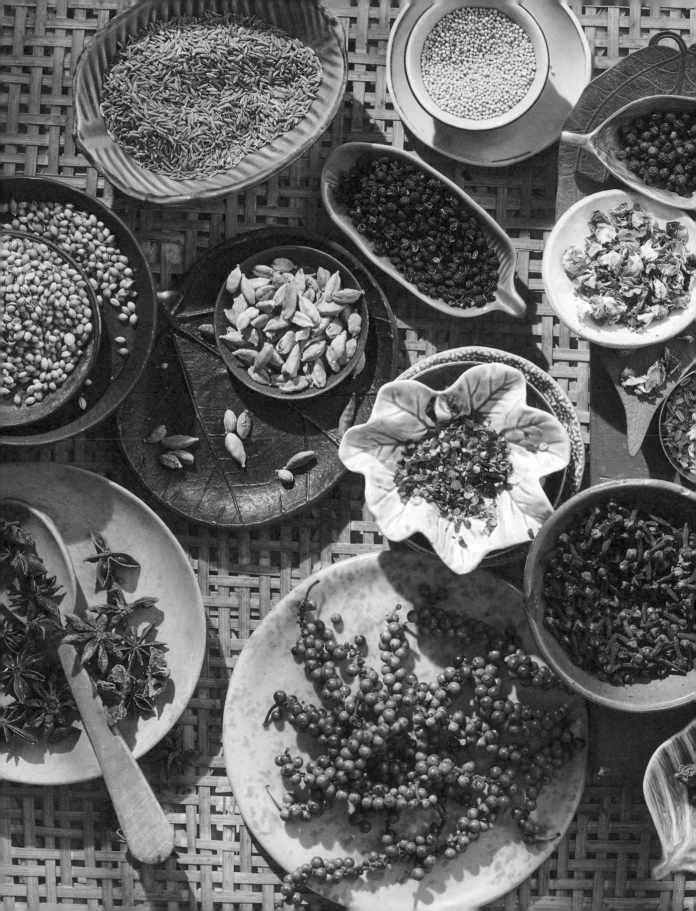

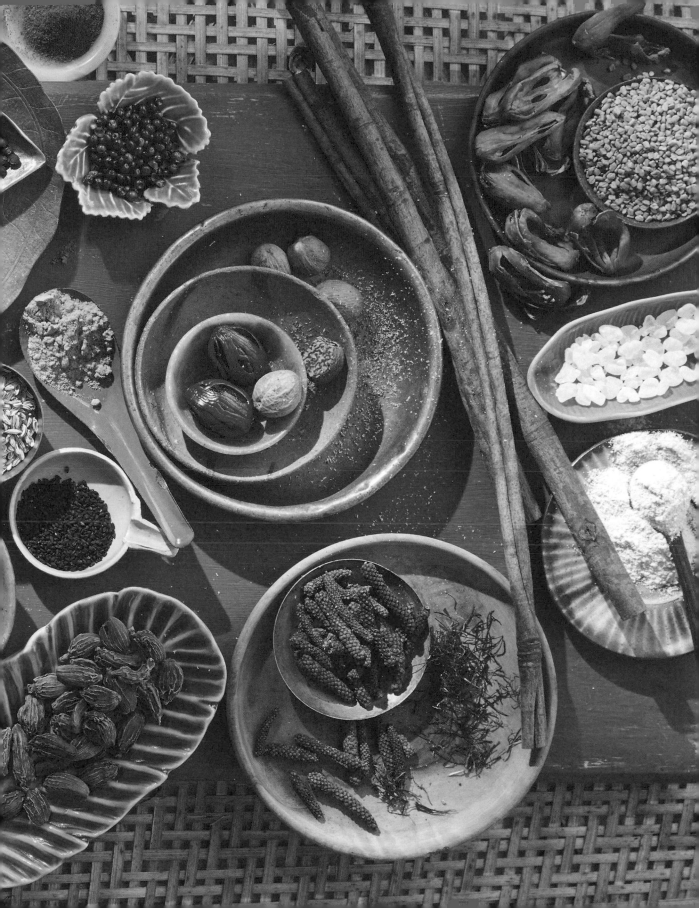

SPICE SKILLS

WHOLE SPICES

CHOOSING & STORING

There are different gradings of spice, with quality depending on size, shape and content of essential oils. The oilier, the fresher. Let your nose be your guide as they should smell fragrant and intense rather than dusty.

Spices' aromas drift away with age, especially once ground, so where possible buy whole, in small quantities and grind as needed. Store in airtight containers away from light and consider refreshing old stock. It will make all the difference to your cooking.

TOASTING

When heated, essential oils are brought to the surface, which intensifies taste and serves to revitalize old spices. Toast whole rather than ground, either one type at a time or grouping together those of a similar size. Use a dry frying pan over a low heat and keep everything moving until you are wafted with the toasty aroma.

TEMPERING

Going by various names, including blooming and tarka, this technique is sizzling spices in oil over a moderate heat. It is widely used in South Asia and countries influenced by these cuisines. Many of the volatile compounds in spices are oil soluble and so the flavors intensify and infuse into the fat, which helps distribute them throughout food. Lightly tempering spices gives a milder flavor, while longer tempering gives an almost charred pungency. Do this at the start of cooking, laying a spicy foundation to build upon, or stir through a tarka to finish as is common in dishes like dal. Sometimes tempering is done twice, bookending a recipe.

INFUSING

Using the dual powers of heat and time, spicy flavors can be infused into liquids. This can be as simple as dropping a star anise or knot of lemongrass into a braise or pot of rice to perfume the entire dish. Chinese flavor-potting uses whole spices to suffuse a poaching broth, while in Syria bundles of cinnamon, bay, cloves and cardamom are used like a bouquet garni. You can also infuse oil such as a chili oil for drizzling on noodles; alcohol as in saffron vodka; or sugar, for example in a cinnamonic syrup to swirl over orange slices.

SMOKING

Robust spices like star anise or cloves can be burnt for their aroma when hot smoking in much the same way as wood chips. See the Jasmine tea-smoked chicken on page 228.

GROUND SPICES

GRINDING & BLENDING

Dry ground spices release their aroma more quickly into food and, when combined in blends, can build subtle layers of flavors. Toast whole spices to enhance the taste and make them easier to break down, then use a spice grinder for a fine grind or a pestle and mortar for more control over the texture. This is best done fresh, but if you prefer to buy ready-ground spices, then do so in small quantities and use before the aroma dissipates. Spices should generally not be roasted after grinding as they are easy to burn and their volatile oils quick to escape.

FRESH SPICE PASTES

Fresh spices like ginger, garlic, shallots, chilies, turmeric and lemongrass are often minced together to make a paste. This is particularly common in Southeast Asia, where spice pastes form the base of many recipes. In South Asia, a ginger and garlic paste is typically used alongside dried spices. Spice pastes are usually fried in oil at the first stages of cooking to mellow and mingle. Don't be hasty with this step; frying until the fat separates from the paste will ensure any disappointing harshness or thinness of flavor is traded in for wonderful depth. Read more on page 155.

RUBS & MARINADES

You can use single spices, pastes or blends to marinate meat, fish or vegetables before cooking. The flavor will permeate into the main ingredient, then develop and change upon cooking.

FINISHING SPICE

Spice can be used for finishing flourish. Think of black pepper or ground sumac at the table, or blends like Middle Eastern za'atar, Egyptian dukkah, Indian chaat masala or gunpowder, and Japanese gomashio or shichimi togarashi, all dusted over food before serving. As with fresh herbs, it often pays to use more than you think, so dust away with abandon.

There are also spice blends designed for use in the final stages of cooking, like garam masala. In contrast to curry powders, which are used early, this toasted mix brings warmth and a little bitterness and shouldn't be used until the end of cooking or the bitterness will intensify. Used sparingly, its strong spices will harmonize other flavors.

COMBINING SPICES

Spices that share flavor profiles have a natural affinity—imagine sweet and warming nutmeg with cinnamon, or citrusy lemongrass with lime leaves. Others play off each other, such as medicinal cardamom with fragrant rose, or earthy cumin with the pretty, floral notes of coriander seeds, a duo more likely to be found together than apart.

Multi-spice blends could risk a cacophony as players from every section compete, yet with balance they fall into harmony and make something beautiful and complex. Think of Indian garam masala, African berbere or Middle Eastern baharat; each is transformative yet not overwhelming. For more on the world of spice blends, see page 209.

LAYERING FLAVORS

Each spice will bring something different to a dish—some sweetness, others fragrance, heat, pungency, sourness or earthiness. Combining them creates complexity and you can layer the same or different spices for greater effect by using multiple techniques in a single dish. This way you can create base notes, middle notes and top notes. For instance, start with tempering whole spices (to coax out their flavors), add toasted ground spices just before the main ingredients (they risk burning if added too early), then finish with a spice blend. Spices added at the beginning tend to permeate, blend and mellow; those at the end retain a sharper pungency. Don't forget to taste as you go to check the balance of salty, sweet and sour.

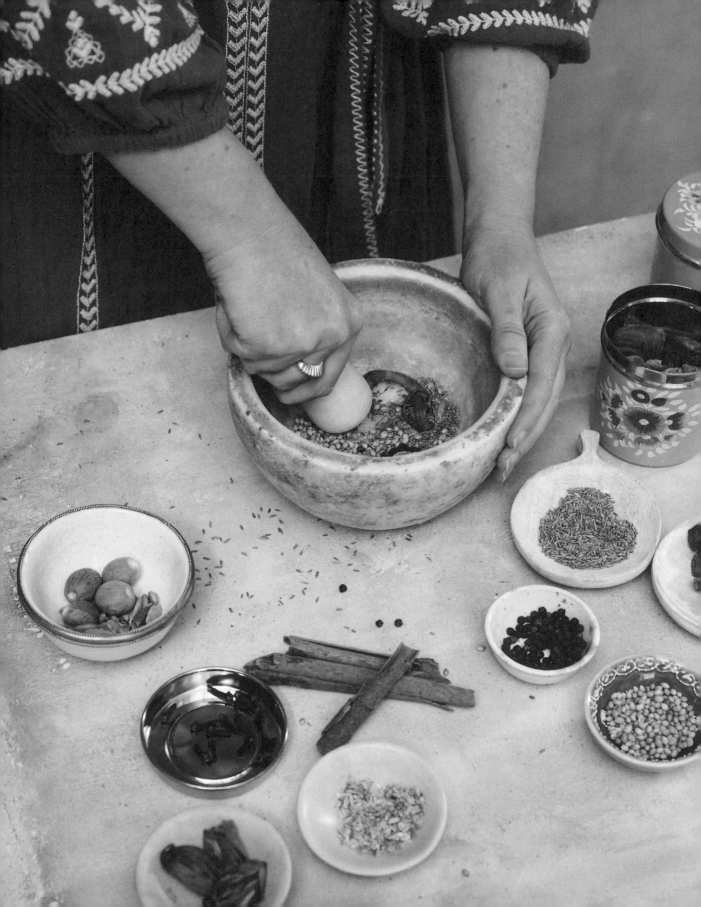

FLAVOR PROFILES

It is the complexity of spices that makes them so valuable for cooks—the different aspects of their flavor profiles interplaying with other ingredients to enhance taste. Opposite, I have grouped spices by their key personalities, but there are also nuances in their aroma compounds.

For instance, nutmeg can sweeten a savory braise, yet conversely its lighter, peppery astringency can be used to cut sweetness in a dessert. In another example, pepper's obvious heat will round out many dishes, but its floral or citrusy back notes are drawn forward when paired with other ingredients with shared characteristics.

The flavor wheels overleaf are a guide to the notes held within the major spices, ready to be coaxed out by the way they are used and combined. Spices with a strong overlap, like pepper and ginger, sing well together. You will often see this put to work in spice blends where there is enough overlap for harmony, but each spice brings something unique.

SWEET & WARMING

Nutmeg
Cinnamon
Cassia
Clove
Allspice

HOT

Chili
Ginger
Peppercorn
Sichuan pepper
Mustard

EARTHY

Cumin
Nigella
Fenugreek
Turmeric
Caraway

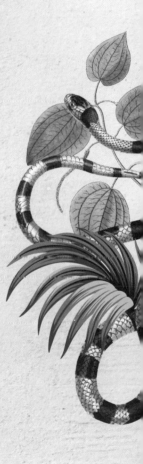

MEDICINAL

Cardamom
Star anise
Fennel
Licorice
Mace
Juniper
Galangal

FRAGRANT & FLORAL

Saffron
Rose
Vanilla
Coriander
Lemongrass
Lime leaf
Curry leaf

SOUR

Sumac
Tamarind
Barberry
Cacao
Amchoor

NUTMEG

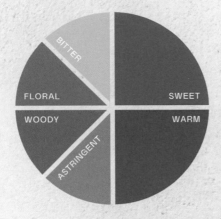

BITTER · FLORAL · WOODY · ASTRINGENT · SWEET · WARM

CINNAMON

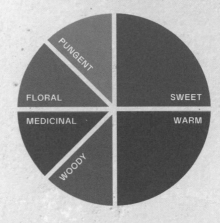

PUNGENT · FLORAL · MEDICINAL · WOODY · SWEET · WARM

CLOVE

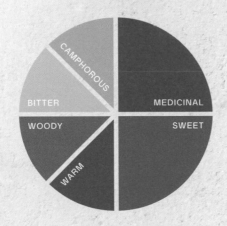

CAMPHOROUS · BITTER · WOODY · WARM · MEDICINAL · SWEET

STAR ANISE

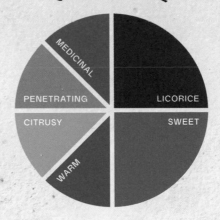

MEDICINAL · PENETRATING · CITRUSY · WARM · LICORICE · SWEET

PEPPER

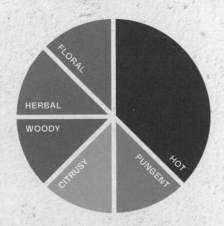

FLORAL · HERBAL · WOODY · CITRUSY · PUNGENT · HOT

GINGER

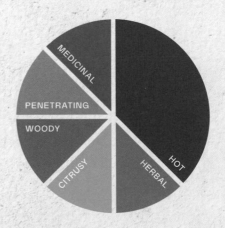

MEDICINAL · PENETRATING · WOODY · CITRUSY · HERBAL · HOT

GREEN CARDAMOM

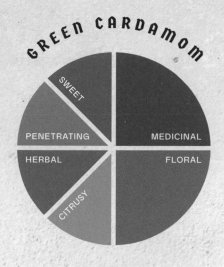

- SWEET
- PENETRATING
- HERBAL
- CITRUSY
- MEDICINAL
- FLORAL

SAFFRON

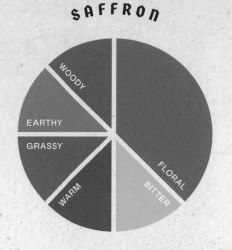

- WOODY
- EARTHY
- GRASSY
- WARM
- FLORAL
- BITTER

LEMONGRASS

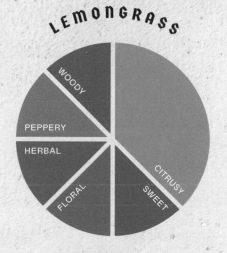

- WOODY
- PEPPERY
- HERBAL
- FLORAL
- CITRUSY
- SWEET

CORIANDER

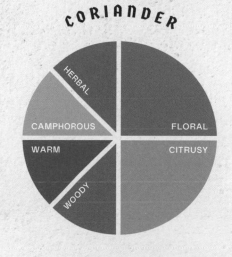

- HERBAL
- CAMPHOROUS
- WARM
- WOODY
- FLORAL
- CITRUSY

CUMIN

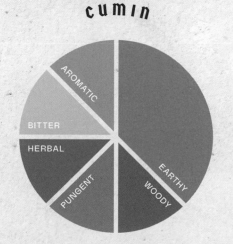

- AROMATIC
- BITTER
- HERBAL
- PUNGENT
- EARTHY
- WOODY

TURMERIC

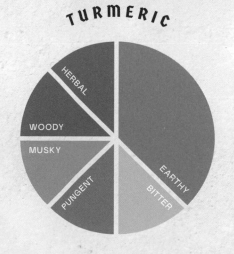

- HERBAL
- WOODY
- MUSKY
- PUNGENT
- EARTHY
- BITTER

SPICE PALETTES: A JOURNEY OF FLAVOR

One spice alone can lift a dish: think of fish grilled simply with lemon, salt and cumin seeds. You could eat this in countries across the Indian Ocean, never being able to root the unassuming yet brilliant combination to a single home. In contrast, take the dish of rasam, where a cornucopia of spices works together in a sour tamarind broth, a unique flavor profile that pins it to southern India.

Countries have different signature spices that define their cuisines and it is interesting to note how often the key flavors are not those grown locally, rather that spices have crisscrossed east and west to be embraced in faraway lands.

INDONESIA
Vibrant, complex, hot
Signature spices: chili, ginger, turmeric, galangal, salam leaf, lime leaf
Blends: bumbu

MALAYSIA
Complex, rich
Signature spices: dried chili, ginger, galangal, lemongrass, curry leaf
Blends: rempah

CHINA
Aromatic, salty, light, sweet, sour (Sichuanese: hot)
Signature spices: ginger, star anise, Sichuan pepper, sesame
Blends: Five spice, Uyghur seven spice, chili oil

JAPAN
Umami, savory, fresh
Signature spices: sesame, ginger, sansho, white pepper
Blends: shichimi togarashi, gomashio, furikake

VIETNAM
Fresh, delicate, vibrant
Signature spices: chili, ginger, lemongrass, cilantro, star anise
Blends: nuoc cham, five spice

THAILAND
Hot, sour, fresh
Signature spices: lemongrass, chili, cilantro, pepper, pandan leaf
Blends: curry pastes, khao kua

MYANMAR

Fragrant, savory, assertive
Signature spices:
ginger, chili, lemongrass,
cumin, turmeric, star anise
Blends: curry powder,
garam masala

HIMALAYAN BELT

Hot, astringent, warming
Signature spices:
ginger, fenugreek, chili,
coriander, cumin, turmeric,
black cardamom, mustard
Blends: panch phoron,
timur ko chhop

NORTH INDIA & PAKISTAN

Complex, pungent, earthy
Signature spices: ginger,
cumin, coriander, turmeric,
chili, cinnamon, fennel, clove
Blends: garam masala

CENTRAL & SOUTH INDIA

Hot, tart, fresh
Signature spices:
tamarind, chili, mustard,
curry leaf, ginger, cumin,
coriander, nigella
Blends: chaat masala,
gunpowder

SRI LANKA

Fresh, hot, zesty
Signature spices:
curry leaf, coriander,
cinnamon, tamarind, chili
Blends: roasted and
unroasted curry powders

IRAN

Floral, musky
Signature spices: saffron,
rose petals, sumac
Blends: advieh

LEVANT

Warm, fragrant
Signature spices: allspice,
cinnamon, pepper
Blends: za'atar, baharat,
taklia

ARABIAN GULF

Fragrant, intense, musky
Signature spices: cardamom,
dried lime, saffron, clove
Blends: baharat, hawaij

HORN OF AFRICA

Fiery, aromatic, smoky
Signature spices:
fenugreek, chili, Ethiopian
cardamom, cumin, coriander
Blends: berbere, mitmita,
xawaash

TURKEY

Mild, smoky, earthy
Signature spices: pul biber,
cumin, sumac, pepper
Blends: Turkish baharat

A WORLD OF SPICE BLENDS

ADVIEH
Cinnamon
Cardamom
Nutmeg
Rose petal
Pepper
Cumin
(Coriander)
(Turmeric)
(Clove)
(Dried lime)

GARAM MASALA
Cumin
Coriander
Pepper
Cinnamon
Cardamom
Clove
(Nutmeg or mace)
(Fennel)
(Star anise)

DUKKAH
Cumin
Coriander
Toasted nuts
Sesame
Salt
(Thyme)
(Mint)

BAHARAT
Paprika
Pepper
Coriander
Cumin
Cloves
Cinnamon
Cardamom
Nutmeg
(Allspice)

BERBERE
Chili
Garlic
Ginger
Fenugreek
Ethiopian
cardamom
(Coriander)
(Cumin)
(Ajwain)
(Nigella)
(Pepper)
(Cinnamon)
(Nutmeg)
(Allspice)
(Clove)

XAWAASH
Cumin
Coriander
Pepper or long
pepper
Nutmeg
Clove
Cinnamon
Cardamom
(Turmeric)
(Fenugreek)

CHAAT MASALA
Green mango
Black salt
Cumin
Coriander
Pepper
Ginger
(Asafoetida)
(Fennel)
(Ajwain)
(Mint)

UYGHUR SEVEN SPICE

Cumin
Star anise
Sichuan pepper
Pepper
Clove
Cassia
Cardamom

FIVE SPICE

Star anise
Fennel
Sichuan pepper
Clove
Cassia
(Nutmeg)
(Orange peel)

SHICHIMI TOGARASHI

Chili
Sansho pepper
Black/white
sesame
Poppy seeds
Orange peel
Ground ginger
Nori

GREEN CURRY PASTE

Coriander
Cumin
Pepper
Galangal
Lemongrass
Garlic
Shallot
Ginger
Chili
Turmeric
Lime leaf
Shrimp paste

PANCH PHORON

Fenugreek
Cumin
Nigella
Black mustard/
radhuni
Fennel

REMPAH

Dried chili
Shallot
Garlic
Galangal
Turmeric
Belachan
Candlenut

SRI LANKAN CURRY POWDER

Coriander
Cumin
Fennel
Fenugreek
Curry leaves
Turmeric

BUMBU

Shallot
Garlic
Chili
Turmeric
Kencur
Galangal
Ginger
Coriander
Lemongrass
Candlenut

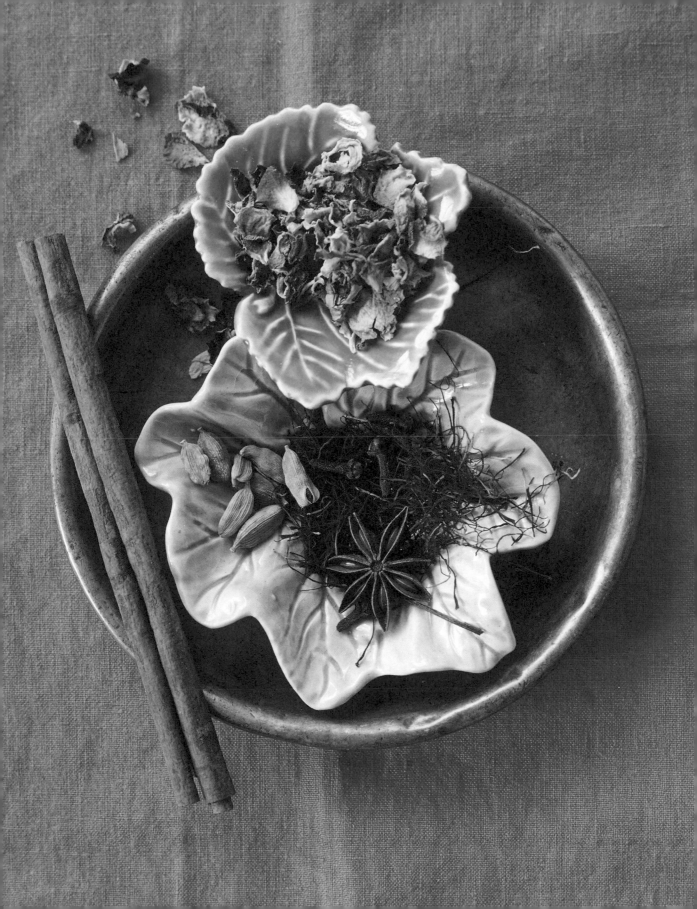

A NOTE ON THE RECIPES

My purpose in this book is twofold. Firstly, at its most elemental, to show different techniques with spice and how to use them to create well-balanced, vibrant meals. Secondly, in a project that has fascinated and consumed me utterly, to explore the culinary history behind spice and how it informs the food we eat.

A collection of spice recipes could be boundless, just as the trade in time came to envelop the globe and bring people the world over into its thrall. I have limited our scope first by geography. We will stay within the bounds of the original spice routes—the sea trade passages of antiquity that wove through Asia and the Middle East. Focusing on the journey, we'll leave the nutmeg-scented custards, saffron paellas and cinnamon buns of Europe. We'll also largely leave aside recipes born of the overland spice trade, another voyage of cultural diffusion winding through China and Central Asia along the paths known as the Silk Road, though crossover is inevitable in this tangled web. We won't venture much along the later trading routes to the Americas and Africa.

Instead, we will be eating our way across the Indian Ocean, the original cradle of spice. We'll explore food from trading hubs and entrepôts, where new flavor combinations were born and culinary cross-pollination is at its most pronounced.

Different cuisines favor particular spice pairings and have unique ways of harnessing their aromas. Small tweaks of spicing make food with similar ingredients that is gloriously diverse. We will look both for dishes that are distinct and those that are reminiscent of others from across faraway seas. Some recipes are modern, some ancient, most have deep-reaching roots.

The selection also reflects my personal predilections in the kitchen: for home cooking, for simple preparations that deliver big flavors. Historically, rare and expensive spices were associated with courts, palaces and festivals, and dishes tended to use meat. For balance, I have tried to seek out some vegetarian variations where they exist. There are relatively fewer fish dishes, where a lighter hand with spice is usually favored. Most importantly, the wealth of choice has allowed me to only include recipes that excite and delight.

I try not to adapt recipes in order to keep the authenticity, or at least the spirit, of each dish. Their stories, histories and heritage are important. Yet, at risk of being contrary, food has always been a living, moving tradition and no dish gets frozen in time. New ingredients, changing circumstances and inventive cooks see to that. Inherently, these recipes reflect my cooking in my London kitchen with the ingredients available to me, and, as they move to your kitchen, they will evolve with your ingredients and personal tastes. Another step in the journey that cooking takes us on.

THE

FIRST

SPICE

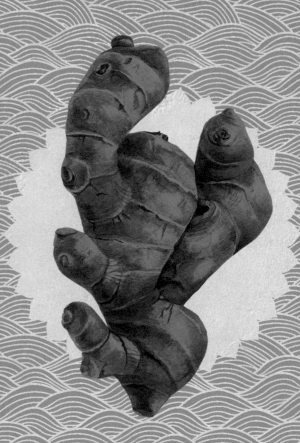

GINGER'S

FIRE & THUNDER

Ginger, with its rasping heat and woody notes, is perhaps Asia's most important spice. It is certainly one of the oldest, its early journeys predating records so we don't know where in the continent it originated, though southern China seems a fair bet. Linguistic clues point to it being taken on voyages by the Austronesians spreading across the Malay Archipelago six thousand years ago. An incorrigible colonist, the gangly rhizome is quick to grow and spread, even in tubs on sunny trading ship decks. For longer journeys later in history, it would be dried or preserved, sometimes packed in decorative blue-and-white ginger jars from China.

The name is from the Sanskrit singabera, meaning "antler shaped," and it shares a family with both cardamom and turmeric.

Fresh ginger brings a thrilling tingle of fire to the mouth

but can be tamed by heat, so the effect changes if you add it at the beginning or the end of the cooking process. When dried it becomes sweeter and more peppery. In modern Japan, as in ancient Rome, young ginger stems are a delicacy, and in Indonesia and Malaysia, the succulent, lipstick-pink flowers of torch ginger are sliced into salads and sambals.

As you trace the old spice routes, it is hard to imagine any cuisine without ginger. It forms base notes in curry pastes from Thailand to Sri Lanka, and top notes in the ginger pickles of Japan and dim sum of Hong Kong. In the Pakistani dry-fry, karahi, it plays both parts as the dish starts and finishes with ginger, a double hit that makes all the flavors sing. It was also one of the first spices to have reached Europe, where the spicy warmth is usually tempered with sweetness in crystallized nuggets and treacly gingerbreads.

Ginger's power and symbolism extend far beyond the kitchen. Recognized worldwide as an antiemetic, it is used for travel and morning sickness. In Myanmar, it prevents flu and in Japan strengthens the heart. Dioscorides, the Greek physician, considered it a laxative, while the Romans held it up as a symbol of wealth and fertility. As early as 500 BC, Confucius welcomed ginger into the Chinese diet, which was otherwise as austere as his philosophy of being, and the Quran assures that those who reach paradise will be welcomed with a silver goblet of warming ginger.

Another reputation across centuries and civilizations is ginger's potency as an aphrodisiac.

As impotence is frigid, so lust is hot, and if desire needs firing, a heating spice is in order.

Indeed, the word "spicy" to this day carries erotic overtones. While it means fragrant, peppery and piquant, it also means racy, spirited, lewd, provocative and risqué. Certainly, spice is the antonym to pure or innocuous.

TYPHOON SHELTER CORN

Bei fung tong sukmai ⟋⟍⟋⟍⟋⟍⟋⟍⟋⟍⟋⟍⟋⟍⟋⟍⟋⟍⟋⟍⟋⟍ Hong Kong

Serves 4 as a side

Hong Kong's name comes from the Cantonese for "fragrant harbor" or "spice harbor," the epithet revealing the port's crucial position in the maritime spice route. It was a place for trading ships to replenish supplies, in particular the aromatic incense agarwood, which was taken by junks around Asia and onward to scent Arabia.

As is the case with many trading hubs, Hong Kong is renowned for its culinary heritage. The Tanka, a group of boat dwellers and one of the native communities, made one of the great contributions to local gastronomy with typhoon shelter crab. While the name is captivating enough, the taste is even better as the seafood is buried under a crunchy mound of garlicky, gingery, salty crumbs. Seek it out in a floating restaurant. Here I have taken inspiration from chef Jowett Yu for a vegetarian interpretation better suited for a home kitchen and one of the most addictive dishes I know.

300g (1½ cups) fresh sweetcorn (2 ears) or frozen corn
4 tablespoons neutral oil
10 garlic cloves, minced
3cm (1¼ inches) ginger, peeled and finely shredded (1 tablespoon)
1 tablespoon black fermented soya beans, rinsed and minced
1 teaspoon chili flakes
1 tablespoon light soy sauce
1 teaspoon Shaoxing rice wine or dry sherry
1 tablespoon sugar
70g (1¼ cups) panko breadcrumbs
3 spring onions (scallions), halved lengthways and sliced into short ribbons
1 red chili, sliced (optional)
Small handful cilantro leaves (optional)

If using fresh sweetcorn, cut the kernels from the cob. If using frozen, defrost and pour over boiling water to speed up the process if needed.

Set a wok over a high heat. Add ½ tablespoon of the oil, then the sweetcorn and stir-fry for 2–4 minutes until sweet and tender. Tip into a bowl and set aside.

Return the wok to a medium–low heat with the remaining oil. Add the garlic, ginger, black beans and chili flakes and stir-fry until soft and fragrant. Season with the soy, Shaoxing wine and sugar and continue cooking until dry and the oil has separated.

Add the breadcrumbs and spring onions and stir-fry to get the crumbs fully crisped and golden. Toss in the sweetcorn and heat through for just a moment. Serve at once, scattered with fresh red chili and cilantro, if you like.

BURMESE GINGER SALAD

Gin throke ～～～～～～～～～～～～～～～～～～～～～～～ Myanmar

Serves 2–4

The Burmese are master salad makers, combining both bold flavors and textures in unique and memorable ways. Make this once and you'll find your mind keeps drifting back to it.

Fermented tea leaves form the basis of the country's most celebrated salad, laphet throke, the earthy astringency of the tea offset with crunchy, umami-rich aromatics in a dish that gives an almost narcotic buzz. This gin thoke is related, but with ginger as the star instead. Many crunchy, nutty elements come together as backing vocalists for the fierce pickled ginger. It can be scaled back to just the ginger pickle with fried garlic and sesame seeds to be served as a digestive after meals, but this fuller salad is a textural delight.

40g (1½oz) ginger, peeled
Juice of 2 large limes
100g (½ cup) dried chickpeas
100g (½ cup) dried yellow split peas
2 tablespoons gram flour
1 tablespoon sesame seeds
120ml (½ cup) neutral oil, for frying
6 garlic cloves, sliced
80g (½ cup) raw red-skinned peanuts
½ Chinese napa cabbage, finely shredded
1–2 green chilies, seeds in or out, sliced
1 green tomato, sliced (optional)

FOR THE DRESSING
Reserved lime juice
2 tablespoons sugar
1 tablespoon fish sauce or vegetarian fish sauce

The day before eating, slice the ginger into very fine matchsticks. Cover with lime juice, season with a pinch of salt and leave to pickle in the fridge. The acid may tinge the ginger a rosy pink.

Soak the dried chickpeas and split peas in separate bowls of water overnight.

The next day, squeeze out the ginger, reserving the juice for the dressing. Drain the chickpeas and split peas and dry them on a tea towel. They need to be very dry so they don't spit upon frying.

In a dry wok or frying pan, toast the gram flour for a couple of minutes, until nutty and fragrant. Set aside. Do the same with the sesame seeds until they are lightly golden. Rinse the pan.

Return to the heat, add the oil and heat until it just begins to shimmer. We are going to fry a series of ingredients until golden and crunchy. Remove each from the oil with a slotted spoon and drain on a paper towel while you fry the next. First the garlic (1–2 minutes), then the peanuts (1–3 minutes), chickpeas (5–8 minutes) and split peas (3–6 minutes). Watch out as the chickpeas will spit, so use a splatter guard if you have one.

Mix the ginger lime juice with the sugar and fish sauce to make the dressing. Add a pinch of salt and stir well to dissolve.

Assemble the salad just before serving. Fill a bowl with shredded cabbage and toss through the dressing. Add the toasted flour and all the remaining fresh and crunchy components and toss again.

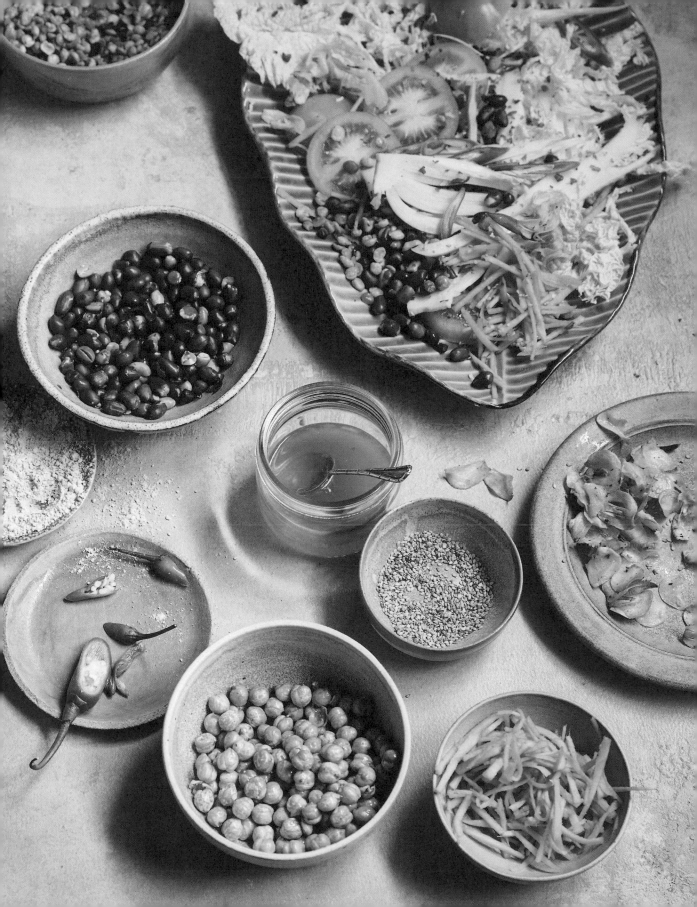

SALTED CHICKEN WITH GREEN GINGER & RED CHILI

Hainan ji fan 〜〜〜〜〜〜〜〜〜〜〜〜〜〜〜〜〜〜〜〜〜〜〜〜〜〜〜 Singapore

Serves 4

This dish is elegant in its simplicity and a showcase of good ingredients. It's something I often turn to when families with small children come for lunch —they invariably like the tender chicken and rice, while adults can add zing and fire to their plates with the sauces.

Appearing in different versions in Vietnam, Hong Kong, Malaysia and Thailand, it maps centuries of Chinese immigration from the island of Hainan. In Singapore, chicken rice is considered a national dish.

There are some interesting cooking methods here. One is the green ginger sauce, made by dousing finely chopped ginger and spring onions with hot oil. With a sizzle, it instantly softens and melds the flavors together to create something very special, much more than a sum of its parts. (Try it tossed through noodles with light soy sauce.)

Another is the chicken. Salting the day before eating makes for the tenderest bird you'll ever taste, and steaming it whole is a revelation. Poaching is more traditional and works well in Singapore hawker stalls, where each subsequent bird added to the pot intensifies the broth, but here it is steamed to perfection in just 35 minutes. The steaming liquid becomes a light broth, just the right amount to cook the rice in so no flavor is wasted.

1 medium chicken
Handful coarse salt
4 slices of ginger
Handful spring onion (scallion) tops
400g (2 cups) jasmine rice
Drizzle of toasted sesame oil

FOR THE GREEN GINGER SAUCE
100g (3½oz) spring onions (scallions),
 white and pale green parts
80g (3oz) ginger, peeled
6 tablespoons neutral oil

FOR THE RED CHILI SAUCE
4 red chilies, seeds in or out
2 garlic cloves
1½ tablespoons rice vinegar

The day before eating, prick the chicken all over. Remove any trussing string and salt exuberantly, inside and out, rubbing the coarse grains into the skin. Cover in a bowl and refrigerate overnight.

A couple of hours before eating, bring the chicken out of the fridge to take the chill off. Forty minutes later, rinse the chicken, inside and out, to remove the salt.

Fill a large steaming pan with 625ml (2½ cups) water. On the upper tier, scatter over the ginger slices and a handful of the green tops cut from the spring onions that you'll be using in the sauce. Sit the chicken breast-side down on top and cover with a lid. Bring to the boil, then steam for 35 minutes, or until the chicken is just cooked through. A meat thermometer should read 74°C (165°F) or the juices in the thigh run clear.

While the chicken is cooking, prepare the sauces. For the green ginger sauce, finely chop equal quantities of spring onion and ginger and mix together in a heatproof bowl. Heat the oil until just smoking, then pour over and mix. Season with salt.

For the red chili sauce, blend all the ingredients together to a rough paste and season with salt.

When the bird is cooked, set it aside to rest breast-side up under a tent of foil. The juices will have dripped through into the steaming water to create a lovely, gingery broth, which we'll use to cook the rice.

Wash the rice thoroughly, swirling the grains in four changes of cold water until most of the cloudiness has gone. This breaks down the surface starch, which could otherwise make the rice sticky. Drain well and put in a pan. Add 625 ml (2½ cups) of the broth, topping up with water if need be. Set over a high heat and bring to a rolling boil. Bubble for 15 seconds, then turn down the heat to the lowest setting and clamp on a lid. Leave to steam for 15 minutes without disturbing. Remove from the heat without peeking in and leave the rice to continue steaming under the lid for 10 minutes. Gently fluff the grains with a fork before serving.

Drizzle the chicken with sesame oil and serve with the rice and sauces.

EAT WITH

Cucumber salad is a good addition. Make a dressing by seasoning rice vinegar generously with sugar, salt and minced ginger. Toss through a couple of finely sliced cucumbers and leave to marinate in the fridge for at least 30 minutes or overnight

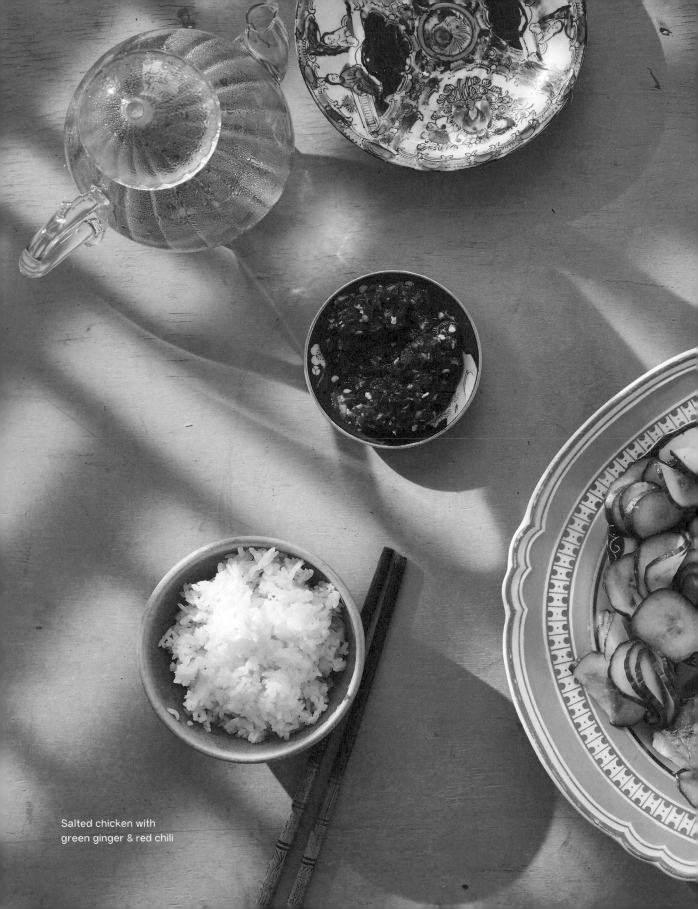

Salted chicken with
green ginger & red chili

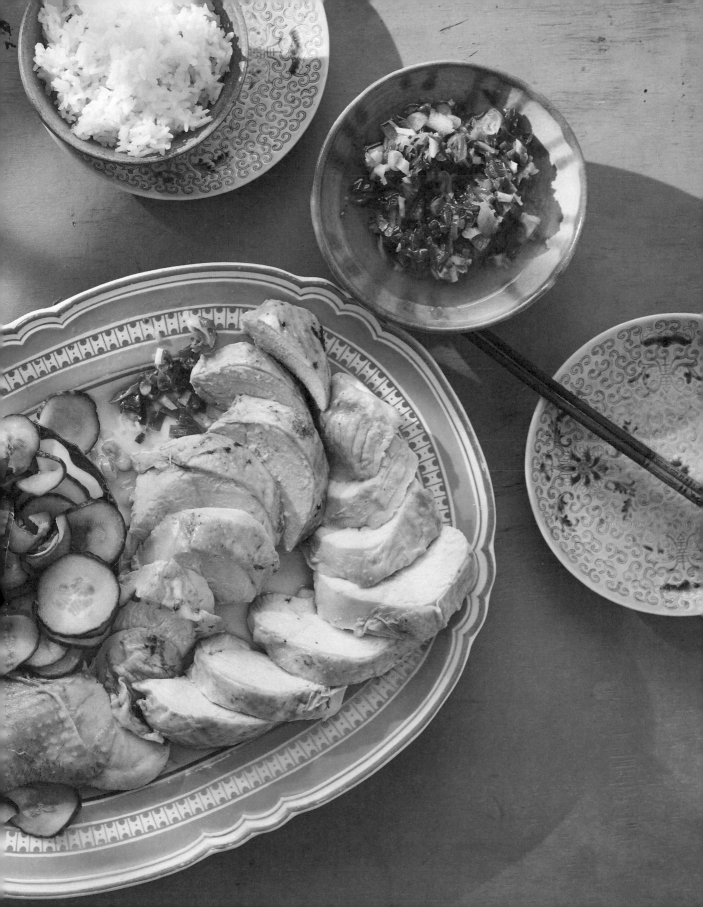

MINCED CHICKEN WITH MIRIN & PINK PICKLED GINGER

Kashiwa meshi ～～～～～～～～～～～～～～～～～～～～～～～～～～～～ Japan

Serves 4

Ginger starts and ends this dish. Its first introduction brings gentle warmth to the chicken, which is balanced out by a salty-sweet, winey glaze. The second application is louder, both in color and taste, in the form of a pickle called beni shoga. I recommend buying a jarful of these shocking pink ginger shreds soused in plum vinegar. While not essential to the dish, I would miss their sweet-and-sour hit of heat as it lends sharp contrast in color and flavor. They are also great for adding to stir-fries or noodles.

Serve the chicken on a mattress of sushi rice, either warm from the pan or made up as a bento box for a lucky pack-luncher.

500g (1lb 2oz) boneless chicken thighs
3cm (1¼ inches) ginger, coarsely chopped
 (1 tablespoon)
2 eggs
1 tablespoon neutral oil
2 garlic cloves, finely chopped
4 tablespoons Japanese soy sauce
2 tablespoons mirin
2 tablespoons sake
2 teaspoons sugar
Pinch of dashi powder (optional)
2 sheets of nori, sliced to ribbons with scissors
Pink pickled ginger (beni shoga), to serve

Remove the skin from the chicken thighs, leaving on any fat. Sit in a pan with the ginger and enough water to cover. Bring to the boil, skim off the scum, then cover and lower to a simmer for 10 minutes. Turn off the heat and leave to stand for 15–20 minutes, until the chicken is cooked with no trace of pink.

Meanwhile, prepare the omelet ribbons. Beat the eggs with a pinch of salt and a couple of teaspoons of water to thin. Lightly grease a non-stick pan. Pour in a little of the egg and swirl the pan to spread—it should be thin enough to cook without flipping. When set, remove to a chopping board and repeat with the remaining egg. Stack and slice into thin strips.

Drain the chicken (save the broth for another use, such as for cooking the rice). Transfer the meat and ginger to a food processor and blitz to a soft rubble. Heat the oil in a frying pan, add the garlic and let it sizzle. Scrape in the minced chicken and stir. Season with the soy sauce, mirin, sake, sugar and dashi powder. Let the liquid reduce and coat the meat.

Traditionally this is served on a bed of rice with three stripes on top: the glazed chicken, the tangled ribbons of egg, and the green nest of shredded seaweed. Finish with a mound of pickled ginger. Serve warm or at room temperature.

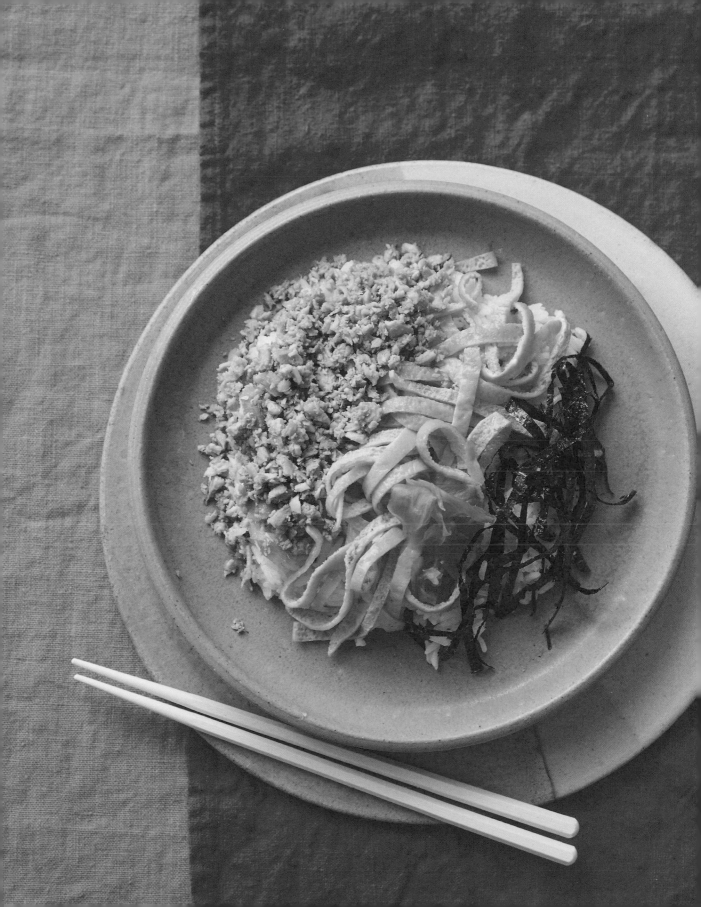

APHRODISIAC GREENS

~~~~~~~~~~~~~~~~~~~~~~~~~~~~~~~~~~~~~~~~~~~~~~~~~~~~~~~~~~~~~~~~~~~~~~~~~~~~~~~~~~~~~~~~~~~~~~~~~~~~~~~~~~~~~~~~~~~~~~~~~~~~~~~~~~~~~~~

**Serves 2 as a side**

Ginger features in the ancient Sanskrit text Kama Sutra, its pungent warmth said to fire desire, fertility and circulation. But why rely on just one stimulant when we can add earthy cumin, a favorite aphrodisiac for early Arabs, and a prick of bittersweet fenugreek, which is recognized by modern science as a libido–booster? Bring in a fortifying dose of iron-rich spinach too and you have a potent mixture, and indeed a lovely vegetable side dish (pictured on page 230) that works alongside any meal.

20g (¼ cup) shelled pistachios
1 tablespoon olive oil
½ teaspoon cumin seeds
Small pinch of fenugreek seeds
1 large onion, finely sliced
3cm (1¼ inches) ginger, peeled and minced
   (1 tablespoon)
200g (4 cups) baby spinach leaves, washed
Squeeze of lemon juice

Toast the pistachios in a dry pan for a few minutes until fragrant. Roughly chop.

Heat a large pan or wok, add the olive oil and wait until it shimmers. Add the cumin and fenugreek and sizzle to toast (which will remove some of the fenugreek's bitterness) before adding the onion and a pinch of salt. Turn the heat to medium–low and cook, stirring often, until the onion is softened, as well as browned to a golden tangle. Add the ginger and cook for a minute longer.

Add a few handfuls of the spinach leaves, mixing them through the spiced onion. As the leaves start to wilt in the heat, add more. Continue adding and tossing the leaves until they have all slumped. Season with salt and pepper.

Remove from the heat, stir through the lemon juice and scatter with the toasted pistachios.

## EAT WITH
An admirer

# SIZZLING GINGER RAITA

Adarak raita ～～～～～～～～～～～～～～～～～～～～ India

**Serves 4 as a side**

A yogurt raita completes a South Asian meal, giving a creamy and sour contrast to simple dals or lavish biryanis. Using the spice-enhancing technique of tarka, tempering in hot oil to intensify the flavors, this raita (pictured on page 199) is memorable in its own right. Cool yogurt envelops shreds of caramelized ginger, cumin seeds and musky curry leaves.

400g (1½ cups) yogurt
½ teaspoon ground cumin
Scant ½ teaspoon fine sea salt
Pinch of sugar
30g (1oz) ginger, peeled
1 tablespoon neutral oil
10 curry leaves
½ teaspoon cumin seeds

Mix the yogurt with the ground cumin, sea salt and sugar.

Finely grate a quarter of the ginger and stir into the yogurt. Cut the rest into thin slices and slice these again to make fine and even matchsticks (julienne).

Heat the oil in a small frying pan over a high heat. Add the ginger, curry leaves and cumin seeds and sizzle in the heat. Stir constantly for a few minutes. When the ginger has turned a deep caramelized golden, pour the contents of the pan over the seasoned yogurt.

Stir and set aside to let the flavors mingle, or leave the ginger shreds prettily on top to serve.

## EAT WITH
Pairs well with any of the following recipes:
Keralan black pepper chicken (page 81)
Kebabs for Babur (page 92)
Coal-smoked biryani (page 118)
Slow-roast lamb with advieh & fragrant rice
  (page 120)
Cauliflower & pomegranate pilaf (page 196)
Every week tomato lentils (page 198)
Tandoori roast chicken (page 231)

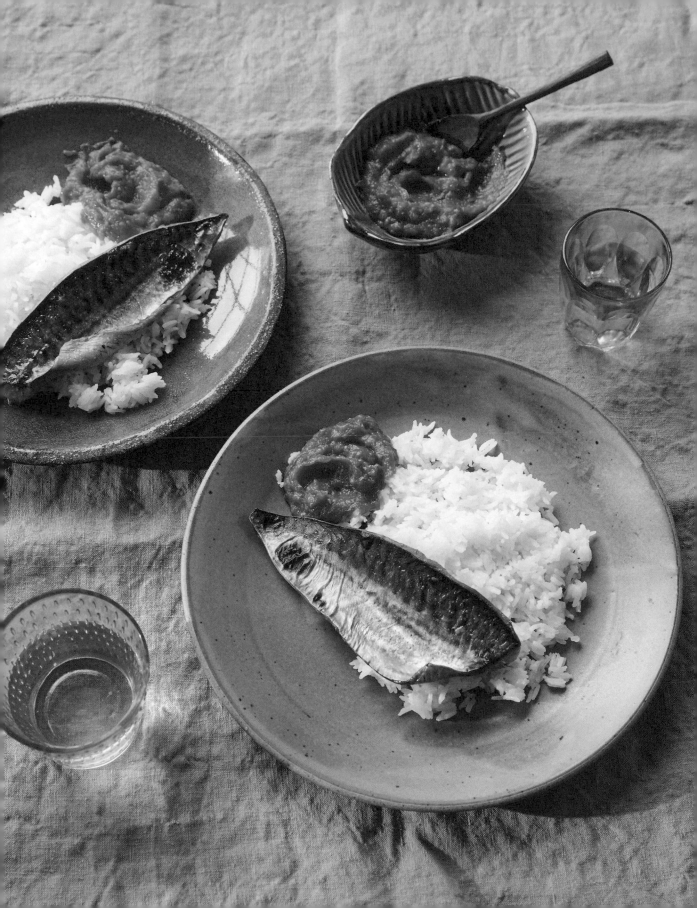

# GRILLED MACKEREL WITH GINGER CHILI SAMBAL

Ikan sambal jahe ～～～～～～～～～～～～～～～～～～～～～～～ Indonesia

### Serves 2

There are two cornerstones of Indonesian eating. Fluffy steamed rice is the canvas onto which the flavors are laid. The final spicy flourish is chili sambal (a sauce or salsa with endless varieties) and no meal would be complete without one.

This sambal has a double hit of heat from chilies and fresh ginger, tamed yet somehow intensified by twice-cooking. Ginger sambals are documented in early Indonesian culinary texts, long before chilies were introduced to Asia.

2 mackerel fillets
2 teaspoons soy sauce
1 teaspoon neutral oil, for brushing

FOR THE SAMBAL
4 tablespoons neutral oil
4 small shallots, roughly chopped
4 garlic cloves, peeled but whole
5cm (2 inches) ginger, peeled and sliced
2 large tomatoes, roughly chopped
2 large red chilies, seeds in or out,
  roughly chopped
1 bird's eye chili, seeds in
½ teaspoon shrimp paste (optional)
1 tablespoon palm sugar or brown sugar
1 teaspoon chinkiang black vinegar or
  rice vinegar

If you prepare the sambal in advance, even an hour or so, it will become more mellow and well-rounded. It should be served at a warm room temperature.

Heat the oil in a frying pan—be generous as it helps build depth of flavor. Soften the shallots and garlic in the oil for a few minutes, then add the ginger, tomato, chilies with their seeds and shrimp paste. Fry over a medium heat until everything is collapsed and softened.

Transfer to a blender and whiz to a purée. Return to the pan with the palm sugar and a pinch of salt. Fry, stirring often, until the sambal darkens a shade and the oil starts to separate slightly if you leave it undisturbed for a while. Balance the flavors with a teaspoon of vinegar and leave to cool.

Brush the mackerel fillets all over with soy sauce. Heat the grill to high and brush the rack with a little oil. Grill the fish, skin-side up, for 3—4 minutes until the skin is charred, turn and grill for 1—2 minutes more, until the mackerel is just cooked through.

Serve the mackerel with steamed rice and sambal to add to taste.

## EAT WITH
Jasmine rice, green beans, prawn crackers

# EGG & BACON ROUGAILLE

Rougaille dizef ～～～～～～～～～～～～～～～～～～～～～～～～ Mauritius

Serves 2

Mauritius is a nation with the spice routes woven into its fabric. The island was uninhabited before the arrival of European settlers during the spice race, when the Dutch, French, then British each took advantage of its strategic Indian Ocean position. A turning point in history came when an eighteenth-century French spice trader, impeccably named Pierre Poivre, smuggled nutmeg plants from Indonesian Maluku and planted them in Mauritius and Réunion, so breaking the Dutch trading monopoly and making spices more accessible to the world than ever before. (Poivre is possibly also the one immortalized in the tongue twister "Peter Piper picked a peck of pickled pepper.")

The well-worn phrase "melting pot" does capture Mauritian culture. A fractured past founded on trade has left a population of Indians, Africans, Chinese and Europeans, and given rise to one of the world's great Creole cuisines.

A cornerstone of the home cooking is a gingery tomato sauce called rougaille. It can enliven seafood, salted fish, sausages or, as here, be used as a base for softly poached eggs. There is an unusual clash of Western and Eastern accents —thyme meets cilantro—that is typical of playful Mauritian cooking. The result is electric.

100g (¾ cup) bacon lardons
1 onion, finely chopped
3cm (1¼ inches) ginger, peeled and minced (1 tablespoon)
4 garlic cloves, minced
1 bird's eye chili, seeds in, finely chopped
1 teaspoon cumin seeds
Small bunch thyme, leaves stripped
400g (14oz) ripe tomatoes, chopped, or good tinned tomatoes
2–4 eggs
Handful cilantro leaves
Flatbreads and hot sauce, to serve (optional)

Put the lardons in a frying pan and set over a medium heat. Cook until the fat renders, then the bacon crisps. Add the onion and fry until well softened. Add the ginger, garlic, chili, cumin and thyme leaves and cook for a few minutes longer.

Add the tomatoes and cook at a slow boil for about 20 minutes, squishing the tomatoes with the back of a spoon occasionally to break them down. The red should deepen a shade. Taste and balance the flavors with salt and a little sugar, if needed.

Make dents in the sauce with the spoon and crack an egg into each one. Sprinkle each egg with a little salt and cover the pan with a lid (or a plate). Leave the eggs to steam for 4–5 minutes, until the whites are set and the yolks are still runny.

Scatter with cilantro and serve with flatbreads and hot sauce, if you like.

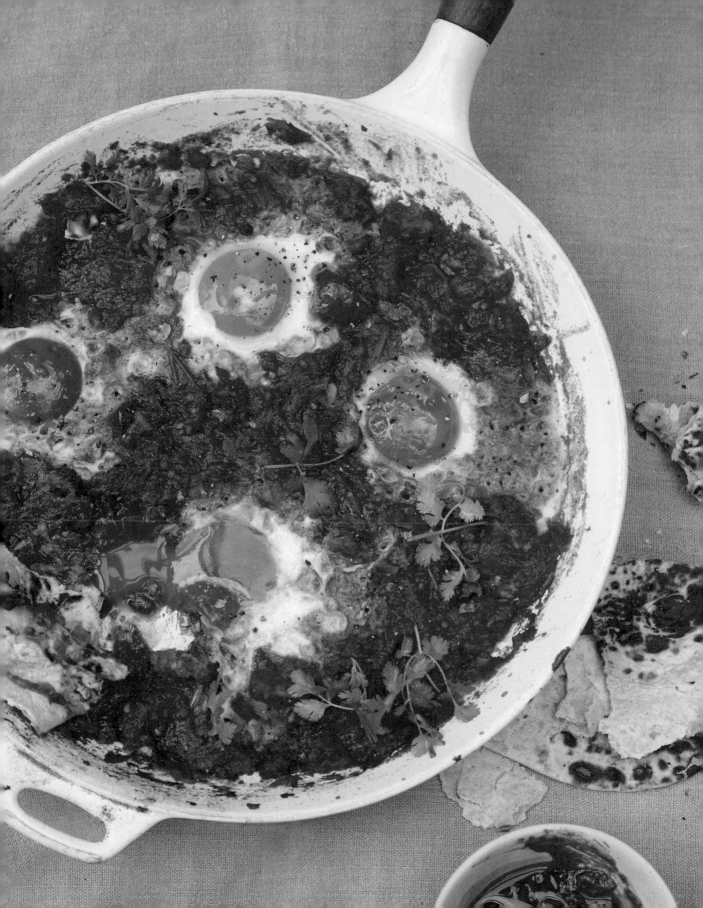

# SILKEN TOFU WITH GINGERED SOY SAUCE

Liang ban dou fu ～～～～～～～～～～～～～～～～～～～～～～～ China

### Serves 2

Raw ginger brings its full rasping heat, mingled here with sourness, umami and deep complexity. This is the sort of handy store-cupboard meal that can be made in minutes. For tofu-sceptics, concerned perhaps about it being bland or rubbery, it also may be the dish to win them over, while enthusiasts will already know about the pleasing wobble-bellied, tremulous texture that makes silken tofu so irresistible.

One of the flavors here is chinkiang vinegar, a Chinese black vinegar made from glutinous rice. It is darker, sweeter and more interesting than other rice vinegars, and is an ingredient I really recommend sourcing—I use it a lot. If substituting another, such as rice or cider vinegar, scale back a little as they are more acidic.

300g (10½oz) soft silken tofu
3cm (1¼ inches) ginger, peeled (1 tablespoon)
2 tablespoons light soy sauce
1½ tablespoons chinkiang black vinegar
1 teaspoon toasted sesame oil
2 spring onions (scallions), sliced

Drain the silken tofu and cut widthways into slices about ½cm thick. Move to a serving plate and push gently to open out like a roman blind.

Julienne the ginger by slicing thinly, then slice again into thin matchsticks.

In a small bowl, mix together the ginger, soy sauce, vinegar and sesame oil. Spoon over the tofu and scatter with spring onions.

## EAT WITH

There is plenty of sauce so serve with white or multigrain rice and stir-fried greens. Or I like to eat the tofu in salad bowls, topped with sliced avocado and a mound of pea shoots.

Stir-fried ginger greens: Separate the leaves from the stems of a bunch of choy sum. Heat a wok over high heat. Swirl in oil to coat, add minced ginger and garlic and cook until just fragrant. Add the stems and stir-fry for a couple of minutes until they are bright green and tender. Toss through the leaves to wilt in the heat. Stir through a spoonful of water along with a pinch of salt and sugar.

# KARAK CHAI

Karak chai ～～～～～～～～～～～～～～～～～～～～～～～～～～ Emirates

## Serves 4

Karak chai is an Emirati take on milky-sweet masala chai, but with fewer spices, allowing the individual flavors to come through more clearly. Cardamom sings the loudest with a backing track from fresh ginger and rose petals. The habit was brought to the Emirates by Indian and Pakistani laborers in the 1950s and absorbed ardently into local food culture.

Although tea has been drunk in China since the fourth century, it didn't reach the Indian subcontinent until relatively recently, except in the northern and eastern fringes. It spread through Tibet to the Himalayan regions where it was, and still is, mixed with yak's butter as a drink to fuel against snowy climes. In Assam, Myanmar and Thailand, fermented tea leaves have long been chewed as a snack. But it was British colonialists who introduced tea brewing to India in a long and exhaustive marketing campaign by the British-owned Indian Tea Association. They traveled from village to village and sponsored chai vendors on the new railway network who, to the disdain of tea inspectors, transformed it with their own cheerful addition of milk, sugar and spices.

In a crisscrossing of ideas, spiced Indian tea was taken to the Middle East, just as coffee had been introduced to India by Arab and Persian traders.

10 green cardamom pods, bruised
3cm (1¼ inches) ginger, peeled and minced (1 tablespoon)
2 dried rosebuds (optional)
1 tablespoon loose black tea
2 tablespoons sugar
250ml (1 cup) milk

Put the cardamom, ginger and rosebuds in a medium pan with 500ml (2 cups) water. Bring to the boil and simmer for 5 minutes. Add the tea and sugar and simmer for a further 2 minutes.

Pour in the milk and turn up the heat to bring to a roaring boil. It will rise like a cloud and as it threatens to bubble over, remove from the heat briefly to calm down, then boil again. Repeat, boiling three times in total. The tea should be a beautiful pale caramel. Strain into tea glasses, pouring from a height to aerate. Serve hot.

# BLACK
# GOLD

# A FAMILY OF

# PEPPERCORNS

Black pepper has always been the world's most sought-after spice. Today, that means ubiquity, its everyday ordinariness leaving it taken for granted. Go back in time though and peppercorns were so hotly coveted and valuable they were known as black gold.

## The berries of the twirling pepper vine, all glossy green leaves and waxy white flowers, provide us with a four-in-one spice.

They start as plump, jade balls growing in dense clusters. Picked before ripening, you get green peppercorns, the essential oils not yet fully developed, giving a spice that is grassy and only mildly hot. Left on the vine in the dappled shade of the undergrowth, they will swell and transform flame-like through yellow and orange to a deep glowing pink. Black peppercorns are harvested while still green but when the first few berries on the spike start to flush, showing they are close to maturity. Fermented in heaps for a few days, they are then laid in the sun to dry to the familiar wrinkled black. White peppercorns are left to mature fully on the vine, then treated with water to rub off the rough surface, forgoing fragrance for the cleaner white heat of the berries' centers. Red peppercorns, rare even in the countries where they grow, are the fully matured berries, which combine the pungency of pepper with a delicate, toffeed fruitiness.

The Piperaceae family is a sprawling one with more than two thousand species growing in steamy tropics around the world, used both for their berries and their aromatic leaves. Two notable varieties are long and cubeb peppers. Native to both India and Indonesia, long pepper grows in stiff, granite-gray catkins and was especially prized in the early days of the spice trade, when it was worth four times the price of black pepper. Its sweet, violet-scented pungency is lovely and it is a shame it has all but been forgotten in kitchens outside the countries where it grows. Cubebs are also known as tailed peppers thanks to their thin, brittle stalks sticking out like perky tails. Camphorous and assertive, they are used both in their native Indonesia and in North African cooking, revealing the link to early Arab spice traders.

Then there are the pretenders—spices that are not true peppers at all but swept into the clan by name or reputation. Sichuan pepper is the best known of the prickly ash berries found in China, Tibet, Japan, Sumatra and India. The flavor isn't in the shiny black seeds, which should be discarded, but in the rough, pinky-brown husks that hold not only a fragrant woodiness but the mouth-numbing heat so important in Chinese cuisine.

## In Han Dynasty China, "pepper houses" were built for the emperors' concubines, with Sichuan pepper ground into the plaster to scent the chambers with warm, sultry spice.

Pink peppercorns are no such thing, rather brittle-skinned berries with a sweet, piney flavor best suited to sweet dishes (and not to be confused with red peppercorns). Allspice, known sometimes as Jamaican pepper, is also not part of the pepper family and has little peppery bite, closer to a mix of clove, nutmeg and cinnamon. Confusion with the name dates to Christopher Columbus sailing west in search of lucrative peppercorns. Instead, locals pointed him to chilies and allspice, both of which he named optimistically for the pepper he was seeking. Another spice introduced to the trade as a cheaper pepper alternative, with a heavenly epithet as a clever marketing ploy, was grains of paradise. This dried African fruit is actually from the ginger family and has a herbaceous pungency. It was abandoned by Renaissance Europe when the price of black pepper dropped, allowing it to become the spice of every table.

Piper nigrum is native to the tangled jungles of the South Indian ghats, where it thrives in the seasonal rhythms of the monsoon. From antiquity, pepper was traded as a commodity and considered as precious as bullion. The ancient Greeks traveled to India for pepper in such quantities that one Sanskrit name for the spice was yavanesta, "passion of the Greeks." The pharaohs were embalmed with it, almost every recorded Roman recipe was freckled with black pepper, and the Caesars held peppercorns in their treasuries. As early as 100 BC, Indians sailed to Indonesia in search of Suvarnadvipa, a mystical peninsula of gold and silver, and with them went peppercorns, which grew happily in the new tropical lands. In turn, Indonesian traders took pepper to China, where it became the spice of choice for the wealthy. In the Middle Ages, over 90 percent of the spices plying the waters to Europe was pepper and, if Marco Polo is to be believed, for every vessel laden with pepper that sailed west, ten sailed to China.

## Before chili arrived in Asia, pepper was the prime source of piquancy in cooking and would be thrown by the handful into dishes from the Middle East to Malaysia.

The discerning can seek peppercorn varieties named for their place of origin. Indonesian and Malaysian pepper tend to be high in piperine, making them hotter and cleaner. Sarawak pepper from Borneo is particularly prized for its round, assertive taste. Indian peppers shine for their quantity of fragrant essential oils, from the complex Malabar pepper to the fine Tellicherry, which has large, dark berries with a floral aroma.

Heat from the piperine is non-volatile so is not dampened by cooking. The fragrance, however, is more fleeting, so pepper is best added twice. The Indian technique of tempering it in fat to add at the end of cooking, or the Western habit of grinding at the table, will ensure a heady hit of the peppery perfume that has been treasured through the ages.

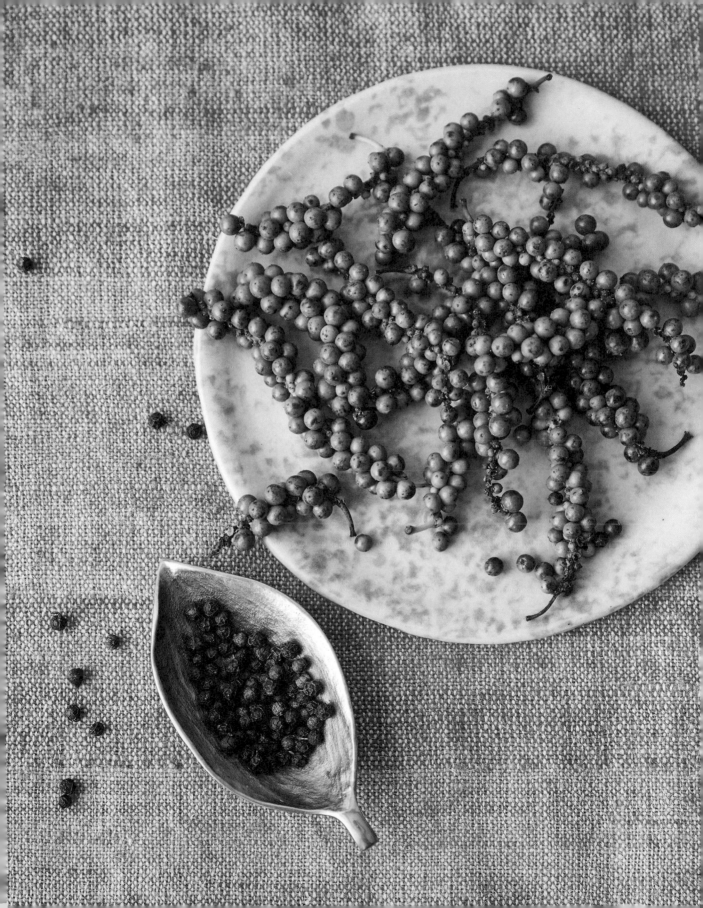

# HOT-&-SOUR TOMATO RASAM

Milagu rasam ～～～～～～～～～～～～～～～～～～～～～～～～～～～～～～～～ India

**Serves 2–4 as a side**

Literally "peppered water," this complex broth is both edgy and soothing, just the thing to scare away a summer cold. The dish was corrupted by the British Raj into the soup mulligatawny, with an added assortment of meat and vegetables, but to my mind this original is better.

The heat comes from peppercorns. Kashmiri chili also lends a kick, but is more there for the gorgeous shade of red it brings.

1½ teaspoons black peppercorns
1 teaspoon cumin seeds
6 garlic cloves
1 tablespoon neutral oil
½ teaspoon black mustard seeds
8 fresh curry leaves
4 ripe medium tomatoes, chopped
½ teaspoon Kashmiri chili powder
¼ teaspoon ground turmeric
Pinch of asafoetida (optional)
½ teaspoon fine sea salt
2 teaspoons tamarind paste
2 tablespoons chopped cilantro

Using a pestle and mortar, crush together the peppercorns, cumin seeds and garlic to make a textured spice paste.

Heat the oil in a saucepan over a medium–high heat. Scatter in the mustard seeds and wait until they start to splutter and pop. Add the spice paste and curry leaves and fry for a minute to cook the garlic, toast the spices and crisp the curry leaves. Add the tomatoes, chili powder, turmeric and asafoetida and cook until the tomatoes break down into a sauce, mashing and squishing as you go.

Pour over 400ml (1½ cups) of water along with the salt and tamarind. Bring to the boil and simmer for 5 minutes. Taste for seasoning, adjusting as needed to make the broth sour, sweet and hot. You can make up to this stage in advance.

Stir through the cilantro and thin with water if you want it more brothy. Cook for a final minute to heat through and serve.

## EAT WITH

Either drink as a soup or serve as a brothy accompaniment to basmati rice with another Indian vegetable dish

# GREEN PEPPERCORN ASPARAGUS

Prik Thai orn kab nor mai farang ～～～～～～～～～～～～～～～～～～～～～～～ Thailand

**Serves 2 as a side**

Picked before ripening, green peppercorns have a verdant grassiness. The spicy piperine in the berries hasn't fully developed, meaning you can use them in a greater quantity than when dried to black. The heat is still sharp, pronounced and interesting, though, here matched with a salty-sweet dressing glazing stir-fried asparagus.

The Thai name for the fresh peppercorns, prik Thai, means literally "Thai chili," revealing its position for millennia before the American immigrant spice arrived, seducing everyone with its brash confidence.

250g (9oz) asparagus spears
1 sprig fresh green peppercorns (2 teaspoons)
2 small garlic cloves, finely chopped
1 bird's eye chili, seeds removed, sliced
1 tablespoon fish sauce or vegetarian fish sauce
2 teaspoons sugar
1 tablespoon neutral oil

Snap the tough bases off the asparagus and cut the stems into short lengths at a steep angle.

Pull the peppercorns from the sprig and crack them using a pestle and mortar, or roughly chop.

Make a dressing by combining the peppercorns, garlic, chili, fish sauce and sugar.

Heat a wok to high, then add the oil. Stir-fry the asparagus until its green color intensifies, then splash in a tiny bit of water to create steam. Stir-fry for a few minutes more, until the stems are just tender to a knife. Add the dressing, bubble for 20–30 seconds, then tumble onto a serving plate.

# BALINESE GREEN BEAN URAP

Sayur urap 〰〰〰〰〰〰〰〰〰〰〰〰〰〰〰〰 Indonesia

Serves 4 (or more as a side)

Indonesian cuisine has arguably been made less distinctive by thousands of years at the heart of a trade hub. Even national dishes show external influences, from Chinese-inspired nasi goreng to the Indian sway on Sumatra's celebrated curries. Urap, however, is a dish uniquely of its home. At its simplest, cooked greens are tossed with fried shallots, garlic and coconut, with a zingy spritz of lime juice to brighten the flavors. Here is a more complexly spiced version based on one I was taught by a wonderful cook and mentor, Dayu Putu, in Bali. The archipelago is home to many varieties of pepper, from the tailed cubeb to smoky Lampong peppercorns. They were a key feature of early Indonesian cookery but were largely knocked out of use by chili. This dish is a throwback, which features both floral long pepper in the spice paste and grassy green peppercorns punctuating the salad. It is a true vegetal celebration and is particularly good served alongside chicken sate.

400g (14oz) green beans
200g (4 cups) baby spinach leaves
4 tablespoons neutral oil
6 small shallots, sliced
4 garlic cloves, sliced
100g (1 cup) grated coconut or rehydrated
  desiccated coconut
1 sprig fresh green peppercorns (2 teaspoons)
1 lime leaf, deveined and finely sliced
Juice and zest of 1/2 a lime

*FOR THE SPICE PASTE*
6 garlic cloves, peeled
6 shallots, peeled

2cm (3/4 inch) ginger, peeled
2cm (3/4 inch) galangal, skin scrubbed
  (2 teaspoons grated)
2cm (3/4 inch) fresh turmeric, peeled,
  or 1/2 teaspoon ground turmeric
2 bird's eye chilies
1 teaspoon coriander seeds
1 long pepper or 1/2 teaspoon black
  peppercorns, crushed
Grating of nutmeg

In salted water, boil the beans for 2–3 minutes until tender-crisp. Put the spinach leaves in the colander and pour the beans and their boiling water over to drain, wilting the leaves in the process. Toss with a spoon and squeeze out as much liquid as possible.

Heat a wok or small frying pan, add 2 tablespoons of the oil and fry the sliced shallots and garlic until pale golden. Drain on a paper towel.

Make the spice paste. Roughly chop all the ingredients and grind to a paste in a food processor, adding a good splash of water. Heat the remaining 2 tablespoons of oil in the wok or pan and fry the paste, stirring often, for 5–10 minutes until sweetly fragrant, the water has cooked away and the oil is beginning to separate.

In a large bowl, mix the grated coconut with the spice paste to make a sunny-colored rubble. Season with salt. Add the other elements: the green beans, spinach, fried garlic and shallot, green peppercorns and lime leaf. Add the lime zest and juice and use your hands to toss and rub everything together. Serve at room temperature.

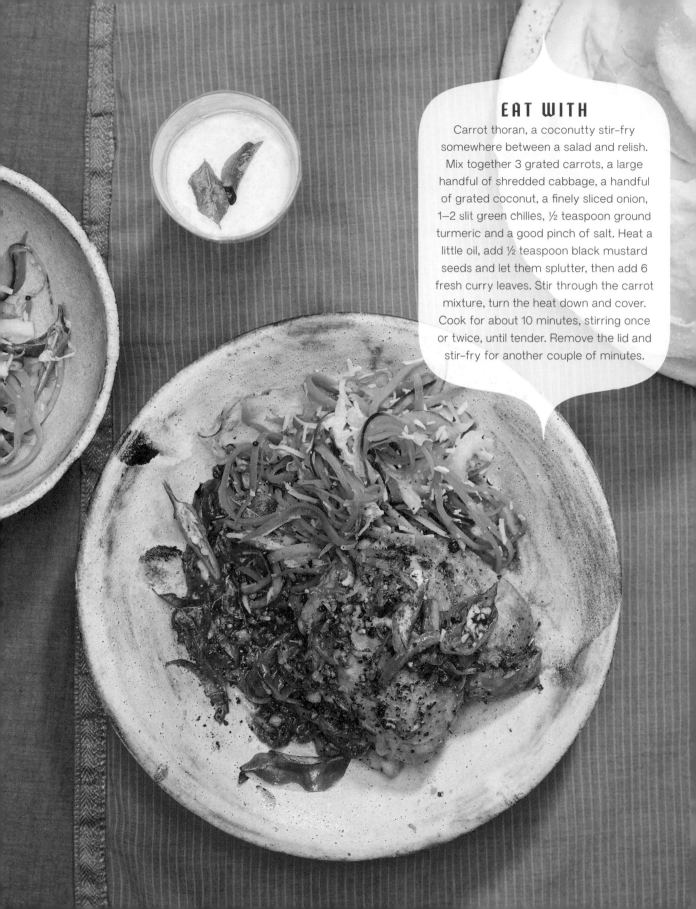

## EAT WITH

Carrot thoran, a coconutty stir-fry somewhere between a salad and relish. Mix together 3 grated carrots, a large handful of shredded cabbage, a handful of grated coconut, a finely sliced onion, 1–2 slit green chillies, ½ teaspoon ground turmeric and a good pinch of salt. Heat a little oil, add ½ teaspoon black mustard seeds and let them splutter, then add 6 fresh curry leaves. Stir through the carrot mixture, turn the heat down and cover. Cook for about 10 minutes, stirring once or twice, until tender. Remove the lid and stir-fry for another couple of minutes.

# KERALAN BLACK PEPPER CHICKEN

Kozhi kurumulagu ～～～～～～～～～～～～～～～～～～～～～～～～～ India

Serves 4

Too often a bit part player, peppercorns here shine as the star performer. Used in quantity, they bring a bold piquancy that hints at an early Asian heat before chilies were brought to the continent. This is balanced by their fragrance as well as by a tangle of sweet, caramelized onions. Use Tellicherry peppercorns if you can as they are especially grassy and bright.

Pepper is native to the steamy, knotted jungles of the Indian Ghats, thriving in the cycles of heavy monsoon rain and sultry heat. Walk through rural areas during harvest and you will have to weave around patches of peppercorns left out to dry in the hot sun.

8 skinless, bone-in chicken thighs
Juice of ½ a lemon
½ teaspoon ground turmeric
1 teaspoon fine sea salt
1 teaspoon fennel seeds
2 tablespoons black peppercorns
2 tablespoons coconut or neutral oil
3 large onions, finely sliced lengthways
5 garlic cloves, minced
6cm (2½ inches) ginger, peeled and minced
   (2 tablespoons)
1–2 green chilies, slit lengthways (optional)
1 teaspoon garam masala
1 tablespoon coconut vinegar or other vinegar
Buttered basmati rice, wilted greens and a
   tangy-sweet Indian chutney, to serve (optional)

Turn the chicken thighs in the lemon juice, turmeric, salt and a few grinds of black pepper (we are layering the pepper flavor; the full hit comes later). Set aside to marinate while you proceed.

Tip the fennel seeds and peppercorns into a dry pan and heat until they are toasty and aromatic. Use a pestle and mortar to crush them coarsely.

Heat a large frying pan over a medium heat, add the oil and fry the onion slices with a pinch of salt until they soften, then turn golden. Add the garlic, ginger and green chilies and stir-fry for another couple of minutes. Stir in the garam masala.

Add the chicken to the pan along with any marinade and the vinegar. Cover, turn down the heat and leave to simmer for 15 minutes. The chicken will release liquid as it cooks.

Remove the lid and turn up the heat. Add the crushed peppercorns and fennel seeds. Stir-fry until the chicken is cooked through and the sauce is dry and caramelized. Taste for seasoning. Set aside to rest for 10 minutes before serving.

Serve with buttered basmati rice, wilted greens and a tangy-sweet Indian chutney, if you like.

# HOT & TINGLY HAND-PULLED NOODLES

Biang biang mien ～～～～～～～～～～～～～～～～～～～～～～～～ China

Serves 2

While we are largely focusing on the maritime spice routes, here I am taking us on a detour to Xi'an. Breathe in the fragrant steam of dumplings cooking in teetering bamboo towers and watch the Muslim traders selling kebabs, nuts and sugared fruits, bright as jewels. We are in the very middle of China and at the terminus of the overland trade routes known as the Silk Road. Here Chinese and Islamic cooking collides.

Noodle-flingers are a staple of the street food theater, demonstrating immense skill in throwing out dough into long silken strands. These thicker, belt-like noodles, known onomatopoeically as "biang biang," are pleasingly easy to make. Yes, really! You could always substitute another chewy noodle like udon or wide bands of pasta, but nothing beats the satisfaction of hand-flung.

The spicing is a unique blend from the Uyghur peoples and shows the fusion of China and Central Asia distinctly. The recipe makes more than you'll need for these noodles but it is hard to scale down and good to have some on hand for your next batch. You can also use it as a rub for grilled meat or vegetables. The creative chefs at Honey & Co restaurant in London used my blend on roast lamb one summer, catching diners off guard as it lends a bewitching flavor, hard to put your finger on.

## FOR THE UYGHUR SEVEN SPICE
2 tablespoons cumin seeds
1½ tablespoons black peppercorns
1½ teaspoons Sichuan peppercorns
1½ teaspoons ground cinnamon
3 green cardamom pods, seeds only
2 cloves
2 star anise

## FOR THE NOODLES
200g (1⅓ cups) Chinese dumpling flour
    or extra-strong bread flour
½ teaspoon fine sea salt
Oil

## FOR SEASONING
3 tablespoons neutral oil
4 garlic cloves, finely chopped
1 teaspoon Sichuan chili flakes
2 teaspoons Uyghur seven spice (see recipe)
2 tablespoons light soy sauce
1 tablespoon chinkiang black vinegar
4 spring onions (scallions), sliced
Handful cilantro leaves

For the Uyghur seven spice, dry roast the spices separately in a dry pan until fragrant (the cinnamon doesn't need roasting). Grind together in a spice grinder or with a pestle and mortar. Store in a jar.

To make the noodle dough, put the flour, salt and 115ml (3¾fl oz) water in a stand mixer with the dough hook attached. Start mixing slowly then, as it comes together, increase the speed. Knead for 6 minutes. It should be smooth and very elastic—you should be able to pull it upward to about 30cm (12 inches) long without breaking. If it breaks, continue kneading for another 2–3 minutes. If it still breaks, add another tablespoon of water and knead again until you have the right consistency. Brush the dough with a little oil, then cover the bowl with plastic wrap and leave to rest for 2 hours to let the gluten bonds relax.

For the seasoning, heat the oil in a large frying pan over a medium heat. Add the garlic and sizzle until softened and fragrant but not browned, then turn off the heat and add the chilli flakes and 2 teaspoons of the seven spice. Set aside.

Oil your work surface and have a small bowl of oil at the side. With oiled hands, transfer the dough to the surface and roll it out to a rectangle about 1cm (½ inch) thick. Cut into 10 strips. Separate them, running an oily hand down each one. Working with one strip at a time, lay it on the work surface and use your palm to smash it out into a long, flat noodle. Pick it up at the ends and give one big pull then lift up and down, slapping against the work surface if you like, to stretch it out. It should be a thick and bouncy ribbon. For a narrower noodle with frilly edges perfect for picking up sauce, you can tear each in half lengthways starting in the middle to make a loop. Repeat with the remaining dough and cook straight away.

Bring a large pan of water to the boil and season with salt. Drop the noodles into the water one by one, a few in the pan at a time, and cook until they float to the surface—it should take less than 30 seconds. Transfer with tongs to the oily pan and toss well. Add the soy sauce, black vinegar and spring onions and toss again.

Serve scattered with cilantro.

Hot & tingly
hand-pulled noodles

# STICKY-SWEET PEPPERED PORK

Bak kwa ～～～～～～～～～～～～～～～～～～～～～～～～～～～～ Singapore

**Makes a boxful to snack on**

Bak kwa is a semi-cured, dried meat snack, somewhere in the realm between jerky and glazed bacon and more addictive than both. It originated in ancient China and was taken by the seafaring Hokkien to Singapore, where it was fully embraced as a local delicacy, most usually associated with celebrations at Chinese New Year.

Here is a peppery, home oven version. Using this as a blueprint, you can play with the spices and seasonings. A few tips: be sure to keep a salty-sweet balance of flavors, use pork mince with a high fat content so the bak kwa stays succulent and, for the same reason, don't roll too thinly. There should be flex and chew to complement the sticky-charred surface.

500g (1lb 2oz) minced pork with 15% fat
70g (⅓ cup) sugar
1 tablespoon dark soy sauce
1 tablespoon Shaoxing rice wine or dry sherry
1 teaspoon fish sauce
1 teaspoon ground black pepper
½ teaspoon Chinese five spice
½ teaspoon fine sea salt
½ teaspoon sesame oil
1 tablespoon runny honey

Put all the ingredients except the honey in a bowl and stir together vigorously. You want a sticky paste with an even texture. Cover and put in the fridge for a few hours or overnight to marinate.

You'll need two large baking trays and five rectangles of baking paper, roughly the same size. Tip half the pork mixture onto a piece of baking paper, cover with a second piece and spread out evenly, using a rolling pin, to 2.5–3mm (⅛ inch) thick. Transfer to a baking tray and remove the top layer of baking paper (which you can reuse for rolling the second piece). Repeat with the remaining pork.

Heat the oven to 120°C (235°F). Put in the trays and bake for 20 minutes.

Remove the trays from the oven and turn up the temperature to 220°C (425°F). Pour off any liquid from the pork, blot with a paper towel, lift the pork out of the trays on the baking paper and set aside. Line the baking trays with two new pieces of baking paper. Cut the sheets of pork into large squares with scissors and lay on the trays, pale-side up.

Thin the honey with a teaspoon of water, then brush some over the top of each pork square. Return to the oven and bake for 5–10 minutes, until the surface is well caramelized and beginning to char in places. Flip the bak kwa, paint the tops with honey-water again and return to the oven for a final 5 minutes. Leave to cool. It will keep in an airtight container for 2 days, or 5 days in the fridge.

# MOUTH-TINGLING POTATOES

Tepla ambat 〜〜〜〜〜〜〜〜〜〜〜〜〜〜〜〜〜〜〜〜〜 India

**Serves 4 as a side**

A firework display in your mouth, reaching every tastebud. There is a firecracker of dried chili offset by creamy coconut milk, sweet red onion and a snap of tangy tamarind. Like smoke trails in the sky after the explosion, you are left with a cooling, tongue-tingling effect to ready you for the next bite.

Sichuan peppercorns tend to steal the glory internationally for their mouth-numbing quality, but there are other varieties from across Asia that bring this extra dimension to food. None are in fact true peppercorns, but the dried berries of prickly ash. Japanese sansho pepper is tangy and lemony, andaliman pepper from Sumatra has a gentler numbing and mandarin flavor, and teppal from India has slightly larger fruit with a woodsy note. Use them interchangeably. This recipe is from the Konkan coast of India where teppal grows. Some cooks infuse just a few in the sauce for a milder effect but if, like me, you are mesmerized by the buzz, grind them into the spice paste.

I've made this vegetarian with potatoes and wilted spinach. You can also poach fish steaks in the same sauce, as is popular in Goa.

2 tablespoons coconut oil or neutral oil
1 large red onion, chopped
500g (1lb 2oz) waxy potatoes, cut into 4cm (1½ inch) chunks
185ml (¾ cup) coconut milk
1 teaspoon ground turmeric
1 scant teaspoon fine sea salt
100g (2 cups) baby spinach leaves
½–1 tablespoon tamarind paste
Juice of ½ a lime

**FOR THE SPICE PASTE**
7 dried Kashmiri chilies
1 teaspoon teppal or Sichuan peppercorns
1½ teaspoons coriander seeds
5 garlic cloves
60ml (¼ cup) coconut milk

Start by making the spice paste. Soak the dried chilies in hot water for 30 minutes to soften. In a dry pan, heat the teppal or Sichuan peppercorns and coriander seeds until they smell toasty, then grind to a powder with a pestle and mortar.

Drain the chilies and transfer to a blender with the ground spices and garlic. Splash in the coconut milk and whiz to a paste.

Heat the oil in a pan that will be large enough to hold the potatoes later. Add the onion and soften in the hot oil. Scrape in the spice paste and cook until fragrant and the rawness has gone.

Add the potatoes, coconut milk, turmeric and salt. If needed, top up with just enough water to cover the potatoes. Bring to a slow boil and cook, uncovered, stirring occasionally, until the potatoes are tender and the sauce has reduced to a good consistency, about 20–30 minutes.

Stir through the spinach and let the leaves wilt in the heat. Add the tamarind and taste for seasoning, then brighten the flavors with a zap of lime juice. This is even better the next day.

## EAT WITH
Rice or roti or they make a good match for some grilled fish

# NUTMEG & PEPPER PORK

Semur babi ～～～～～～～～～～～～～～～～～～～～ Indonesia

Serves 2–4

The Banda Islands in eastern Indonesia are the original home of the nutmeg and three-quarters of the world's supply are grown in Indonesia to this day. The tart yellow fruit is prized as much as, or perhaps more than, the seed in the cooking of the islands where they grow. Its spiced flesh is candied or made into jam. The lacy web of red mace that is layered between the fruit and seed is rarely used in local cooking, instead packed up for export or used in cosmetics.

This is a recipe that turns all that on its head, with both Myristica spices lending delicate warmth to the sticky, sweet pork. It has similarities to babi kecap, a favorite dish of the Indo-Chinese population in Java, but here the braise is more spiced. The kitchen will be filled with the scent of nutmeg.

650g (1lb 7oz) boneless pork shoulder
2 tablespoons neutral oil
8 small shallots or 2 small onions, sliced
1 teaspoon freshly grated nutmeg, plus more
  to finish
3/4 teaspoon coarsely ground black pepper
1/4 teaspoon ground mace
1 clove
1 tablespoon light soy sauce
3 tablespoons kecap manis (sweet soy sauce)

Cut the pork into 3cm (1¼ inch) cubes, keeping the fat on as this will render as it cooks and make the meat succulent. Season with a good pinch of salt and set aside.

Heat the oil in a casserole pan over a medium heat. Add the shallots and cook until soft and light golden. Add the pork and stir-fry for 4–5 minutes to color the meat.

Add the spices, soy sauce and kecap manis and cook for a minute longer. Top up the pan with just enough water to cover. Bring to a simmer and skim off any scum that rises to the surface. Cover with a lid and cook at a bare simmer for 1½–2 hours, until the pork is very tender. Remove the lid for the last half an hour or so to help the sauce reduce.

Skim off any fat from the surface. The sauce should be glossy and coating the meat. If it is too thin, remove the pork with a slotted spoon and bubble the sauce, uncovered, to reduce further. Return the pork to the pan and taste for seasoning. The sweetness of the kecap manis should be balanced by salt and richness. An extra grating of nutmeg will bolster its ephemeral scent.

## EAT WITH

Jasmine rice, bitter greens, prawn crackers

For a tangy, crunchy contrast, try Acar pickles: Cut 300g (10½oz) carrot and/or cucumber into thin julienne sticks. Put in a lidded container with 2 finely sliced small shallots, 3 tablespoons rice vinegar, 2 tablespoons sugar, 3/4 teaspoon fine salt and a slit red bird's eye chili with the seeds removed. Shake to muddle, then leave to sit for half an hour.

# THE KEBAB EMPIRE

At almost every spice route port, from Istanbul to Singapore,

**you'll be able to catch a smoky-sweet aroma on the breeze to lure you to a kebab vendor.**

Few dishes are so ubiquitous and so varied as kebabs, which have conquered the world under a myriad of glorious guises but all trace back to the same roots.

With their origins in Turkey, kebabs in their earliest form were cubes of meat skewered onto swords and roasted over open fires, an ideal method to feed soldiers traveling to new lands. The Ottoman Empire spread word from Athens to Baghdad; Afghans took them to India, where they were popularized by the Mughals; Arab traders carried the dream of these smoky morsels along sea routes to Indonesia, Malaysia, Thailand, even as far as Japan. In each new home, local influences enveloped the concept and made something distinctive and redolent of its geography.

The kebabs of Central Asia stay truest to their simple origins, large pieces of meat marinated in oil and grilled. In Uyghur country, they get a hit of chili and a crisp coating of egg and potato starch. Moving to South Asia, they pick up earthy spices and yogurt marinades. In fact, India, alongside Turkey, has some of the greatest varieties of kebabs in the world: they can be grilled, fried, smoked, roasted in tandoors or on hot stones, made with minced meat, meat ribbons, drumsticks, fish or vegetarian versions using paneer or potatoes. Islamic and Hindu food traditions fuse from the centuries of Muslim rule in India, so you will find meaty kebabs sprinkled with mouth-puckering chaat masala, a spice mix soured with dried mango powder that was once the preserve of Hindu vegetarians. In Afghanistan, Syria and Iran, a different sour note comes from the sumac that diners can add liberally at kebab stalls.

A thread of commonality runs through many of the kebabs of the Middle East.

**Complex blends are used, heavy with sweet and warming spices. Cinnamon, nutmeg, cardamom, cloves and black pepper. You'll also find feathery green herbs and saffron, as well as kebabs minced with garlic and tomatoes, stuffed into lavash bread or eaten with buttered rice.**

They often come served under a tangle of paper-thin onion to keep the meat moist and with a tart yogurt drink alongside.

Travel east and kebabs take on an entirely new character and name. Satay (spelled "sate" in Indonesia and Malaysia) uses seafood or much smaller pieces of meat threaded onto sticks, often with a sweet soy marinade. It is the ultimate street food and

## vendors will vigorously fan coconut husk embers, calling them to life. As fat drips from the satay, a crackle of flames will lick the outsides, giving them char while the centers stay succulent.

Sate originated in Java then spread across the archipelago and to Thailand, where curry powder and lemongrass combine. In both countries, salty-sweet peanut sauce is a favorite accompaniment. In the Philippines, isaw is served with vinegar and in Japan, yakitori has a sweet mirin glaze.

We mustn't forget kebabs without the stick. There are Turkish doner and Arabic shawarma, meat layered with spices and carved off a vertical rotisserie. Koftas are meatballs and their vegetarian cousins, eaten from Eastern Europe to India. In Karachi and Dushanbe, you can find minced and spiced meat wrapped around hard-boiled eggs; in Lebanon, it is stuffed into breads then grilled; and in Afghanistan, it is studded with pomegranate jewels then flattened to the shape of a sandal. I have eaten steam kebabs, stews cooked in earthenware casseroles, in both Uzbekistan and Turkey. These feel furthest from the origin but still bear the name. Perhaps the most curious I have tried is the shammi from Lucknow. The eighteenth-century nawab, Asaf-ud-Daulah, was a renowned glutton and lover of kebabs, but also toothless. His cooks devised a solution by mincing lamb so finely with ginger, spices and poppy seeds that it had a texture of silk velvet. The spicing is incredible and intense, but eating it is an unusual sensation for those of us with teeth.

# KEBABS FOR BABUR

Serves 4

Two events, just twenty-eight years apart, had a seismic impact on India's food. In 1498, Vasco da Gama arrived on the Malabar Coast, opening up a new sea route to Europe. In 1526, "The Tiger" Babur invaded India from the North, founding the great Mughal empire that dominated South Asia for more than three centuries.

Coming from Central Asia, where eating was recognized as a great pleasure, Babur brought with him a love of plovs, rice layered with gently spiced meat and the rich fat of lambs' tails, and also the kebabs roasted over campfires that he ate in the Steppes. In the newfound Mughal court, Babur hired Hindustani cooks to work alongside those from Persia and Central Asia, so bringing these very different culinary traditions together in glorious fusion. Still, he always pined for the fruits of his homeland, the delicate scent of melons and the sweetness of a Samarkand apple.

Here, I have imagined a simple kebab Babur might have eaten. Though chilies were arriving in India via da Gama's new sea passage, they were not yet spicing the food, so heat comes instead from ginger and black pepper. The yogurt marinade is a signature Mughal technique for tender lamb.

800g (1lb 12oz) lamb steaks
50g (¼ cup) Greek-style (strained) yogurt
3 tablespoons neutral oil
Juice of ½ a lemon
1cm (½ inch) ginger, peeled and minced (1 teaspoon)
2 garlic cloves, minced
1 teaspoon ground black pepper
1 teaspoon ground coriander
1 teaspoon ground cumin
1 teaspoon fine sea salt
1 small onion, cut into small chunks

Trim any excess fat from the lamb steaks and cut into 2.5cm (1 inch) cubes.

In a large bowl, combine all the ingredients except the onion and cover. Leave the lamb to marinate for 4–8 hours in the fridge. Bring back up to room temperature about 30 minutes before cooking.

Remove excess marinade from the meat and thread the meat onto eight metal skewers, alternating with small pieces of onion.

Heat a barbecue or large griddle pan to medium–high. Grill the meat, turning occasionally, for 7–8 minutes or until cooked to your liking. The meat should be slightly charred and a little pink inside, the onions soft and beginning to char. Rest for 5 minutes.

Serve with buttered basmati rice, followed by slices of melon, if you like.

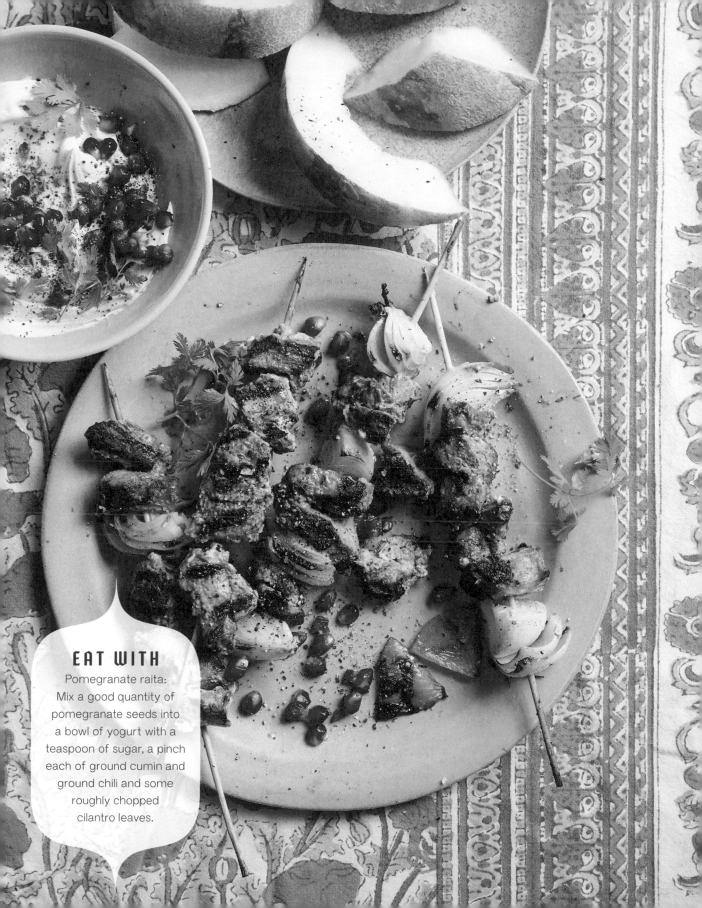

### EAT WITH

Pomegranate raita:
Mix a good quantity of
pomegranate seeds into
a bowl of yogurt with a
teaspoon of sugar, a pinch
each of ground cumin and
ground chili and some
roughly chopped
cilantro leaves.

# SCALLOPS WITH GINGER & BLACK PEPPER

Ching jing dai zi ⌇⌇⌇⌇⌇⌇⌇⌇⌇⌇⌇⌇⌇⌇⌇⌇⌇⌇⌇⌇⌇⌇⌇⌇⌇ Hong Kong

### Serves 2

Pepper has been around since the first syllables of recorded time. An early culinary use was noted by Diphilus, a third century BC physician from the Greek island of Sifnos, who recommended it with scallops. It is indeed a time-honored pairing, hot with sweet, and here employed millennia later across faraway seas.

Just as in ancient Greece, China was an early and enthusiastic consumer of imported peppercorns. In this recipe, ginger and pepper work together to bring a double hit of piquancy, just enough to complement not overwhelm, for the Cantonese are masters at cooking seafood in a simple, elegant manner.

Note, if you are unable to source scallops in their shells, cook the scallops directly in the steamer, along with the ginger, for 4–6 minutes.

6–8 scallops in their shells
2 spring onions (scallions)
3cm (1¼ inches) ginger
1½ tablespoons light soy sauce
2 teaspoons Shaoxing rice wine or dry sherry
1 scant teaspoon coarsely ground black pepper
1½ teaspoons sesame oil

Prepare the scallops by using a cutlery knife to slice along the inside of the flat shell with sweeping motions to release the muscle and open the hinge. Discard the flat shells. Cut out the scallop meat and reserve the curved shells. Gently pull away the frill and darker colored stomach sac and discard. Pull away the small white ligament and you'll be left with the fleshy white scallop meat and bright orange coral. Season with a little salt and leave for 10 minutes to begin to cure the meat and enhance its flavor. In the meantime, scrub the curved shells, then put in a pan of boiling water for 15 minutes to sterilize. Rinse off the salt from the scallops in cold water and pat dry.

Trim and thinly slice the spring onions, then put into icy-cold water to curl. Peel the ginger and julienne by slicing thinly, then slicing again into thin sticks. Divide among the shells with the scallop meat.

Cook the scallops by either laying the shells in a steaming pan or placing the shells directly into a couple of centimeters of boiling water in a shallow pan. Cover and steam for 6–8 minutes or until the scallop meat is opaque.

In a small pan, combine the soy sauce, Shaoxing rice wine, pepper and sesame oil and warm through. Spoon over the steamed scallops and serve right away, topped with a tangled curl of spring onions.

## EAT WITH
Glass noodles, garlicky greens

# FIERY LONG PEPPER TEA

Pippali chai ～～～～～～～～～～～～～～～～～～～～～～～～～～～～～ India

**Serves 4**

For five millennia, the Indian healing science of Ayurveda has advocated chai and infusions to promote health and balance doshas. This tea brings together pepper and ginger, the spicy heat duo, to warm the throat and stimulate digestive fire. It is said not only to aid digestion but also to better assimilate experiences, and who wouldn't want that?

Long pepper has a gingery warmth and complex floral notes. A scant teaspoon of cracked black pepper could be used in its stead for a cleaner heat.

**2–3 long peppers, lightly crushed**
**1 slice of ginger**
**Juice of a lemon**
**2 teaspoons honey**

Pour 600ml (2⅓ cups) water in a pan with the long peppers and ginger. Cover and bring to the boil, then turn off the heat and leave to steep for 5 minutes.

Stir in the lemon juice and honey and taste for sweetness. Strain into teacups. (I like to brew the spices again for a second, milder cup without honey and lemon.)

# FRAGRA
## &G

PETALS, BARKS

& OTHER DELIGHTS

Delicately scented petals and seeds and other aromatics, such as balsam, sandalwood and frankincense, crisscrossed the world in early trade, being embraced wholeheartedly into the cuisines and perfumes of adopted nations.

Rosebuds came to the Middle East from China, lending romance to both their pilafs and poetry. In the twelfth century, distilled damask rose water came back to the Chinese courts from Persia, more fragrant and evocative than the form in which it had left. Tibetan musk reached Rome in around 400 AD, prompting Jerome to disapprovingly dub it "well suited to lovers and hedonists." Coriander seeds sailed in the opposite direction, exported from the Mediterranean for their citrusy, woody aroma to find a natural home in Middle Eastern braises, South Asian curry powders and Indonesian bumbus.

The thread-like stigma of the saffron crocus, worth more than its weight in gold due to its painstaking harvesting process, traveled both west and east from Persia. Cleopatra once bathed in saffron-stained milk; Romans mixed it with sweet wine and spritzed it into the air in theaters; Chinese Buddhist monks used it to dye their robes; Mughal maharajas prized it in smoky biryanis and the sultry yogurt-based drink lassi, scented not only with saffron, but rose water and cardamom. In turn, the sweet, floral, lingering green cardamom traveled from the rainforests of southern India and Sri Lanka to be welcomed into Arabic coffee and Scandinavian sticky buns and feature as a nectarous aphrodisiac in the tales of the Arabian Nights. Its black cousin, with a smokier, resinous edge, found its way from the Himalayas into Sichuanese braises and Vietnamese broths.

## Both of these might also feature a licorice kiss of Chinese star anise.

Cinnamon was the subject of ancient tales woven by Arab traders in an effort to hide its origins and keep a stranglehold on the spice trade. It was said a fearsome cinnamologus bird used cinnamon sticks to make its mountaintop nest, and only by luring it out with large chunks of meat could plucky merchants gather the sweet bark. It was enough to fool the Greeks and Romans, warding off curiosity to find its true source in Sri Lanka. While in the West the curled bark of the cinnamon tree has become a bakers' spice, in much of the world it is used more in savory cooking. Find it in Sri Lankan curries, suffusing Thai broths and ground into Middle Eastern spice blends baharat and advieh. Sometimes the interchangeably used, coarser bark of China's cassia tree is favored, its robust sweet warmth being one of the five in five spice.

Spices, we must remember, are nutritionally superfluous, and it is the sweetly scented ones that remind us most keenly that they are there for pleasure over functionality. Much of what we taste in them isn't true taste at all, it is fragrance sensed with the nose rather than the tongue. This is drawn upon outside the kitchen in the intoxicating smoke of church incense, sweet-smelling pomanders studded with cloves, and spicy notes captured in fine perfumeries. Perhaps the most wantonly decadent example of scent and taste coming together was in ancient Rome, where Emperor Nero had a water-powered, rotating banqueting hall, from which the fretted ivory ceiling rained down violets and flower waters on diners drinking honeyed wine below, in a prelude to a feast that could last all day.

# ROYAL SAFFRON PANEER

Shahi paneer ～～～～～～～～～～～～～～～～～～～～～～～～～ India

**Serves 4**

Mughal kitchens must have been exquisite places, the air scented with the saffron, flower waters and cardamom used to suffuse their rich, creamy foods. Here is a derivative of one of the courts' most celebrated dishes, silky-soft morsels of fresh cheese cloaked in a sumptuous, sweetly spiced tomato cream with the merest thread of heat. Delicate and divine.

1 tablespoon neutral oil

1 onion, finely chopped

400g (14oz) ripe tomatoes, blended, or good tinned tomatoes, finely chopped

4 green cardamom pods, bruised

2 cloves

1 teaspoon ground turmeric

1 teaspoon Kashmiri chili powder, plus extra to serve

1 teaspoon grated jaggery or sugar

1 teaspoon fine sea salt

450g (1lb) paneer

¼ teaspoon saffron strands

1 teaspoon rose water or kewra (screw pine) water

125ml (½ cup) thick (double) cream

Heat the oil in a pan and cook the onion until soft and golden. Add the tomatoes, cardamom, cloves, turmeric and chili powder. Season with jaggery and salt. Bring to a simmer and cook for 15 minutes.

Meanwhile, cut the paneer into bite-sized cubes and put in a bowl. Pour over boiling water, cover and set aside for 10 minutes to soften. (There is no need to soak if you are using homemade paneer.)

Toast the saffron in a dry pan for just a few moments, you want to wake it up not scorch it. Tip into a small bowl and crush to a powder with the back of a spoon. Add a tablespoon of hot water and leave to infuse.

When you are ready to serve, drain the paneer and add it to the hot pan of spiced tomato. Simmer for 2 minutes. Stir in the saffron infusion, rose water and all but a dribble of the cream. Warm through.

Serve with the reserved cream, white dripped lacily on saffron yellow, and a red dusting of chili powder.

## EAT WITH

Roti or paratha and other Indian dishes. Pictured here with Every week tomato lentils (page 198)

Panch phoron bitter greens pair well with the sweet creaminess. Heat a little oil, add 1 teaspoon of panch phoron (page 197), sizzle briefly, then stir-fry blanched greens in the spiced oil.

# EGYPTIAN "BIRDS' TONGUES" SOUP

Shurbat lisan asfour ～～～～～～～～～～～～～～～～～～～～～～～～～ Egypt

### Serves 4 as a starter

Named for the tiny tongued shape of orzo pasta, the only bird here is the one for the chicken broth at the base of this golden, soul-restoring soup. Three spices—cardamom, cloves and mastic— all hover between piney eucalyptus and floral sweetness, each barely perceptible, but they work together to bring depth and intrigue amid browned buttery comfort.

Typically, chicken pieces would be poached for the broth then the meat used elsewhere, but I like to make use of the bones left behind from a roast chicken.

Carcass of a roast chicken
1 onion, skin on, roughly chopped
2 celery stalks, roughly chopped
1 large tomato, roughly chopped
2 bay leaves
½ teaspoon fine sea salt
8 green cardamom pods, bruised
2 cloves
2 mastic grains
50g (¼ cup) butter
125g (¾ cup) orzo pasta
Nutmeg or black pepper, to serve

Put the chicken carcass in a large pan with any leftover skin and scraps of meat. Push down to crush the bones, then add the onion, celery, tomato and bay leaves. Season with salt and all the spices. Pour in 1.6 liters (6½ cups) of water, cover and bring slowly to a simmer. Cook at a whisper for 2 hours (or 1 hour in a pressure cooker).

Strain the stock, discarding the bones and aromatics. Let it settle, then skim off any fat that rises to the surface (if preparing in advance, refrigerate, then it is easy to remove the layer of hardened fat). Taste for seasoning.

To make the soup, wipe out the pot and set over a medium heat. Melt the butter, add the orzo and stir constantly for about 3 minutes until toasted and golden. Pour in the stock and bring to the boil. Cook for 8–10 minutes until the orzo is tender. Ladle into bowls and finish with a scratch of nutmeg or pepper.

# CASHEW CREAM CHICKEN

Kaju ni gravy ma marghi 〜〜〜〜〜〜〜〜〜〜〜〜〜〜〜〜〜〜〜 India

Serves 4–6

Here is a showcase of chicken at its most festive and luxurious and yet, pleasingly, it is deceptively simple to cook. Cashew nuts make a silky cream sauce that has sweetness from caramelized onion and a subtle but definite prick of chili heat fortified by judicious spicing. Scattered with a flourish of glassy red pomegranate seeds, it makes a splendid party dish or rather fine picnic fare if cooked in advance and chilled so the sauce thickens.

The recipe comes from the Parsi community of India and, more specifically, from my friend and culinary anthropologist, Niloufer Ichaporia King. Parsis are the descendants of Persian Zoroastrians who set sail for India 1300 years ago and brought with them one of the world's oldest culinary traditions.

During the maritime spice trade epoch, Parsis got on well with both local suppliers and foreign buyers, acting as mediators, brokers and interpreters. While adapting fluidly to a new and changing land, the community clung to its roots and you can see in this dish links to Persian and Ottoman braises such as Fesenjan and Circassian chicken. Those are made with ground walnuts but Parsis are more likely to use almonds or cashews. Korma is another similar dish, also stemming from an Indian-Persian fusion, where nuts and dairy combine in voluptuous richness.

8 skinless, boneless chicken thighs or 4 breasts
4 garlic cloves, minced
2cm (3/4 inch) ginger, peeled and minced
1 teaspoon fine sea salt
2 tablespoons ghee or neutral oil
4 dried Kashmiri chilies
2 x 5cm (2 inch) cinnamon or cassia sticks
6 cloves
4 green cardamom pods
1 large onion, finely sliced
200g (1¼ cups) raw cashew nuts
140g (½ cup) Greek-style (strained) yogurt
Pomegranate seeds, to decorate (optional)

If you are using chicken breasts, halve them. Mix with the garlic, ginger and salt and leave to marinate at room temperature for 30 minutes.

Meanwhile, heat the ghee in a large casserole pan. Toss in the chilies and spices and let them sizzle. The chilies should start to turn dark, and the cardamom toasty. Add the sliced onion and cook, stirring occasionally, until soft and golden.

Add the chicken to the pan and cook for 3 minutes or so, turning it in the aromatics. Barely cover with water and bring to the boil. Turn the heat right down, cover and simmer for 20–25 minutes, until just cooked through. Remove the chicken to a plate.

Put the cashew nuts into a blender with the yogurt and a ladleful of the cooking liquid. Be sure to leave the whole spices behind in the pan with the rest of the liquid, but fish out two of the chilies and add to the blender if you want some heat. Whiz to a smooth and creamy purée. Scrape the purée back into the pan with the cooking liquid and whisk until well combined. Taste for seasoning. Return the chicken to the pan.

To serve, rewarm over a very low heat and scatter with a flourish of pomegranate seeds.

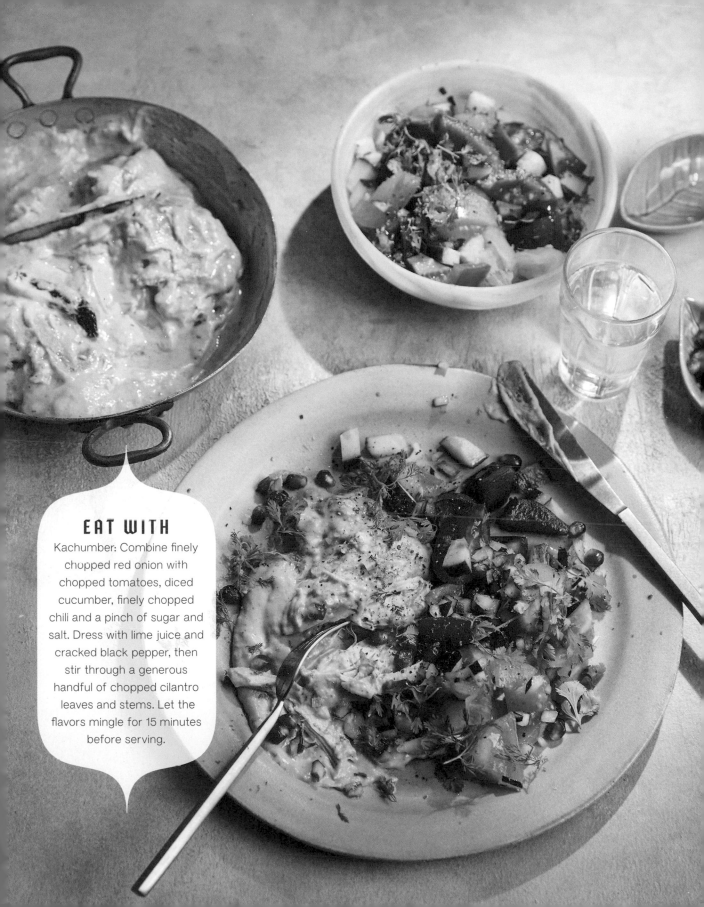

## EAT WITH

Kachumber: Combine finely chopped red onion with chopped tomatoes, diced cucumber, finely chopped chili and a pinch of sugar and salt. Dress with lime juice and cracked black pepper, then stir through a generous handful of chopped cilantro leaves and stems. Let the flavors mingle for 15 minutes before serving.

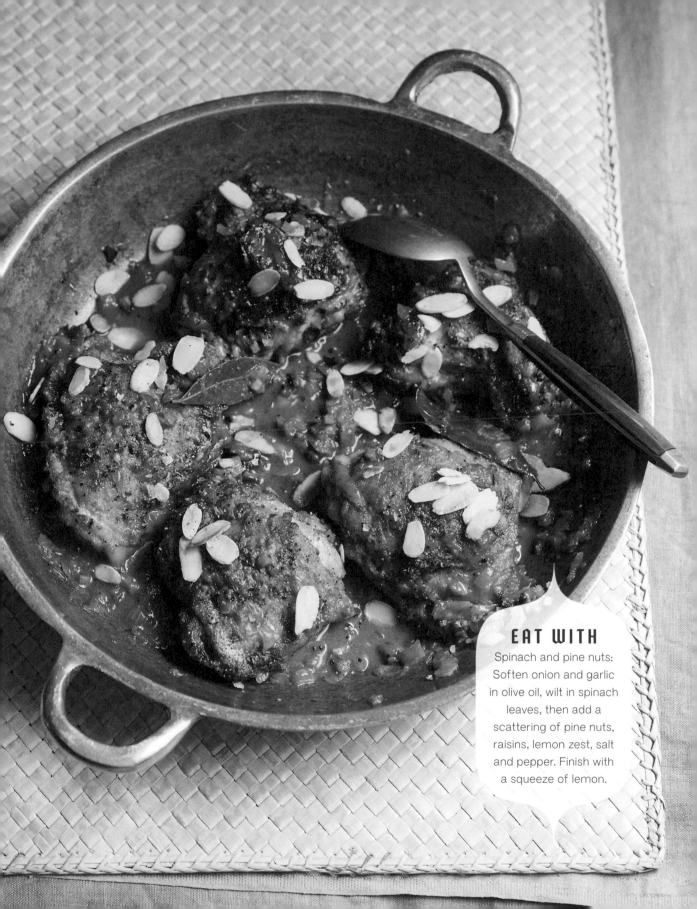

## EAT WITH

Spinach and pine nuts: Soften onion and garlic in olive oil, wilt in spinach leaves, then add a scattering of pine nuts, raisins, lemon zest, salt and pepper. Finish with a squeeze of lemon.

# VENETIAN CHICKEN WITH ALMOND MILK & DATES

Ambroyno ～～～～～～～～～～～～～～～～～～～～～～～～ Italy

Serves 4

The Persian and Arab fondness for using sugar, spice and ground almonds in savory dishes spread both East, notably to Indian Mughal cuisine, and West to Medieval European cookery. This recipe is based on one handwritten in a fourteenth-century cookbook from Venice. At the time, the city lay at the end of the fabled spice route, the European hub of spices and silks arriving from the East. Just as Venetian art and architecture drew on Islamic influence, so too does this sweetly spiced braise.

A heavy hand with spice continued for centuries in Northern Italy and the Renaissance chef Cristoforo di Messisbugo included spices in almost every recipe. A ravioli dish for 10 used a heady ounce of cinnamon and half an ounce of ground ginger. There was little distinction between sweet and savory, dishes freely mingling together and pasta doused in sugar and scented with cloves, pepper and saffron. This recipe has only a gentle sweetness and stands the test of time.

8 skin-on, bone-in chicken thighs
1 tablespoon plain flour
3 tablespoons olive oil
2 small onions, finely chopped
60g (2oz) ginger, peeled and finely chopped
4 garlic cloves, finely chopped
1 teaspoon ground cinnamon
1/2 teaspoon freshly grated nutmeg
1/2 teaspoon ground coriander
Pinch of ground cloves

2 bay leaves
400ml (1½ cups) unsweetened almond milk
2 tablespoons verjuice
Pinch of saffron strands
2 tablespoons date syrup
4 medjool dates, stoned and quartered
2 tablespoons toasted almond flakes
Handful cilantro leaves
Rice or polenta, to serve (optional)

Season the chicken thighs generously with salt and pepper, then dust with the flour. Set a large casserole pan over a medium–high heat and when hot, pour in the olive oil. Add the chicken thighs and brown to a deep golden on all sides. Remove to a plate, leaving the oil behind.

Add the onion to the pan and cook to soften but not color. Stir in the ginger, garlic, spices and bay leaves and cook for a few minutes until fragrant. Return the chicken to the pan in a single layer.

Pour in the almond milk and verjuice, scrunch in the strands of saffron and add the date syrup and dates. Season with salt. Bring to a bubble, then lower the heat and simmer for 1 hour. The chicken should be tender and falling from the bone.

Remove the chicken with a slotted spoon and turn up the heat. Bubble the sauce until it has reduced and thickened. Taste for seasoning and adjust. Serve the chicken in the sauce, scattered with almonds and cilantro, alongside rice or polenta.

# HONEYED MEATBALLS WITH PISTACHIOS

Dajaj Mudaqqaqah ⌇⌇⌇⌇⌇⌇⌇⌇⌇⌇⌇⌇⌇⌇⌇⌇⌇⌇⌇⌇⌇⌇⌇⌇⌇⌇⌇⌇⌇⌇⌇ Syria

**Serves 4 as a side**

A wonderful cookbook called *Scheherazade's Feasts* by the Salloum family translates medieval Arab recipes for the modern kitchen. This Golden Age for the Islamic world was one of opulent splendor brought about by the riches, produce and knowledge that came with trade and conquest. Sweet spices, tart fruits and floral perfumes infused the foods. Though my interest was piqued by sugared lettuce (laced with anise, cinnamon and ginger), and lamb and date kebabs (coriander seed, saffron, mastic and dried mint), it was these meatballs that my mind kept wandering back to.

I have adapted their recipe, originally based on one from a twelfth-century chronicler from Aleppo, Ibn al-'Adīm. While he specified the meatballs should be rolled the size of hazelnuts, if you haven't the patience, go for more of a walnut.

225g (8oz) minced lamb
225g (8oz) minced chicken
1½ teaspoons fine sea salt
½ teaspoon ground cumin
½ teaspoon ground coriander
½ teaspoon caraway seeds
½ teaspoon ground black pepper
2 tablespoons olive oil
3 tablespoons honey
100g (¾ cup) shelled pistachios
Pinch of saffron strands
Juice of ½ a lemon
Small handful mint leaves
2 teaspoons rose water

In a bowl, combine the lamb, chicken, salt and ground spices and mix everything together. (If your chicken needs mincing, do so in a food processor then add the other ingredients for a final blitz together.) Everything should be well combined, but not handled too much to save the meatballs from becoming tough.

With oiled hands, roll the mixture into small meatballs. If you have time, chill in the fridge to help them firm and hold their shape.

Heat the olive oil in a large frying pan over a medium–high heat and fry the meatballs for about 5 minutes, until browned on all sides. Pour over 75ml (⅓ cup) water and add the honey and pistachios. Crumble in the saffron and bring to a simmer. Cook, shaking the pan occasionally, for 15 minutes or until the meatballs are cooked through. If checking with a meat thermometer, it should read above 74°C (165°F). The liquid should be reduced to a shiny glaze.

Stir through the lemon juice, mint and rose water.

## EAT WITH

Biwaz: Toss together a coarsely chopped bunch of flat-leaf parsley, a thinly sliced red onion, 1 tablespoon extra-virgin olive oil, 1½ teaspoons pomegranate molasses, 1½ teaspoons sumac and a pinch of salt

# RED-COOKED DUCK BREASTS

Hong shao yazi ~~~~~~~~~~~~~~~~~~~~~~~~~~~~~~~~~~~~~~~~~~~~~~~~~~~~~~ China

### Serves 2

A classic Chinese cooking technique called red-cooking involves building an intense broth layered with spice, soy and sweet wine. In this, you braise meat until tender with a deep reddish-brown sheen. Flavor-potting is a related technique, where you top up and reuse the aromatic cooking liquor. Some of Beijing's top restaurants claim their flavor pots are twenty generations old!

Star anise, ginger and cassia are added whole to infuse their flavor without disrupting the smooth glossiness of the sauce. It then reduces to coat and almost lacquer the duck. In Chinese cuisine, both medieval and modern, no one spice should dominate; rather they work together to provide complexity and depth.

2 duck breast portions
2 star anise
1 cassia or cinnamon stick
5cm (2 inches) ginger, peeled and thickly sliced
2 tablespoons Shaoxing rice wine or dry sherry
1 tablespoon dark soy sauce
1 tablespoon light soy sauce
1 tablespoon light brown or yellow rock sugar

Put the duck breasts skin-side down in a pan that will hold them with just a little surrounding space. Add all the other ingredients, tucking the spices under the meat. Top with enough water to barely cover and bring to the boil. Lower the heat and cook at a lively simmer for 15 minutes, turning the duck halfway through.

Remove the duck breasts and set aside. Over a high heat, bubble to reduce the liquid until syrupy and shiny. Scoop out the aromatics.

Lower the heat to medium and return the duck to the pan. Cook, spooning over the sauce and occasionally turning the breasts, for 5 minutes until dark and thickly glazed. Rest for 5 minutes, then slice and serve with a slick of the remaining sauce.

## EAT WITH
Rice or noodles, broccoli drizzled with toasted sesame oil

# DUCK WITH VANILLA

Canard à la vanille 〜〜〜〜〜〜〜〜〜〜〜〜〜〜〜〜 Réunion

Serves 4

The French island of Réunion is scented by plantations of bourbon vanilla and sugarcane, as well as the spices used in the lively Creole cuisine. It is a natural paradise known for its cultivation of nutmegs, cloves, date palms, tropical fruits, almonds and pink peppercorns. Ginger, turmeric and tamarind trace their roots back to India along with the banyan trees of the island. Vanilla, an American import grown here since the nineteenth century, has wound its way into savory cookery.

This braise is rich and fragrant. Cooking it on the stove would be more usual, but the oven keeps a steadier temperature, allowing you to leave it unfussed until the tough meat melts to bone-slipping tenderness.

4 duck legs
1 onion, finely chopped
400ml (1½ cups) red wine
1–2 vanilla pods, split
2 cloves
6cm (2½ inches) ginger, peeled and minced
  (2 tablespoons)
1 tablespoon honey
2 teaspoons vanilla extract
Cracked pink pepper, to serve (optional)

Season the duck legs with salt and lay skin-side down in a casserole pan large enough to hold them quite snuggly in a single layer. Set over a medium heat and let the fat slowly render and the skin brown; it will take about 15 minutes. Turn and cook the other sides for a minute or so, then remove the duck to a plate.

Heat the oven to 130°C (250°F).

Spoon off all but about a tablespoon of fat from the pan (saving it for another use). Return to the heat and add the onion with 1 teaspoon of salt, cooking gently for a few minutes to soften.

Add the wine, vanilla pods, cloves, ginger and honey, then return the duck legs to the pan skin-side up. Let it bubble for a few minutes. Tear off a piece of greaseproof paper, scrunch then unscrunch. Lay this over the meat, tucking the edges up the side, then cover the pan with a lid. Cook in the oven for 3 hours, until the meat is very tender and beginning to slip from the bone.

Skim off any fat from the surface and add the vanilla extract. Taste for seasoning. You may want to serve with a flourish of pink pepper.

## EAT WITH
Brown lentils, roasted squash

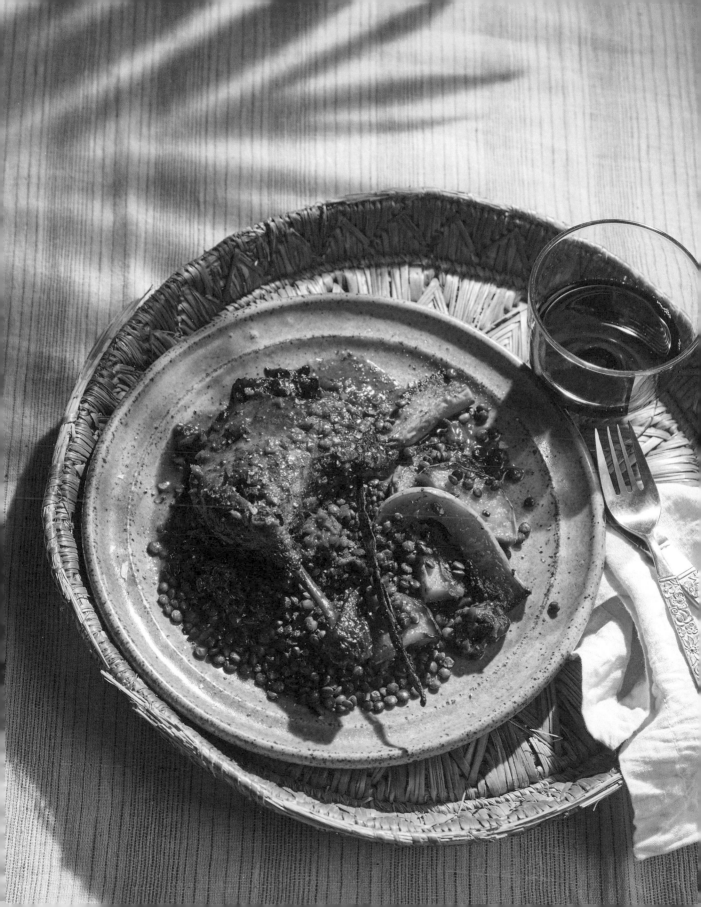

# LAYERS OF SPICE & RICE

Cracking into a sealed pot at the table—releasing a cloud of fragrance to overwhelm diners and reveal a mound of exquisitely spiced rice and meat—this is dining as theater. It is no wonder that pilaus, pilafs, palovs, biryanis, kabsa, and the many other names these layered rice dishes go by, are saved for weddings and party celebrations. Great skill is required in their cooking to keep every grain of rice separate, and expensive spices are used with abandon: saffron, cardamom, cloves, nutmeg and mace.

We can find derivatives across half the globe, acting as bonds linking distant cultures. They are usually tied to the Islamic world, though the cooking predates the religion—both spread with traders and conquerors along the spice routes. The most likely origin is in ancient Persian kitchens, where rice was an imported luxury, so pilafs evolved to enhance its fragrance with other prized ingredients. Both Ottoman and Mughal cuisines owe much to Persian roots and took these influences global.

Arab traders carried the concept to Asia, where it melded and adapted to new lands. The Muslim communities of Thailand enjoy khao moag, rice and meat flavored with curry powder and sweetly mellow coconut milk. In Indonesia and Malaysia, nasi kebuli ("kebuli" in reference to Kabul, an apparent source for the dish) uses the spices of the old trading routes combined with local notes of soy sauce, lemongrass and lime leaves. Interestingly, Burmese food writer MiMi Aye explains how they have two very different types of danbauk: one in the south with a curried sauce and rainbow vegetables that seems to have arrived by sea; and a northern version closer to Persian cooking, all sweetly spiced meat and caramelized onions, that traveled via the Silk Road.

A similar pattern can be seen in India. While the Mappila descendants of spice traders in southern India have biryanis using mint, cashews and plump golden raisins, in northern India the biryani developed in the royal Mughal kitchens, where Persian, Central Asian and Hindu cooking came together. Delicate pilafs fused with pungent Hindu rice dishes to create something new, just as the delicate geometric designs of Persia married with vibrant North Indian art to create the prized miniature paintings. Mughal dining was unashamedly about opulence and pleasure.

**Served by eunuchs dressed in colored silks, sweet-smelling foods were brought out alongside vessels of jewels and dancing girls. The Mughal rulers traveled the country to remind subjects of their power, and in tow would come their imperial kitchens with fifty camels to carry supplies and fifty cows to provide the cream, butter and curds required.**

This was not cooking that could be ignored and the Persian flavors were warmly embraced in India.

In contrast, the most pared-back layered rice dishes are the plovs, palovs and osh of Central Asia, where lamb fat provides a dominant taste. Legend has it that Alexander the Great ordered it made in cauldron-like kazans as a campaign meal for his soldiers. At the base of a Samarkand plov is stewed lamb or beef, topped with a layer of cumin-spiked yellow carrots, then rice that cooks in the fragrant steam. Love of plov has spread through the former-Soviet lands and versions abound, those studded with barberries, quince, nuts, dill and sweet spices more reminiscent of Persian pilafs.

We must turn to the Middle East for the most perfumed varieties as spice and sugar combine in savory meals and rice is sewn with green herbs, sultanas, apricots, figs, almonds, petals and flower waters. The dish known as majboos in most Arabic countries has saffron and cardamom as its star spices. Majboos means "betrothed" and represents the marriage of rice and meat, or sometimes fish. Remove the dominant protein element and you arrive at pilafs, which can be as simple as rice cooked in an aromatic broth (though can also contain meat). As they spread west, these evolved into the risottos of Italy and paellas of Spain.

## If the Middle Eastern rice dishes are the elegant queens of the ball, South Asian biryanis are the party girls full of fire and spice.

Yogurt marinades act as the souring agent and flavors are bold. Sumayya Usmani has a recipe from the Sindh province of Pakistan that has no fewer than twenty-eight ingredients, including aniseed, black cardamom, mace, green chilies, screw pine water, dried plums and pomegranates. Chili heat is a later development and modern biryanis are especially vibrant and piquant, nowhere more so than in Indian diasporas. Yemen's zorbian is heady with ginger, pepper, saffron, cardamom, cloves, coriander, cumin and cinnamon, the flavors brought together with browned butter. South Africa's biryanis shout loudest of them all, a riot of paprika and cayenne, yogurt and citrus, saffron and spice. These are party dishes to remember.

# COAL-SMOKED BIRYANI

Biryani ～～～～～～～～～～～～～～～～～～～～～～～～～～～ India

Serves 6–8

Undoubtably the Emperor of rice dishes, an exquisite one-pot meal with Mughal roots. Some traditional biryanis, those made by true masters, tenderize raw meat in a marinade before cooking it simultaneously with rice. The method here is more forgiving as the lamb is braised before layering, guaranteeing tenderness.

What sets this apart is the smoking technique, which I learned from my friend Roopa Gulati. A glowing ember of charcoal is dropped into the pot, suffusing the dish with its seductive plumes of smoke. Celebratory by nature, you might feel drawn to bring the biryani to the table scattered with a confetti of dried rose petals or even shimmering with silver leaf.

### FOR THE SPICE MIX
5 green cardamom pods, seeds ground
5 black cardamom pods, seeds ground
2 blades mace, ground
2 teaspoons ground coriander
1 teaspoon ground cumin
½ teaspoon ground fennel seeds
½ teaspoon ground cloves
1 teaspoon Kashmiri chili powder

### FOR THE LAMB
4 tablespoons neutral oil
2 onions, finely chopped
6 garlic cloves, minced
6cm (2½ inches) ginger, peeled and minced (2 tablespoons)
1 cinnamon stick, snapped in half
750g (1lb 10oz) lamb leg, cut into 3cm (1¼ inch) cubes
1 teaspoon fine sea salt
200g (¾ cup) Greek-style (strained) yogurt

### FOR THE BROWNED ONIONS
2 onions, finely sliced
Neutral oil, for frying

### FOR THE RICE
450g (2¼ cups) basmati rice
Large pinch of saffron strands
1 teaspoon kewra (screw pine) water or rose water
Handful mint leaves
1 tablespoon ghee or butter

### FOR SMOKING
3 tablespoons melted ghee or neutral oil
A lump of natural charcoal
½ teaspoon black peppercorns

Make the spice mix by combining or grinding together all the spices to a powder.

For the lamb, heat the oil in a large casserole pan and fry the onion for about 5 minutes, until softened but not colored. Add the garlic and ginger and stir for a couple of minutes. Stir the ground spice mix and snapped cinnamon stick into the oil then tip in the lamb. Add 100ml (scant ½ cup) water and the salt and bring to simmering point. Stir in the yogurt a little at a time to stop it splitting. Turn the heat down to a whisper, partially cover and simmer for 1 hour or more. The lamb should be tender and the masala thick and clinging to the meat.

While the lamb is cooking, prepare the other ingredients. Over a medium–high heat, fry the sliced onion in a generous amount of oil until it is a dark reddish-brown. Drain and lay out on a paper towel.

Wash the rice very well in several changes of water until it runs clear. Put in a large bowl of cold water to soak for at least 20 minutes.

Crumble the saffron into a small bowl and add 2 tablespoons hot water. Leave to soak and when cool, stir in the kewra or rose water.

When the lamb is almost ready, bring a pan of water to the boil. Add the rice and cook for 6 minutes—it should be largely tender but with a slim, hard core. Drain.

Heat the oven to 180°C (350°F).

Layer the biryani in a large, clean casserole pan for which you have a tightly fitting lid. Lay half the stewed lamb at the bottom, top with half the rice and half the browned onions. Scatter over the mint leaves. Add the remaining lamb, then rice and finally the onions. Sprinkle the saffron–flower water over the top and dot with the ghee or butter.

To smoke, make a cup shape out of a square of tin foil and press it into the surface of the rice. Warm

the ghee or oil in a small pan over a low heat. If you have a gas stove, sit the lump of charcoal directly on the burner. (Alternatively, heat in the hottest oven.) Once the charcoal is glowing and smoldering, use metal tongs to carefully transfer it to the foil cup. Scatter some peppercorns into the tinfoil, and a few over the rice too. Pour the sizzling hot ghee directly onto the hot coal to release a gust of smoke, then clamp on the tight–fitting lid.

Set the pan over the stove briefly to warm the bottom. Transfer to the oven and cook for 25 minutes. Discard the charcoal and bring the biryani to the table in its pan.

## EAT WITH
Sizzling ginger raita (page 61)

Or double down on the smoke with Smoked yogurt. Put yogurt in a large bowl, fashion a tin foil cup in the middle, add a smoldering lump of charcoal and pour over hot ghee as for the biryani. Cover tightly and leave to smoke for 30 minutes. Stir in a pinch of salt.

FRAGRANT & FLORAL

# SLOW-ROAST LAMB WITH ADVIEH & FRAGRANT RICE

Serves 4–6

There is poetry to the ingredients in Persian advieh: nutmeg, cinnamon, rose petals, cardamon, cumin, coriander, black pepper. You can almost taste the words. Advieh comes from the Farsi for "spice" with roots in the Arabic word for "medicine" (adwiyeh), revealing the intertwined history between spices and health. The mix has many variations; the blend here combines sweet fragrance with a little earthiness lending a subtle, aromatic opulence to the lamb.

1.5kg (3lb 5oz) lamb shoulder, on the bone
400g (2 cups) basmati rice
Juice of a lemon
Large knob of butter
1–2 teaspoons rose water
3 tablespoons nibbed pistachios
2 tablespoons pine nuts, toasted
Handful mint leaves, finely shredded
Small handful dried rose petals

*FOR THE ADVIEH*
1 teaspoon freshly grated nutmeg
1½ teaspoons ground cinnamon
1 teaspoon dried rose petals
1 teaspoon ground cardamom
1 teaspoon ground coriander
½ teaspoon ground cumin
½ teaspoon ground black pepper
3 teaspoons flaky salt or 1½ teaspoons fine
  sea salt

Bring lamb to room temperature. Heat the oven to 200°C (400°F).

Mix together all the ingredients for the advieh. Sit the lamb in a roasting tin and rub the spice all over it. Pour 400ml (1½ cups) water into the bottom of the roasting tin and cover the whole thing with tin foil, making sure it is well sealed. Put in the oven and turn the temperature down to 170°C (340°F). Roast for 3½–4 hours. The meat should be soft, melting and sticky, almost falling from the bone so you can pull it apart with a fork.

Half an hour before the lamb is ready, wash the rice well and soak in water.

Remove the lamb to a plate and rest under its foil tent. Spoon off most of the fat from the roasting pan and scrape all the sticky bits into the pan juices, adding a splash of water if needed. Tip the flavorful juices into a measuring jug, add the lemon juice and top up to 625ml (2½ cups) with water. Pour into a pan along with the drained rice and lay a fat slice of butter on top. Bring to a rolling boil, then turn down the heat to the lowest setting and cover. Steam for 12 minutes, remove from the heat and sprinkle the rose water over the rice. Return the lid and leave to sit for 10 minutes.

Tip the rice onto a serving platter and gently fluff with a fork. Lay the lamb shoulder on top and scatter over the pistachios, pine nuts, ribbons of mint and a flourish of rose petals. Serve with garlicky yogurt.

# SAFFRON BEEF KEBABS WITH GRILLED SUMAC TOMATOES

Kabab barg ～～～～～～～～～～～～～～～～～～～～～～～～～ Iran

Serves 4

Opulent ingredients need only simple preparation. Here fine beef steak is marinated in saffron and its bitter-honeyed notes come through distinctly. The other spice at play is ground sumac berries, whose mouth-puckering, sour earthiness marries well with tomatoes.

Generous pinch of saffron
1kg (2lb 4oz) sirloin steak
1 small onion, roughly chopped
4 garlic cloves, peeled
1 teaspoon fine sea salt
½ teaspoon ground black pepper
Juice of a lime
4 ripe tomatoes, halved
Olive oil
1 teaspoon sumac

Soak the saffron in a tablespoon of hot water while you prepare the beef. Trim any excess fat from the steak and cut into 2.5cm (1 inch) cubes.

Put the onion, garlic, salt, pepper and lime juice in a blender. Add the saffron with its soaking liquid and blitz to a paste. Scrape this marinade onto the beef and leave to marinate for 30 minutes at room temperature (or up to 12 hours in the fridge but bring up to room temperature before cooking).

Scrape the excess marinade off the meat and thread the meat onto metal skewers, leaving a little space between each piece. Toss the tomato halves in the remaining marinade and drizzle over a little olive oil.

Heat a barbecue or large griddle pan to medium–high then brush with oil. Grill the meat, turning once, until cooked to your liking (around 5–7 minutes in total for medium rare). Cook the tomatoes at the same time until blistered and softened.

Rest the meat for 5 minutes. Sprinkle the tomatoes with sumac for a lemony tang. Wrap everything together in lavash bread, if you feel so inclined.

## EAT WITH

Lavash bread, thinly sliced onions, seasoned yogurt

Or basmati rice topped with a thick pat of butter, whole mint leaves

# ROSE & SAFFRON LASSI

Kesar lassi 〰〰〰〰〰〰〰〰 India

## Serves 4

Here we have a sweet yogurt drink, the sort so romantic and ambrosial, it could inspire poetry. Go gently with the spices and rose water, tasting as you add. We are after ethereal, not incense.

Pinch of saffron, crumbled
500g (2 cups) Greek-style (strained) yogurt
3–4 tablespoons caster sugar
4 green cardamom pods, seeds ground
1/2–2 teaspoons rose water
Ice (optional)
1 tablespoon pistachios, finely chopped (optional)

Soak the saffron in a tablespoon of hot water and leave to cool and infuse to a buttercup yellow.

Put the yogurt and sugar into a blender with 250ml (1 cup) icy-cold water. Add the saffron and most of the ground cardamom and rose water. Blend then taste for sweetness and fragrance, adding more sugar, cardamom and rose water to taste. Rose waters vary enormously in strength.

Blend again until a foamy cloud floats on the top. Pour into glasses and add ice and a sprinkle of pistachios on top, if you so fancy.

# ALMOND MILK FOR WRESTLERS

Thandal 〰〰〰〰〰〰〰 Pakistan and India

## Serves 2–4 (or 1 wrestler)

An invigorating drink enjoyed in the uncompromisingly hot summers of Pakistan and the northern states of India, and a favorite of wrestlers for its fortifying nuts and cooling properties. With no exertion expended, I love it for its licorice-kissed, caramel butteriness.

One or more "cooling" spices should be included —fennel, aniseed, cardamom or cumin. Black pepper brings a little balancing warmth and rose water adds fragrance.

150g (1 cup) blanched almonds
1 teaspoon fennel seeds
4 black peppercorns
2 tablespoons sugar
1/4 teaspoon rose water, or to taste (optional)

Put the almonds, spices and sugar into a heatproof bowl and cover with 500ml (2 cups) boiling water. Steep for 1 hour or more.

Transfer everything to a high-speed blender and blitz for 1–2 minutes to milky smoothness. Line a sieve with muslin and strain the almond milk into a jug. Squeeze the muslin to extract the last of the liquid. (The pulp can be saved for baking.)

Stir in the rose water, adding to taste as strengths vary hugely. You want just a floral hint.

Chill and serve in small glasses.

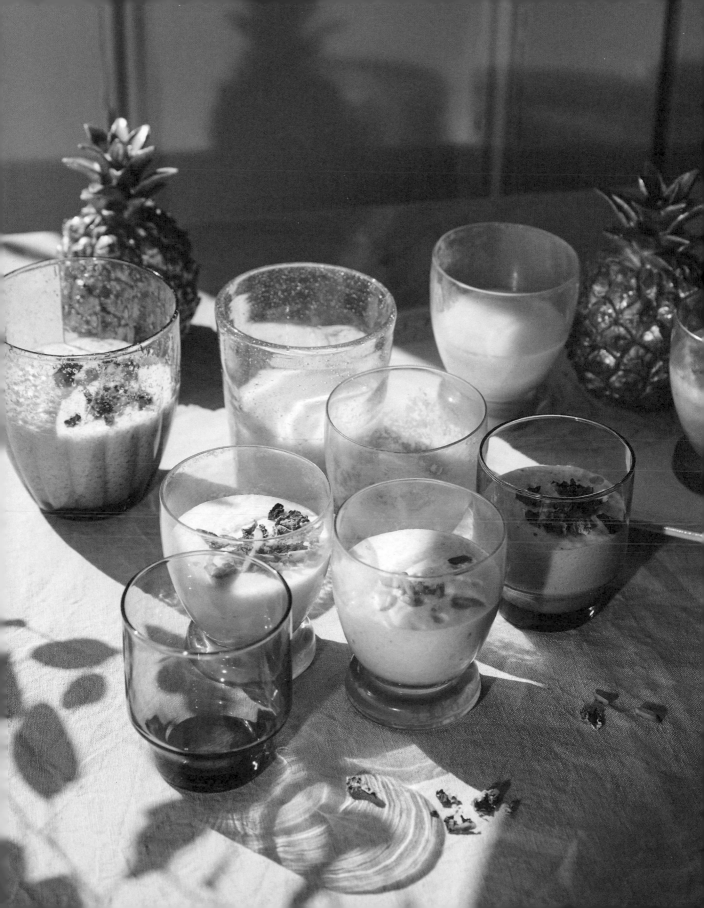

THE
FIERY
IMPORT

CHILIES

ARRIVE IN ASIA

It is a uniquely human trait to find enjoyment in the disquieting: a horror movie, looping rollercoaster or fierce chili that teeters just close enough to pain to bring pleasure.

## We are sensation seekers, hungry for adrenaline.

This addictive rush saw the chili fruit, whose heat is paradoxically designed to be aversive to animals, become the fastest spreading and most used spice on earth.

Spicy heat is a defining feature of much Asian cookery, but for millennia the food was considerably milder. Chilies only arrived from the New World in the sixteenth century, when the use of them was fervently adopted. The crop was well suited to the monsoon climate and was soon being cultivated locally, its fiery fruits finding their way into piquant broths, enlivening sambals and hot curries.

The blistering spice had been eaten in Central and South America since prehistoric times, but on New Year's Day 1493, Christopher Columbus "discovered" chili and so marked the start of its world domination. It was a search for valuable peppercorns that had lured the European explorer across the Atlantic to find a new route to the East, and throughout his life he always disclaimed his great discovery, insisting he had found India and pepper, not America and chili. He came to the conclusion that the world must be pear shaped, with the paradise spice lands on a protuberance shaped like a nipple on a woman's breast. Columbus returned to Spain with parrots and gold, "Indians" and "cinnamon" (in fact the rotten bark of a Caribbean tree). And

## chilies he named "peppers," to the confusion of generations to come.

Taken from the Americas to the Iberian Peninsula and West Africa, within decades chili had spread so rapidly and been received so enthusiastically that the origin was forgotten and it became widely regarded as a native plant in Asia. Six years after Columbus's discovery, Portuguese ships landed on India's Malabar Coast for the first time and the new spice soon became part of their cargo. Once in the Old World, it was absorbed into the regular spice shipments meandering across Asia and the Middle East. Hindu, Arab and Persian merchants took chilies from India to Indonesia. Moluccan and Papuan traders took them along the coast of New Guinea and they burned their way eastward throughout the Orient. By the mid-sixteenth century, chilies reached central China, this time overland from the Middle East and India. Ironically, chilies had to circle the world before being introduced to North America from Europe in 1692.

Pepper had long reigned as the hot spice but here was one that was easier to grow and store, and was hotter to boot. The seeds traveled easily and the plant was a weedy colonizer, hybridizing in new climates. People had never been able to grow black pepper in their gardens, but chili was an inexpensive spice they could grow for their own use.

This had the potential to turn the spice trade upside down. After its rapid spread, chili neither needed to be transported nor traded so had no real value. However, spice

production did not decline and nutmeg, ginger, cloves, cinnamon and pepper continued to sail the seas to the Middle East and Europe, where piquancy was never so warmly embraced and pepper proved quite hot enough. It was the cuisines of the original spice-producing nations that were most notably altered. Indian and Indonesian cooks were already hooked on heat from piquant pepper and rasping ginger, so took to chili right away. Within the lifetime of the conquistadors, chili had melded into these cuisines.

The New World held other vegetal riches too. There was tobacco to fuel addictions; vanilla to challenge cinnamon as the bakers' spice; quinine to protect travelers from malaria; and allspice, which, as its name hints, combines the tastes of all the fine spices in one berry. The Central American jungles yielded tomatoes, potatoes, corn, squash, cassava, papaya, pineapples, avocados, peanuts and cashews, and the Portuguese introduced them all to the world. It is hard to imagine Indonesian sate without peanut sauce, or Indian samosas without their chili-spiked potato filling. A fifteenth-century royal recipe from Malwa Sultanate has samosas stuffed with aubergine (eggplant) and minced meat scented with rose water and saffron, revealing the medieval taste for sweet and perfumed before the encroachment of chili fire.

Fervor for the fiery remains regional.

## A wide chili belt girdles the equator, spreading into the cuisines of the tropics.

Hotspots where dishes have an extreme kick include southern Thailand, southeast India, the Chinese provinces of Hunan and Sichuan, and the Indonesian island of Sulawesi. Linking them all is a starch-based diet to which chilies add much-needed flavor, color and zing.

Portuguese sea trade ignited a fire in Sri Lankan, Malaysian, southwest Chinese and southwest Indian cooking. In India, chili use in hot pickles and chutneys spread from Goa across the south. Only when the Maratha armies, renowned as particularly fiery fighters due to their chili consumption, challenged the Mughals did the north of India succumb and pepper was outgunned. From India, the fiery cooking marched across Myanmar into Thailand. Crossing the Himalayas, the entry point into China was landlocked Sichuan, where the food remains some of the hottest in the world and chilies can outnumber any other ingredient on the plate.

Korea now has the highest per-capita consumption of chili on earth, largely thanks to their indispensable, salty, funky, red-stained kimchi, yet chili only arrived on its shores in the seventeenth century (and other spices don't feature much in its cuisine, which relies more on fermented sauces for flavor). Though Japan had an early lick of chili heat during the Nanban trading period, it then largely closed its doors to foreigners and their imports for two hundred years and, as a result, chili doesn't feature in classic Japanese cookery. Chili use is growing in modern Japan and spreading into other countries not previously on the hot map, such as Germany and the Arab world. It is firing imaginations of a new generation of cooks just as it did when it first conquered Asia.

# CHILIES IN THIS BOOK

Two chili types dominate the Eastern world. There is the narrow-shouldered cayenne, which was the first species introduced to Asia and has become the most used in the world, and the fierier bird's eye. Different varieties have evolved in different regions, but these are the chilies I use in this book:

## FRESH

### RED OR GREEN CHILIES

Large, firm and glossy, used for color and flavor as well as mild–medium heat. A cayenne or finger chili is the best choice

### BIRD'S EYE CHILIES

Small and more potent bird's eye or Thai chilies are there for their fruity, peppery heat. Indonesian cooking will often use the larger and smaller chilies in tandem.

## DRIED

### KASHMIRI CHILIES

Dried, crinkly Kashmiri chilies have a sweet earthiness and are a beautiful bright red. Used both whole and powdered in Indian cooking, they bring more color and flavor than heat

### DRIED CHILIES

Usually a cayenne or sometimes Thai variety, dried chilies have a ruddy, earthy heat and bring smoky depth to cooking. They can be used whole, in flakes or ground

### GROUND CHILI

Watch out for Mexican chili powders, which can include a blend of spices. In Asian cooking, ground chili should be pure. Heat varies wildly, so taste yours and adjust quantities accordingly.

# CRUNCHY GREENS WITH ROASTED CHILI JEOW

Jeow mak len ～～～～～～～～～～～～～～～～～～～～～～～～～～ Laos

**Serves 4**

Two New World foods, unknown in South East Asia a few hundred years ago, have been enthusiastically embraced: chilies and tomatoes. Here they are combined in a salsa–like Laotian sauce, their tastes intensified and made smoky by roasting. This can be done either over flames, threading the vegetables onto skewers and turning over the heat until charred, or in a hot oven. There are no quiet flavors, rather acidic heat interrupted by the impolite, salty oomph of fish sauce.

Use the jeow either as a dipping sauce for crunchy vegetables or to serve alongside meat, fish or tofu with a scoop of sticky rice. Chili heat can vary hugely, even within the same variety. I have listed six bird's eyes, which will make a pleasingly fiery sauce. If your chilies are especially hot or your tolerance is lower, remove the seeds or scale back the number of chilies accordingly.

### FOR THE JEOW
300g (10¹/₂oz) ripe tomatoes, quartered
6 bird's eye chilies
2 spring onions (scallions), trimmed
4 garlic cloves
3 small shallots
¹/₂ teaspoon fine sea salt
2 tablespoons fish sauce or vegetarian fish sauce
1 tablespoon lime juice
Large handful cilantro, chopped
1 teaspoon sugar (optional)

### CRUNCHY VEG TO SERVE, SUCH AS:
**Fine green beans, blanched**
**Romaine (cos) lettuce leaves**
**Cucumber wedges**
**Daikon sticks**
**Raw Thai aubergines (eggplants), quartered**

Heat the oven to 210°C (410°F).

Tumble the tomatoes, chilies and spring onions onto a large baking sheet (no oil needed). Add the unpeeled garlic and shallots. Roast for 20 minutes, or until vegetables are softened and blackened in spots. If your tomatoes were a little firm and so haven't yet slumped enough, roast them for another 10 minutes. Peel and discard the garlic and shallot skins and chili tops, keeping all or some of the chili seeds, depending on your tolerance for heat.

Transfer everything into a food processor with the salt, fish sauce, lime juice and cilantro. Blend to a roughly textured purée. Taste for seasoning—a little sugar may help intensify the flavors.

If possible, make a few hours in advance for the flavors to get to know each other. Chill if making further in advance, but try to lose the chill of the fridge before eating. Serve the jeow in a bowl alongside a platter of crunchy greens.

## EAT WITH
Jasmine or sticky rice

Barbecued lemongrass skewers (page 170)

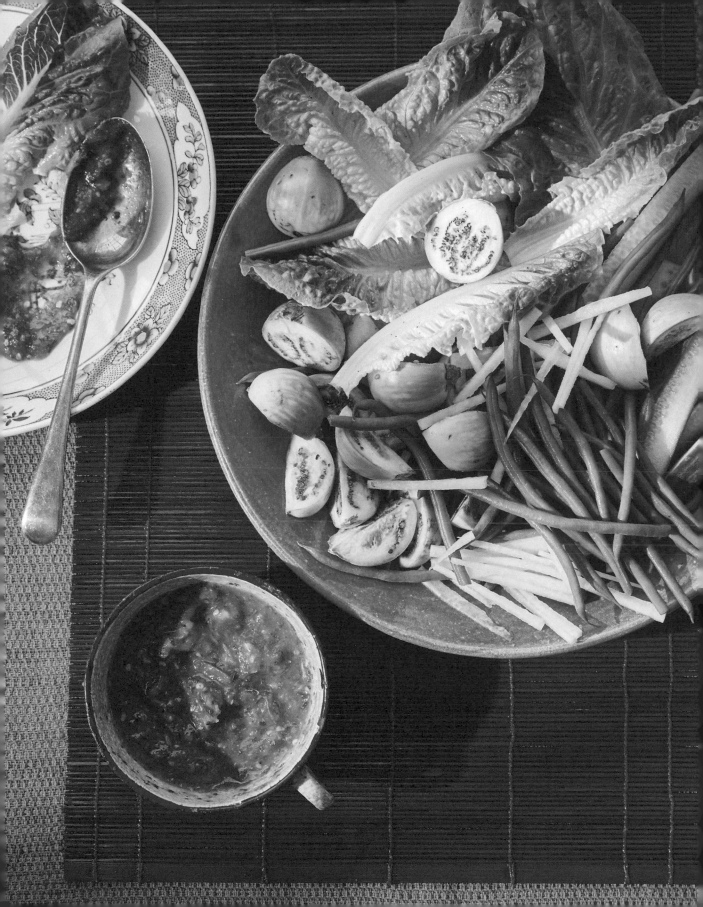

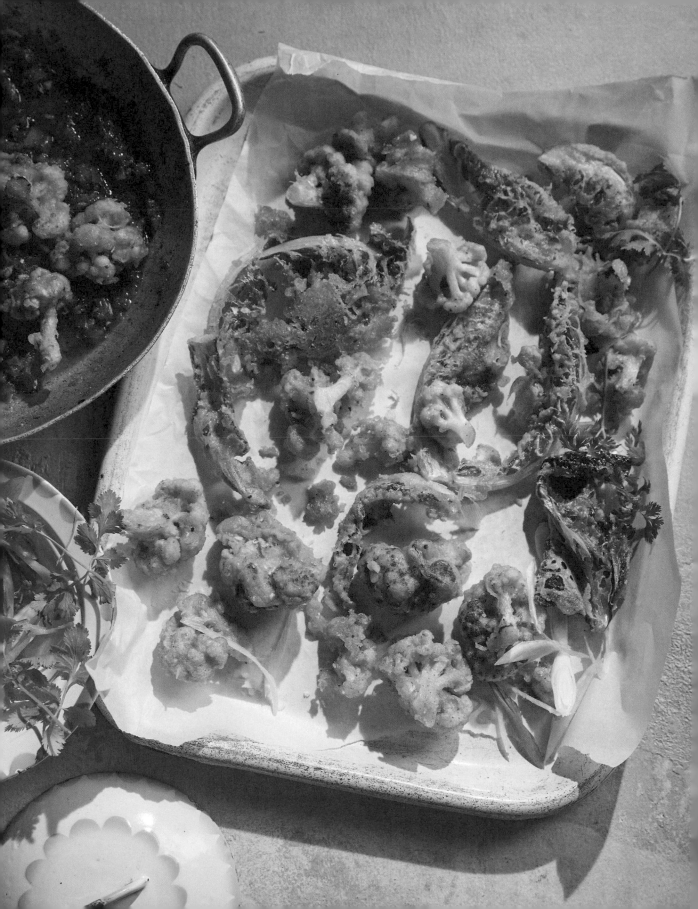

# GOBI CHILI

Gobi chili ～～～～～～～～～～～～～～～～～ Indo-Chinese

Serves 4 as a side

Indian and Chinese cuisines have a long history of fusion. Geography and millennia of trade have created blurring at ports and borders. There are many dishes showing this dual influence across the Malay Archipelago, the merchant seafaring route between the two great nations. Another source was Chinese immigrants to Calcutta (now Kolkata) at the time of the British Raj, who opened restaurants blending their lighter Cantonese cooking with the loud flavors and spicing of their new home. Deliciously greasy, spicy "Manchurian" dishes, such as gobi chili, are now restaurant and street-food favorites in cities across India and Bangladesh. Paneer became Sichuan paneer, aloo bhindi became kung pao potatoes, chow mein became a national obsession. This dialed-up style traveled overseas to countries including the UK and USA, shaping the global view of Chinese food.

500g (1lb 2oz) cauliflower
Neutral oil, for frying
1 onion, chopped
4 garlic cloves, minced
3cm (1½ inches) ginger, peeled and minced
   (1 tablespoon)
2 green finger chilies, seeds in, sliced
2 tablespoons Indian chili tomato ketchup
   or sweet chili sauce
2 tablespoons light soy sauce
1 tablespoon rice vinegar
2 spring onions (scallions), finely sliced
   at an angle
Handful cilantro leaves

*FOR THE BATTER*
75g (½ cup) plain flour
75g (2½oz) cornstarch
3 garlic cloves, minced
1 teaspoon Kashmiri chili powder
¾ teaspoon fine sea salt
Grinding of black pepper

Cut the cauliflower into bite-sized florets, using the leaves too if you like. Bring a pan of salted water to a rolling boil, add the cauliflower and boil for 3 minutes. Drain and ensure the florets are dry.

Combine all the ingredients for the batter. Add 170ml (⅔ cup) water and whisk to make a smooth, coral pink batter with a good coating consistency.

Fill a frying pan to 3cm (1¼ inches) with oil and set over a medium–high heat. Drop a blob of batter in and when it rises to the top and starts to bubble, you are ready to fry (or measure to 190°C/375°F). Work in batches, dipping the florets into the batter and frying for 5–10 minutes until crisp and golden. Turn occasionally with a slotted spoon to stop them from sticking, then remove onto a paper towel.

While the cauliflower is frying, heat a tablespoon of oil in a clean frying pan. Add the onion and cook over a medium heat until soft and translucent. Add the garlic, ginger and chili and continue cooking until fragrant. Add the chili sauce, soy sauce and vinegar. Add a good splash of water and bubble for a couple of minutes until the sauce has thickened to a light glaze. Taste for seasoning.

Toss the cauliflower in the sauce. Serve right away while still crisp, scattered with spring onions and cilantro.

# GUNPOWDER OKRA

Brinjal podi ～～～～～～～～～～～～～～～～～～～～～～～～～ India

## Serves 4 as a side

Gunpowder is an explosive chili spice blend from South India, also known as podi. Typically mixed with sesame oil or ghee and served alongside dosas or idli, it can add nutty oomph to just about anything. Try it sprinkled on lamb chops, stirred through buttery rice or shaken over french fries. Here it coats green stars of okra, fried until tender-crisp.

350g (12oz) okra
3 tablespoons neutral oil
1 onion, chopped
2 garlic cloves, minced
1cm (½ inch) ginger, peeled and minced
    (1 teaspoon)

*FOR THE GUNPOWDER*
3 dried Kashmiri chilies (10g/¼oz)
1 tablespoon urad dal
1 tablespoon chana dal
2 teaspoons white sesame seeds
1 tablespoon neutral oil
20 curry leaves
1 teaspoon black peppercorns
¼ teaspoon asafoetida
Pinch of salt

For the gunpowder, heat a dry frying pan over a medium–high heat. Toast the chilies for about 1 minute then transfer to a plate and snip into pieces, keeping the seeds in. Add the urad dal and chana dal to the pan and toast for a few minutes, until lightly browned all over and smelling nutty. Tip onto the plate. Do the same with the sesame seeds. Finally, add the oil to the pan and fry the curry leaves for just a moment, to crisp and curl. Drain on a paper towel.

Grind all the ingredients for the gunpowder together with a pestle and mortar or in a spice grinder. Take it only as far as a rubbly powder, stopping before the oils come out or it will start to turn to a paste. Taste for salt.

Prepare the okra by slicing into thick rounds. It should be dry to prevent sliminess, so make sure it has no moisture clinging to it. (Fresh okra is better than frozen for this reason.)

Heat 2 tablespoons of the oil in a frying pan over a medium–high heat. Cook the onion until soft and starting to brown. Add the garlic and ginger and cook for a minute longer. Turn the heat down to medium and pour in the last tablespoon of oil. Add the okra and fry for around 5 minutes, stirring often, until the okra is bright green, tender-crisp and just starting to char at the edges. Toss through the gunpowder and serve at once.

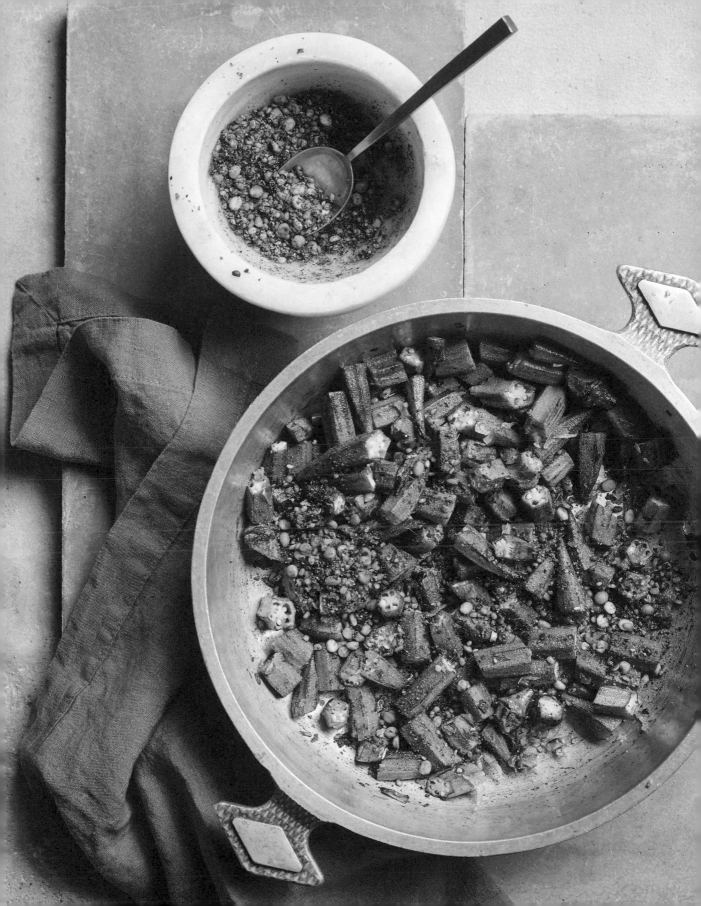

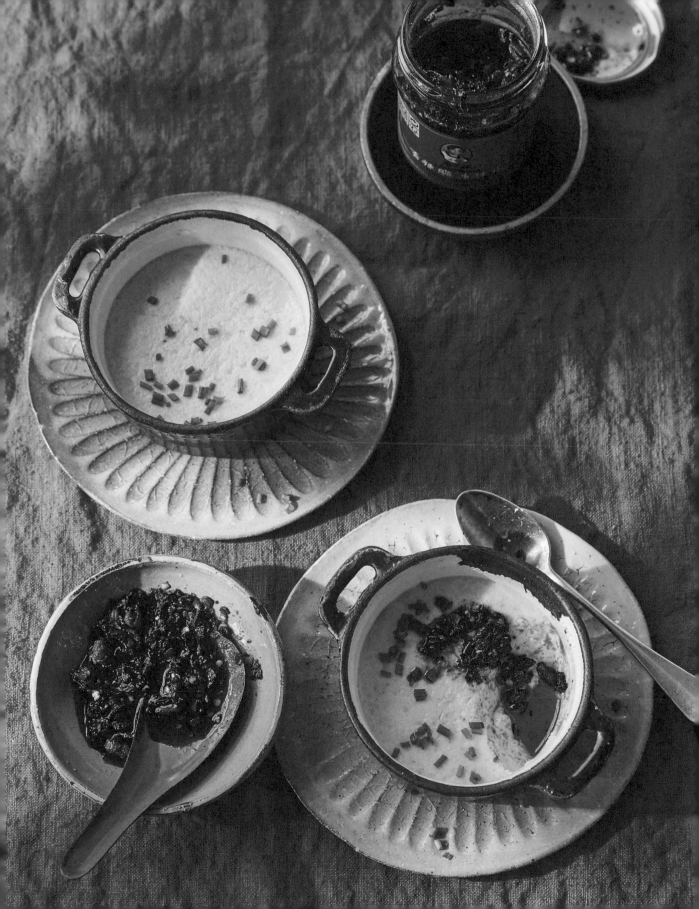

# STEAMED EGG CUSTARD WITH CRISPY CHILI OIL

Zheng shui dan ～～～～～～～～～～～～～～～～～～～～～ China

**Serves 2 as a snack**

Crispy chili oil is a festival of heat, crunch and umami, and a condiment I implore you discover immediately if it isn't already in your arsenal. Lao Gan Ma is the most popular brand in China (literally "old godmother" and you'll spot the jar by her face) and has dried chili mixed with fermented soya beans and crisp fried onion. Alternatively, there is Chiu Chow chili oil, which has a soft-textured, salty mix of preserved chilies and huge quantities of fried garlic. The eggs here are really just a vehicle for the chili oil, but it is a great Chinese home cooking technique to have up your sleeve as they are quick to make and have the satisfying smooth, creamy wobble of panna cotta.

2 large eggs
1 teaspoon light soy sauce
A few chives, snipped
Crispy chili oil

Break the eggs into a measuring jug and beat well without frothing. Note the volume and add one-and-a-half times as much warm water (probably around 150ml/generous ½ cup). Whisk in the soy sauce.

Pour the egg mixture through a fine sieve into two small rice bowls or ramekins. Cover with foil or saucers and put into a steamer set over already-boiling water. Cover and steam for 10–14 minutes, until the eggs have just set to a delicate custard.

Serve warm, topped with a scattering of chives and anointed with crispy chili oil.

*SICHUAN SPICED CHILI OIL*
**Makes 200ml (generous ¾ cup)**

If you'd prefer to make your own oil, here is a great one where Sichuan peppercorns lend a pricking, tingling heat and the black cardamom brings a resinous depth.

Note, without the garlic, the oil will keep for months. With the garlic, you should store in the fridge and use within a few days.

2 teaspoons Sichuan peppercorns
200ml (generous ¾ cup) neutral oil
   (such as groundnut/peanut)
2 tablespoons Sichuan chili flakes
2 teaspoons sesame seeds
2 black cardamom pods, bruised
½ teaspoon fine sea salt
2–4 garlic cloves, minced (optional)

Grind the husks of the Sichuan peppercorns to a rough powder using a pestle and mortar (discard any of the shiny black seeds).

Put all the ingredients in a small saucepan and set over a very low heat. Cook gently for around 10 minutes. Toward the end it should be quietly sizzling and everything lightly toasted and a pale golden.

Leave to cool, then transfer the oil along with the sediment to a glass jar and seal.

# CHONGQING HOT GLASS NOODLE BROTH

Suan la fen ～～～～～～～～～～～～～～～～～～～～～～～～～～～～ China

Serves 2

One can't consider chilies without visiting Sichuan, China's spiciest region. It was here that the fruits first blazed into the country having crossed over the Himalayas, and here where they are used most keenly, combined with the piquancy of native Sichuan peppercorns.

This lip-puckering hot-and-sour broth comes from the city of Chongqing, also famous for eye-wateringly fiery hotpots. Sweet potato noodles are made fresh by Sichuanese vendors, who pass batter through sieve-like holes directly into boiling water, but can be bought dried in Chinese supermarkets. Seek them out for their glorious, slippery transparency, which makes an agreeable contrast to the riot of crunchy toppings.

This is good made with Sichuan spiced chili oil (page 137), in which case you can omit the sesame seeds but keep in the garlic, even if you've added it to the oil.

250g (9oz) sweet potato noodles
350ml (scant 1½ cups) unsalted vegetable
  or chicken stock

### FOR THE SEASONINGS
2 garlic cloves, finely chopped
2 tablespoons Chinese chili oil, plus
  1 tablespoon sediment
2 tablespoons chinkiang black vinegar
2 tablespoons light soy sauce
1 teaspoon toasted sesame seeds
½ teaspoon roasted, ground Sichuan pepper

### FOR THE TOPPINGS
1 tablespoon neutral oil
2 tablespoons raw red-skinned peanuts
1 spring onion (scallion), sliced
⅓ celery stalk, finely chopped
2 teaspoons zhaicai (pickled mustard stems),
  chopped
Small handful cilantro leaves

Cook the sweet potato noodles following packet instructions. It may suggest presoaking overnight but this can be fast-tracked to a few minutes using warm water, if needed. When tender and slippery, drain and rinse. Set aside.

Prepare your toppings. Heat a wok over medium–high heat, add a slug of oil and when shimmering, add the peanuts. Stir-fry for 30 seconds, then reduce the heat to low and continue to fry, stirring often, until the nuts are a deep golden brown. Remove with a slotted spoon and drain on a paper towel.

Divide the seasonings between two serving bowls. Heat up the stock and pour half in each, stirring to mix. Add the noodles.

Sprinkle the toppings over and eat at once.

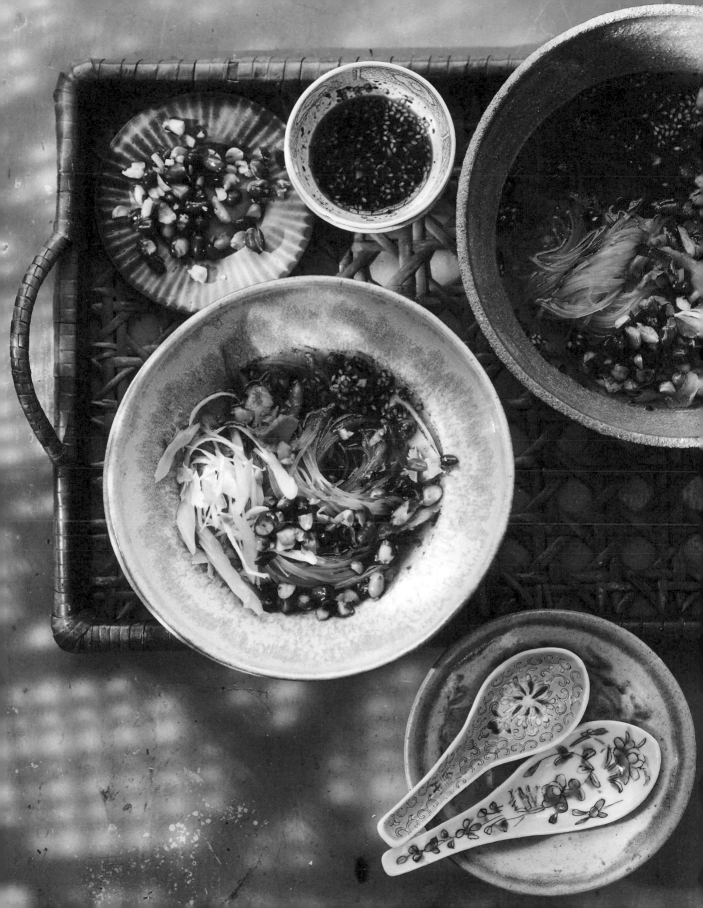

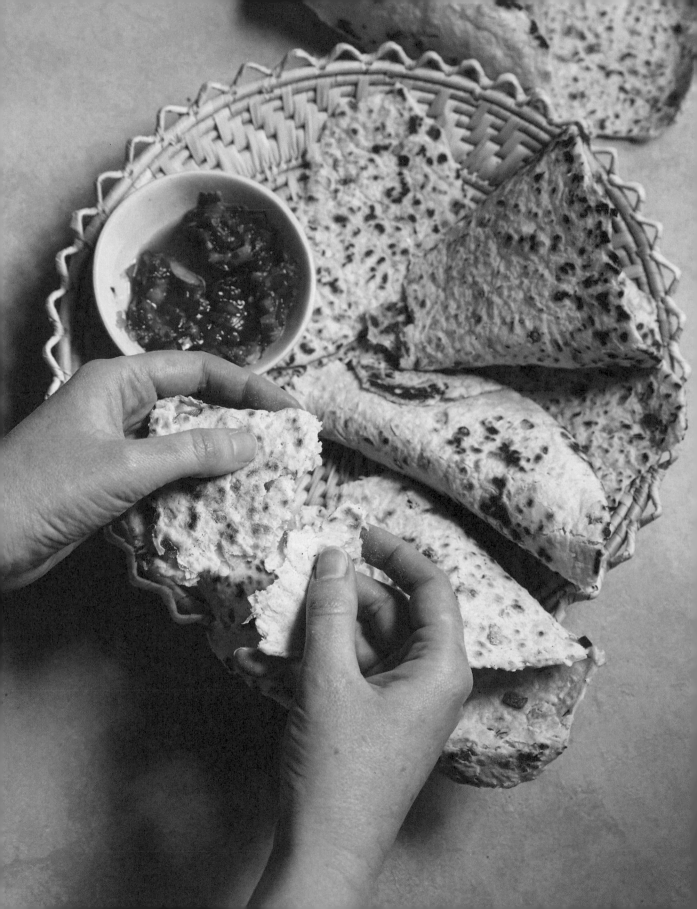

# COCONUT & GREEN CHILI FLATBREADS

Pol roti ~~~~~~~~~~~~~~~~~~~~~~~~~~~~~~~~~~~~~~~~~~~~~~~~~~~~~~~~~~~~~~ Sri Lanka

Makes 6

These soft, bouncy unleavened breads are big on flavor and incredibly easy to make. Grated coconut adds texture as well as milky tenderness to the dough. If you have spare coconut milk to hand, a splash in place of some of the water will give extra richness and delicacy.

325g (11½oz) plain flour
75g (1 cup) grated coconut or rehydrated
  desiccated coconut
2 green chilies, seeds removed, finely sliced
½ small red onion, finely chopped
1 teaspoon fine sea salt
Neutral oil, for brushing

Mix all the ingredients in a large bowl. Pour in 200ml (7fl oz) water and use a fork or your fingertips to bring everything together. Knead briefly to make a soft and elastic dough that doesn't stick to the bowl. Add a little extra flour if it is too sticky.

Form into a ball and cover with a tea towel. Rest for 30 minutes or more in a warm place.

Oil your work surface and rolling pin. Divide the dough into 6 balls and roll each into a circle or elongated oval about 3–4mm (⅛ inch) thick.

Heat a frying pan over medium–high heat and cook each roti for about 3 minutes on each side, until blistered in spots. Wrap in a tea towel to keep soft and warm while you make the rest.

## EAT WITH
A good partner for curries

Or try with the Sri Lankan chili paste Lunumiris: Grind a chopped red onion with 1 tablespoon chili flakes, ½ tablespoon Maldive fish, the juice of ½ a lime and salt to taste.

# GREEN COCONUT HOT SAUCE

Basbas qumbe ～～～～～～～～～～～～～～～～～～～～～～～～～～～～ Somalia

Makes a jarful

Somalia, the easternmost point of the Horn of Africa, was an important hub of the early spice trade. The Romans called it "Cape Aromatica" for its aromatic resins, frankincense and myrrh. Centuries of traders ploughing its shores has left a cuisine influenced by Arabia, India, Turkey and Italy.

Spices are key to the food, especially African cardamom but also nutmeg, cinnamon, ginger, fenugreek and cumin. Somalis also like their food hot, using chili sauces served on the side so the diner can dial up the fire to their liking. Do look out for a source of Somali-made basas (chili) sauces as the flavor combinations, such as date, tamarind and green chili, are superb. Here is a coconutty green one that lends itself to being made fresh. It is reminiscent of South Indian chutneys, but here chili is the star.

100g (3½oz) green chilies
20g (¾oz) cilantro leaves and stems
1 small onion
1 garlic clove
3 tablespoons neutral oil
Juice of a lemon
1 tablespoon white vinegar
1 teaspoon fine sea salt
½ teaspoon sugar
40g (½ cup) grated coconut or rehydrated desiccated coconut

If you like fire, leave the chili seeds in, otherwise you can remove some of the seeds and the surrounding membrane. Roughly chop the chilies, cilantro, onion and garlic. Transfer to a blender with the oil, lemon juice, vinegar, salt and sugar. Blend to a green-flecked paste.

Stir through the coconut and taste for seasoning.

This will keep in a jar in the fridge for up to 5 days and the heat will mute a little with time.

## EAT WITH
Grilled fish, chicken or vegetables, dry-rubbed with xawaash spice mix

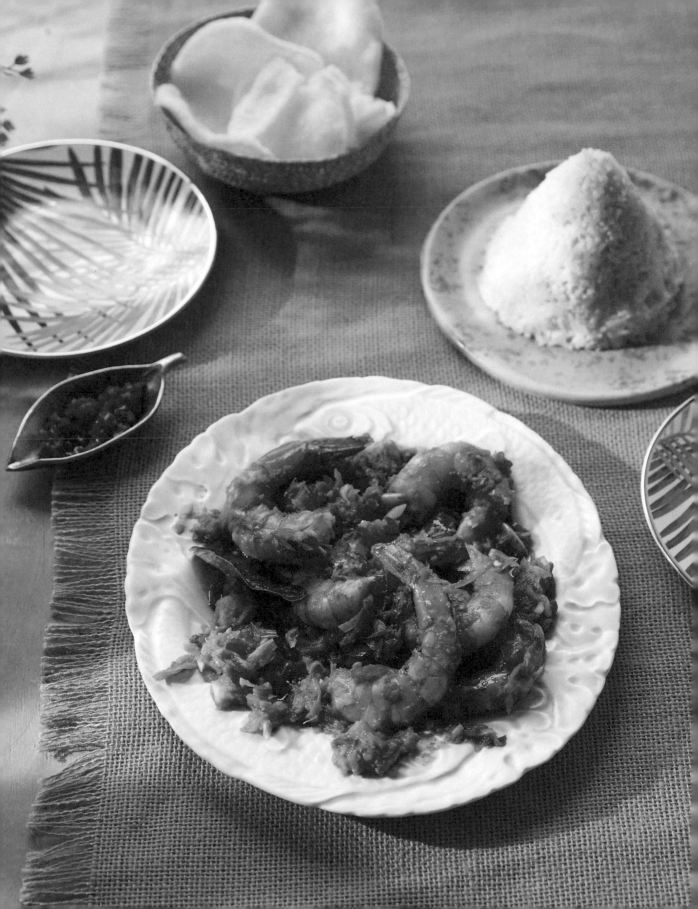

# RICA RICA PRAWNS

Udang rica rica ～～～～～～～～～～～～～～～～～～～～～～～～～～～ Indonesia

Serves 4

One of the chili hotspots of the world is Northern Sulawesi. Here fragrant lime leaves, lemon basil and extreme use of chili typify the food, for heat that hits you with shouts, not whispers. Spice pastes are often used in one-to-one ratio with the quantity of meat or seafood. Rica rica is the signature cooking style, the "c" pronounced "ch" as in "chili," which is also what the word means. Stoke the fire to your taste, by all means scaling up the bird's eyes. These are for heat; the seeded larger chilies are there for flavor. Other chili-seafood dishes of the wider region to explore include prawn sambal (Indonesian versions tends to be more tomatoey than the salty-sweet Malay renditions), Singapore chili crab (hands-on eating with a rich, sweet red sauce), and the prized spanner crabs of the Philippines island of Mindanao, doused in spicy coconut milk red-stained by annatto.

2 tablespoons neutral oil
3 tomatoes, chopped
100g (3½oz) spring onions (scallions), chopped
4 lime leaves, vein removed
½ teaspoon sugar
360g (13oz) raw peeled prawns, tails intact
Squeeze of lime

*FOR THE SPICE PASTE*
5 large red chilies, seeds removed
1–4 bird's eye chilies, seeds in (optional)
4 small shallots
4 garlic cloves
5cm (2 inches) ginger, peeled
½ teaspoon fine sea salt
Juice of a lime

Roughly chop the aromatics for the spice paste and blitz all the ingredients together in a blender to a rough paste.

Heat the oil in a frying pan or wok and scrape in the spice paste. Fry on a medium heat, stirring often, until it is sweetly fragrant and the harsh, raw edge has gone. Stir in the tomato, spring onion, lime leaves and sugar and cook so the tomato starts to break down to a sauce.

Add the prawns and simmer for about 5 minutes, until they lose their glassiness and are just cooked through and pink. Spritz in some lime juice and taste to see if any of the flavors need balancing — add more lime to brighten, or sugar and salt as needed. Serve at once.

## EAT WITH

Yellow coconut rice (page 234) for a good color contrast

You may also like a Sour-and-spice pineapple relish: Peel, core and chunk a small pineapple. Chop 2 red chilies, removing the seeds, then grind to a rough paste with 1 tablespoon sugar and ½ teaspoon salt. Loosen with 1 tablespoon vinegar and stir through the pineapple. Leave to sit for 15 minutes for the flavors to mingle.

# DEVIL'S CURRY

Curry debal ～～～～～～～～～～～～～～～～～～～～～～～～～～～～ Malaysia

**Serves 4**

It is no wonder this fiery chicken curry, laden with so many dried chilies, it is stained flame orange, got the name "devil." In fact, it is a culinary misnomer that has stuck in this Malaysian dish from the Portuguese Eurasians of Malacca. "Debal" actually means "leftovers" in the local Kristang language and once this was a dish saved for Christmastide, a spicy way with festive leftovers.

Located midway on the straits that linked China to India, Malacca was long one of the most important trading ports in Asia. It attracted a cosmopolitan mix of Chinese, Arab, Persian, Javanese and Indian traders, joined by the Portuguese when they took over in 1511. They soon married locals as the long sea journey from Europe tended to be a one-way trip and was only made by men.

The vinegar tang that offsets the heat is a defining feature of Portuguese Eurasian cooking, as are dried chilies, which give smoky complexity to food. You can see a relationship to Goa's piquant vindaloo (Goa being another Portuguese trading outpost). If you have curry debal made by the Portuguese community in Singapore, it is more likely to be pork-based and served with sausages.

I have given a wide range of chili quantity for this dish as they vary so much in heat, even within the same variety. I find 30 dried Thai bird's eye chilies perfect, but the ones I use are not too densely packed with seeds and have only a medium heat. If yours are spicier, scale back accordingly so you get flavor rather than pure fire.

3 tablespoons neutral oil
1 teaspoon brown mustard seeds
8 skinless bone-in chicken thighs
800g (1lb 12oz) potatoes, peeled and cut
    into chunks
1 lemongrass stick, smashed
1 teaspoon fine sea salt
1 teaspoon sugar
2 tablespoons white vinegar

*FOR THE SPICE PASTE*
15—30 medium-heat dried chilies (such as Thai)
100g (3¹/₂oz) shallots
6 garlic cloves
1 lemongrass stick, tender heart only,
    thinly sliced
3cm (1¹/₄ inches) ginger, peeled (1 tablespoon)
3cm (1¹/₄ inches) galangal, skin scrubbed
    (1 tablespoon)
1cm (¹/₂ inch) fresh turmeric or ¹/₂ teaspoon
    ground turmeric
3 candlenuts or 6 blanched almonds

For the spice paste, soak the dried chilies in hot water for 30–60 minutes to soften. Drain and remove any stems but keep the seeds in. Transfer to a blender with the remaining ingredients. Blitz to a rough paste, adding a little neutral oil and a splash of water if needed to help the blades turn.

Heat the oil in a large pan or casserole and add the mustard seeds. When they start to splutter and pop, scrape in the spice paste and cook over a medium–low heat, stirring frequently, for about 10 minutes until softened and fragrant.

Add the chicken to the pan, turning it in the spice paste, and cook for a couple of minutes. Add the potatoes, whole lemongrass and just enough water to nearly cover. Season with the salt and sugar.

Bring to the boil then turn down the heat, cover with a lid and simmer for 30 minutes, or until the potatoes are tender and the chicken cooked through. You are after a thin gravy rather than a coating sauce, but if it is too thin, remove the solids to a plate with a slotted spoon then bubble uncovered to reduce. Stir in the vinegar, cook for a minute longer then taste for seasoning. Too spicy? Calm with more vinegar and sugar. Too flat? Add salt and vinegar.

This dish benefits from sitting for a few hours, or overnight, to develop the flavor and round out the heat of the chilies.

## EAT WITH

Steamed rice, roti, fried peanuts, sliced chili for those who like it hot, and a cooling cucumber salad

# PORK SHOULDER VINDALOO

Vindaloo 〜〜〜〜〜〜〜〜〜〜〜〜〜〜〜〜〜〜〜〜〜〜〜〜〜〜〜〜〜〜 India

Serves 3—4

An assertive, almost pickle-sour braise resulting from three continents' ingredients and ideas coming together. It is notably not, however, the vindaloo that has evolved in British Indian curry houses, which holds the dubious honor of being the hottest dish on the menu. Here, the intensely red masala comes from Kashmiri chili powder, which brings more in color and flavor than heat.

The dish is from the Catholic community of Goa, with roots in a Portuguese pickled pork dish called carne de vinho e alhos. Fifteenth-century spice-seekers from Portugal brought the notion to India, where it acquired local spices. Another key addition were chilies, also newly imported by the Portuguese from the Americas. It is a dish forged in a time of empire building and appropriation, but emerges as an exemplar of integration.

Choose a slightly fatty cut of pork for unctuous results, and make a day ahead if you can. This will allow the flavors to mellow and mingle.

500g (1lb 2oz) pork shoulder, cut into 3cm (1¼ inch) chunks
3 tablespoons neutral oil
2 large onions, finely sliced
3 medium ripe tomatoes, chopped
2 teaspoons tamarind paste
2 teaspoons jaggery or brown sugar

*FOR THE SPICE PASTE*
4 teaspoons Kashmiri chili powder
1 teaspoon fine sea salt
¾ teaspoon ground cumin
¾ teaspoon ground coriander
¾ teaspoon black mustard seeds
½ teaspoon ground black pepper
½ teaspoon ground cinnamon
½ teaspoon ground turmeric
4 cloves
4 green cardamom pods, seeds only
4 garlic cloves, minced
3cm (1¼ inches) ginger, peeled and minced (1 tablespoon)
60ml (¼ cup) wine vinegar

Mix together all the ingredients for the paste in a bowl. Toss in the pork, staining it brick red, and marinate for 2—3 hours, or overnight in the fridge.

Over a medium heat, warm the oil in a casserole pan and fry the onion until soft and pale golden. Add the pork and its marinade and cook, stirring frequently, for 5—10 minutes until the spice paste starts to brown.

Stir in the tomatoes, tamarind and jaggery. Loosen with a small splash of water. Bring to a bubble then cover and turn the heat right down. Simmer for 1 hour or more, stirring occasionally. The pork should be tender and the masala thick and clinging —partially remove the lid toward the end of cooking if it needs to reduce. Rest before serving or make in advance.

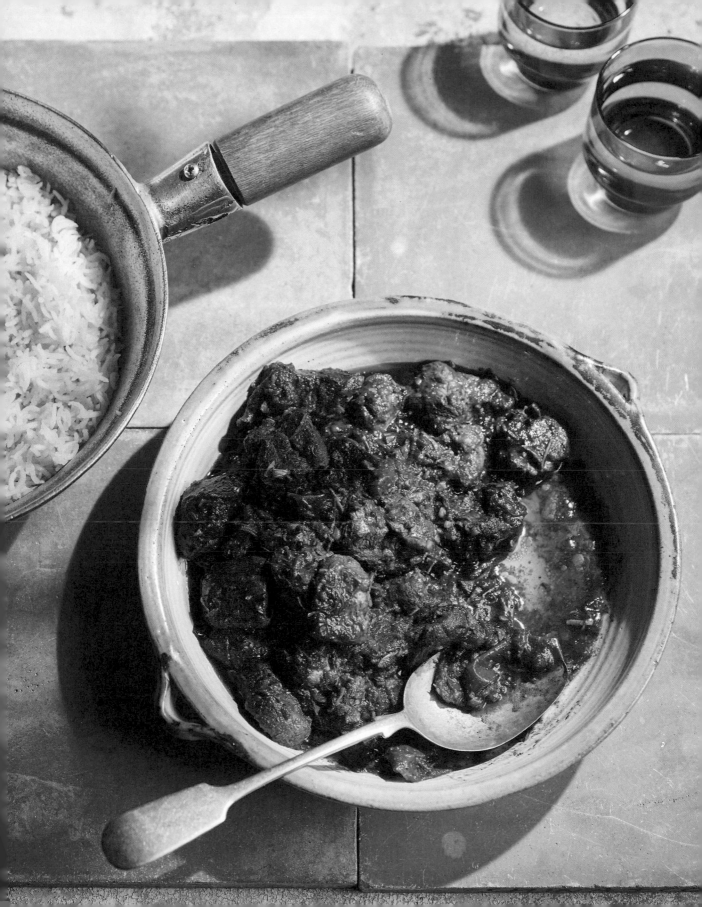

# MASALA BUTTERMILK

Masala chaas 〜〜〜〜〜〜〜〜〜〜〜〜〜〜〜〜〜〜〜〜〜〜〜〜〜 India

Serves 2—4

Savory yogurt drinks have a sweeping culinary reach, mainly across the Islamic world. At the simplest and most refreshing is ayran, yogurt lightly salted and thinned with iced water. It is drunk in Turkey, the Middle East and Central Asia, a perfect pairing for kebabs. To transform it to Iranian doogh, add mint, or a pinch of ground cumin to make a South Asian lassi. Or up the ante on the spicing and head to southern India for buttermilk.

With its refreshing blend of cooling yogurt and fire-fanged chili, this is served on hot days or as a palate cleanser mid-feasts. Buttermilk goes by many names, including chaas and sambhaaram. The lactic tang originally came from the liquid left after churning cream to butter but yogurt is a substitute often used today.

Black salt, toasted cumin, ground fennel seeds or cracked peppercorns are all possible additions to consider.

500g (2 cups) yogurt
1 green finger chili, seeds in, chopped
2.5cm (1 inch) ginger, peeled and chopped
2 small shallots, chopped
Generous pinch of salt
Ice (optional)

*FOR THE TOPPING (OPTIONAL)*
Neutral oil, for frying
6—12 curry leaves

Heat a splash of oil in a small frying pan and fry the curry leaves for just a moment until they frizzle and crisp. Drain on a paper towel.

Put all the ingredients for the buttermilk in a blender with 100ml (scant ½ cup) cold water. Blitz. Strain into glasses and top with the crisped curry leaves.

LEMO

LIME
LEAVES
&
NGRASS

FRESH

SPICE PASTES

While dried spices lend themselves to long-distance boat journeys, in the tropics flourish fresh rhizomes, roots, stems and leaves that harness

**intense fragrance and bright camphorous notes.**

Fresh spice pastes lay the foundations of South East Asian cookery, with the highly sought dried spices of the region playing a smaller role in local cooking.

In a crude way that neglects the nuances of a vast region's gastronomies, one can divide South Asian from South East Asian cooking techniques by the use of spice: dried blends versus fresh pastes. A typical South Asian dish might start with a spluttering of mustard seeds followed by frying a duo of garlic and ginger, then a medley of dried spices and chilies to create the complex foundation on which to lay vegetables or protein. If a wet masala is used, it will likely still contain dried spices. Across much of South East Asia, a dish starts by grinding together a paste of garlic, shallot, galangal, ginger, chili, turmeric and lemongrass. The aromatic base can be taken in many directions with small tweaks—perhaps to a Thai curry paste, green with cilantro and lime zest; or an Indonesian bumbu, with a salty hit of shrimp paste and candlenuts for body; or maybe a Malay rempah, given a smoky edge by the addition of dried chilies.

To make a spice paste, start by finely slicing fibrous ingredients like lemongrass and galangal, then roughly chopping everything else. The ingredients then need to be pounded or blended together to form an even but texture-flecked slurry. Most cooks agree that using a pestle and mortar gives superior results to a blender because the grinding, as opposed to finer and finer chopping of the blades, extracts more flavor, Unlike dry grinding, where a pounding motion is used, for wet pastes rocking and rolling is better. You can still make a great paste in a high-speed blender with none of the arm ache, though you may need to add a little oil, water or coconut milk to help the blades do their work.

The next step is frying the paste and this should be done in a generous amount of oil to unlock the flavors. Use a moderate heat as you want to tease out the fragrance of the spices, not caramelize them. Oil starting to rise to the surface shows it is time to move onto the next stage. This might be adding coconut milk, its virgin whiteness instantly spice-stained red or gold, then infusing a new layer of seasoning with whole spices: lemongrass, lime leaves, slit chilies or ginger slices. These add fragrance and brightness to dance on top of the heat, pungency, depth and resonance imbued by the paste.

Some dishes switch around the method. Sumatran beef rendang is singular as the cooking passes from braising to frying in the same pan, like a casserole made backward. Meat is simmered in a raw spice paste and rich coconut milk; as the liquid reduces, the beef starts to sizzle and brown in the coconut oil left behind. In the popular style of Burmese curry, sibyan, a spice paste, oil and liquid are combined. Its name means "oil returns" for it is the point that the flavored oil separates to the top of the cooking pot that signals the spices have fully released their essence to the food.

# CRUNCHY, TANGY VIETNAMESE SALAD

Goi Chay ～～～～～～～～～～～～～～～～～～～～～～～ Vietnam

**Serves 4 (or more as a side)**

This vibrant, zingy salad demonstrates the integral role of chili heat in Vietnamese, and wider South East Asian, cooking. It is all about balance, carefully combining salty with sweet, and sour with hot. A chili garlic paste forms the base of many of the country's dipping sauces and this dressing, here with a jolt of ginger in the mix as well. Add in zesty lime, brackish fish sauce and licorice herbs and there are plenty of big flavors to offset the fresh delicacy, making it a salad you can eat in mounds.

1 Chinese napa cabbage, finely shredded
2 carrots, peeled and grated
Handful bean sprouts
½ small red onion, very finely sliced
Handful mint leaves, roughly chopped
Handful Thai basil leaves, roughly chopped
80g (½ cup) roasted peanuts, roughly chopped
Generous scattering crisp-fried shallots

*FOR THE CHILI GINGER DRESSING*
1 red bird's eye chili, seeds in, finely chopped
1cm (½ inch) ginger, peeled and minced
   (1 teaspoon)
1 garlic clove, minced
2 tablespoons lime juice
2 tablespoons rice vinegar
2 tablespoons fish sauce or vegetarian fish sauce
1 tablespoon white sugar

Combine all the ingredients for the dressing and set aside for half an hour for the flavors to mingle.

Combine the cabbage, carrot, bean sprouts and onion in a large serving bowl. Toss through most of the herbs and the dressing, then use your hands to squeeze everything together (messy though it may be, it really makes a difference to the flavor). Taste for seasoning, adding salt if needed.

Scatter over the remaining herbs, peanuts and fried shallots. Eat freshly made, but leftovers keep well as the vegetables will slightly pickle in the tangy dressing.

## EAT WITH
Add cooked and shredded chicken for another Vietnamese classic, goi ga

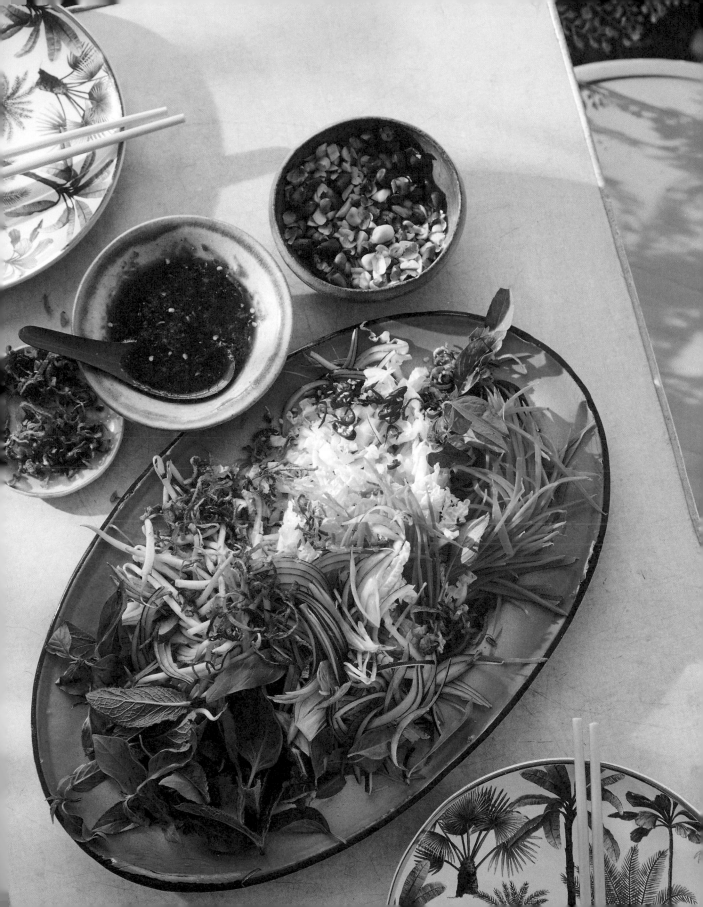

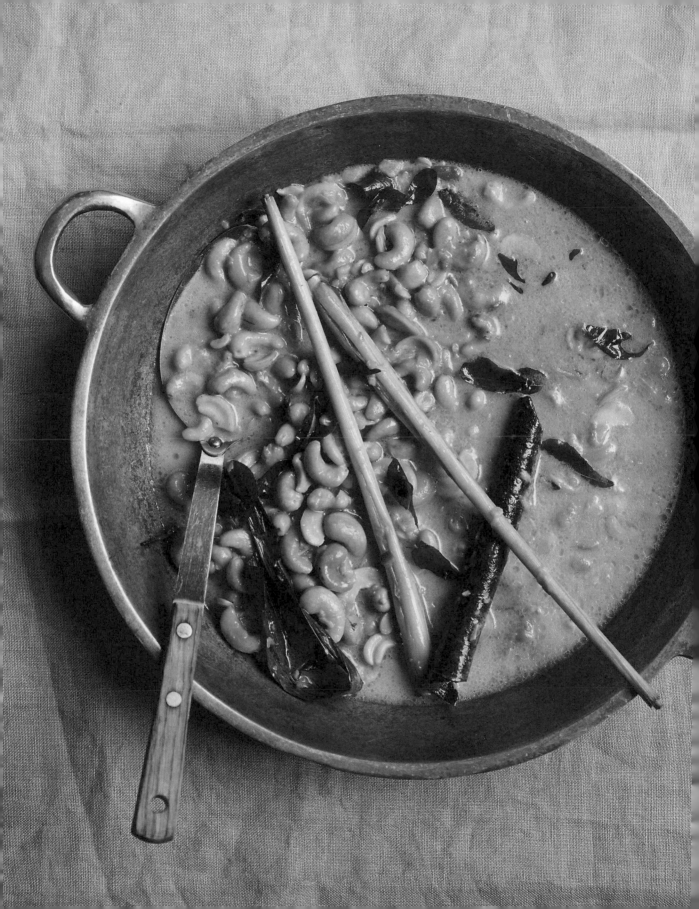

# CASHEW NUT & LEMONGRASS CURRY

Kaju maluwa ～～～～～～～～～～～～～～～～～～～～～～～～～～ Sri Lanka

**Serves 4–6 as a side**

The cashew tree, with its extraordinary-looking rainbow fruit and hanging curved seeds we erroneously call nuts, is a member of the sumac family. Native to Brazil, it was brought to Goa by the Portuguese in the 1560s, from where it spread to become a staple of South Asian cookery. In curries, the nuts are often ground into silky sauces, but in this rich and delightful Sri Lankan dish they get star billing: soft, sweet and plump with coconut milk.

There is a similarity between this and the Garlic clove curry (page 189), however the flavor profile is different. Here, fresh stems of lemongrass bring out the slight citrusy notes of both curry leaves and cinnamon, where they sit behind its more obvious sweet warmth.

250g (1²/₃ cups) raw cashews
1 tablespoon ghee or neutral oil
1 large onion, finely chopped
4 garlic cloves, minced
1.5cm (⁵/₈ inch) ginger, peeled and minced
  (1¹/₂ teaspoons)
10 fresh curry leaves
400ml (1¹/₂ cups) coconut milk
1 scant teaspoon fine sea salt
¹/₂ teaspoon ground turmeric
2 lemongrass sticks, bruised
2 green finger chilies, slit lengthways
1 cinnamon stick
12cm (4¹/₂ inch) pandan leaf (optional)

Soak the cashew nuts in a bowl of water for at least 1 hour, or overnight. Drain and rinse.

Heat the oil in a pan over a medium–high heat. Fry the onion until softened and just starting to turn golden. Add the garlic, ginger and curry leaves and cook for a few minutes, until fragrant.

Add the cashews to the pan along with the coconut milk, salt and turmeric. Drop in the lemongrass, chilies, cinnamon and pandan, pushing them beneath the surface to infuse their flavors into the creamy sauce. Bring to a simmer, then cook on a low heat, uncovered, for 30 minutes, stirring occasionally.

## EAT WITH
Rice, other curries (Beet mallum on page 194 perhaps), and a pickle to cut the sweet richness

# INDONESIAN SEAFOOD GULAI

Gulai ikan 〜〜〜〜〜〜〜〜〜〜〜〜〜〜〜〜〜〜〜〜〜〜〜〜〜 Indonesia

**Serves 4**

A seafood curry that is both sunny in color and bright in taste, the rich mellowness of coconut milk offset by hot red chilies, sour tamarind and fragrant lemongrass. Like rendang, gulai comes from Indonesia's most westerly island, Sumatra, where food is often heavily spiced in a legacy of Indian influence. This recipe is lighter as it uses only fresh spices pounded together in a paste called bumbu. Traditionally this is done using an ulek, a bowl-shaped mortar of volcanic rock partnered with a curved pestle, but many Indonesians favor a food processor, as do I, making this a quick dish. Vary the fish or seafood as you like, poaching it at the last minute in the sauce.

400ml (1½ cups) coconut milk
8 raw king prawns
2 small squid
400g (14oz) firm white fish fillets, such as monkfish or cod cheeks
Juice of ½–1 lime
2 lemongrass sticks, bruised
3 lime leaves, scrunched
1 tablespoon tamarind paste
1 teaspoon palm sugar or brown sugar
1½ teaspoons fine sea salt

### FOR THE SPICE PASTE
5 small shallots, roughly chopped
4 garlic cloves, roughly chopped
5cm (2 inches) ginger, peeled and roughly chopped (1½ tablespoons)
2cm (¾ inch) fresh turmeric, peeled, or 1 teaspoon ground turmeric
3 bird's eye chilies, chilies seeds removed
½ teaspoon shrimp paste (optional)

Grind the ingredients for the spice paste in a blender or food processor, adding a good splash of the coconut milk to help the blades turn.

Prepare the seafood. Peel and devein the prawns, leaving the tail on if you like. Clean the squid by pulling out the tentacles, ink sac, entrails and the clear piece of cartilage. Cut across the head, which is next to the ink sac and has two eyes, and discard. Scrape away the mottled membrane from outside the body, then cut open the bodies along the natural line and wash along with the tentacles to remove all traces of ink and slime. Spread out the squid bodies on a board, outside-down, then use a sharp knife to lightly score a diamond pattern on the inside surfaces before cutting into quarters. Cut the fish into bite-sized pieces and rub with the juice of half a lime. Set aside while you make the sauce.

Scrape the spice paste into a dry pan or wok along with the lemongrass and lime leaves (the added coconut milk provides the fat in which it will fry). Cook over a medium heat, stirring, for a few minutes to lose the harsh raw flavors. Add the remaining coconut milk, turn the heat up to bring to a bubble, then reduce to a simmer for 5 minutes, stirring frequently.

Stir in the tamarind paste, palm sugar and salt. Add the fish and prawns, simmer for 1 minute, then add the squid. Cook for 2 minutes or until the fish is just starting to flake but not falling apart, the prawns have turned pink and the squid has curled into opaque pieces. Taste for seasoning, adjusting the salt, sugar, tamarind or lime juice as needed.

## EAT WITH
Jasmine rice, red chili sambal, prawn crackers

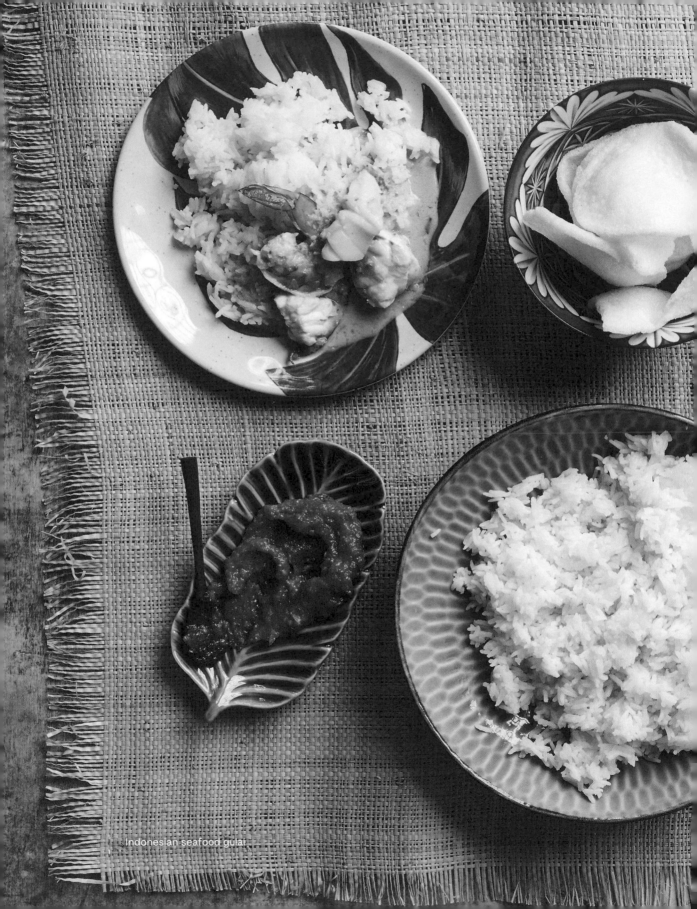

Indonesian seafood gulai

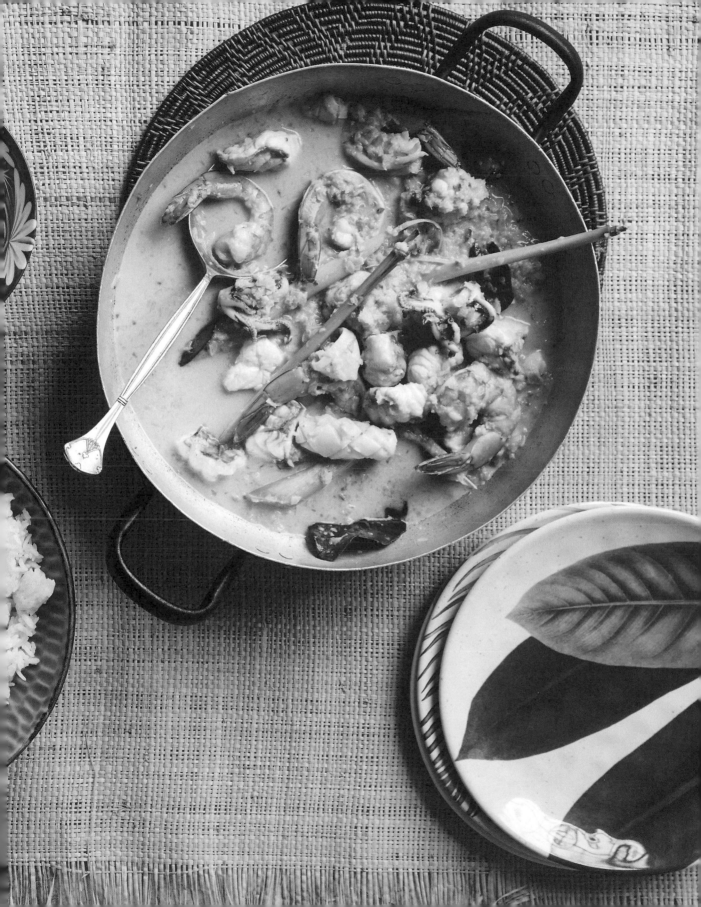

# MOULES AU COMBAVA

Moules au combava ∿∿∿∿∿∿∿∿∿∿∿∿∿∿∿∿∿∿∿∿∿∿∿ Réunion

Serves 4–8

A tropical way with mussels, typical of the spirited, heavily creolized Réunion cooking.

The volcanic island is a French department in the Indian Ocean with a strong cultural and culinary influence from both France and India. French settlers to the uninhabited island first brought slaves from Africa to work their sugar plantations, then, after slavery was abolished, turned to Indian laborers from Tamil Nadu and the Malabar coast. These workers were given no choice but to "assimilate," relinquishing their names, religions and languages, and have stayed in a country that is a true union of people from everywhere. With them came a potpourri of world cuisines.

Moules are a local favorite and can be served in French style with a creamy sauce or, as here, where the Eastern influence is clearer. Both ways use the fragrant, bittersweet and intensely perfumed zest of the wrinkled combava fruit (also known as makrut or kaffir lime), which is well worth seeking out.

2kg (4lb 8oz) mussels
2 tablespoons neutral oil
1 large onion, finely chopped
6 sprigs thyme
5 tomatoes, chopped
1 teaspoon ground turmeric
Finely grated zest of a makrut lime
    (½ teaspoon) or 6 shredded lime leaves

*FOR THE SPICE PASTE*
3cm (1¼ inches) ginger, peeled
4 garlic cloves
1 green chili, seeds in or out, sliced
½ teaspoon fine sea salt

Debeard the mussels and scrub the shells clean with a brush under cold running water, at no stage immersing them in water. Give each a sharp tap and discard any that don't close. You can store in the fridge for up to 24 hours, in a colander over a bowl and covered with a clean damp tea towel.

Grind together the ingredients for the spice paste using a pestle and mortar.

Heat the oil in a sauté pan over a medium heat. Fry the onion until soft and translucent then add the spice paste and thyme. Stir until it becomes fragrant and the harsh rawness has mellowed, then add the tomato and turmeric. Cook for about 20 minutes to break the tomato down and reduce to a thick sauce. Stir in the zest and remove from the heat. Taste for seasoning but remember the mussels will bring their own salinity.

Put the mussels into a large cooking pot and clamp on a lid. Cook over a high heat, shaking occasionally. After a couple of minutes all the shells should be open. Discard any that aren't.

Strain off the mussel juices into a jug and use just a few spoonfuls to thin the spiced tomato sauce. Add the sauce to the pot and heat through quickly, mixing to coat the mussels.

## EAT WITH
French fries or baguette, or preferably both

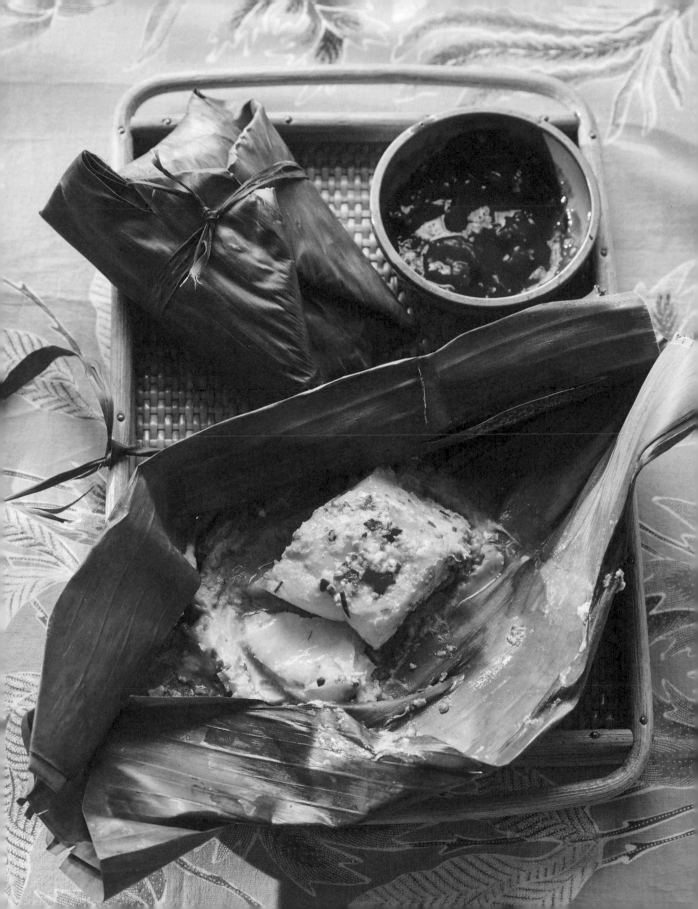

# STEAMED FISH PARCELS WITH LEMONGRASS

Serves 4

Banana leaves are nature's tin foil, with a waxy surface that makes them strong and waterproof. (They also make a good umbrella if you are caught in monsoon rain.) In this Javanese recipe, the fish is flavored with fresh spices and the leaf wrappings themselves, which impart a subtle herbaceous note. Open at the table to release aromatic steam, balmy with lemongrass, and a tender piece of fish.

Trip along the spice routes and you'll find fish parcels in many cultures. In Thailand, fillets might be infused with spicy coconut milk, in the Philippines with ginger, calamansi juice and pork lard. Eat in a Parsi kitchen and your parcel could contain a coriander mint chutney, or head to Kerala for an onion masala laden with curry leaves.

4 x 150g (5½oz) skinless white fish fillets
Banana leaves or tin foil, for wrapping

*FOR THE SPICE PASTE*
4 large red chilies
1 lemongrass stick
2 lime leaves
2cm (¾ inch) kencur, galangal or ginger
1cm (½ inch) fresh turmeric or ⅓ teaspoon
    ground turmeric
3 garlic cloves, peeled
3 candlenuts or 5 blanched almonds
1 tablespoon tamarind paste
1 teaspoon ground coriander
1 teaspoon fine sea salt
½ teaspoon sugar
1 large egg
1 tablespoon neutral oil
Stir-fried vegetables and chili sambal, to serve
    (optional)

Prepare the ingredients for the spice paste: scrape and discard the seeds and surrounding membrane from the chilies and roughly chop. Trim the lemongrass, removing the tough outer leaves, bruise with the handle of a knife, then finely slice. Pull out the central vein from the lime leaves and finely slice into green ribbons. Roughly chop the kencur, fresh turmeric and garlic. Whiz all the ingredients to a paste in a blender. Scrape into a bowl, add the fish fillets and turn to coat.

Wash the banana leaves. You will need eight pieces, each large enough to wrap a fillet. Frozen leaves may be supple enough already, but fresh they crack easily, so soften by holding over a gas flame or hot pan until they slightly wilt and change color, becoming pliable and easy to work with.

Lay out the leaves in double thickness and sit a fish fillet on each, including all the spice paste. Wrap well as if wrapping a present in paper, securing with bamboo skewers or a ribbon of banana leaf. At this point, you can refrigerate them for up to 4 hours.

Heat the oven to 180°C (350°F). Space out the parcels on a baking sheet. Bake for 18 minutes, then rest for 5 before opening at the table. Serve with stir-fried vegetables and sambal, if you like.

# SPICY STIR-FRIED TOFU WITH LIME LEAVES

Khua kling ∼∼∼∼∼∼∼∼∼∼∼∼∼∼∼∼∼∼∼∼∼∼∼∼∼∼∼∼∼∼∼∼∼ Thailand

Serves 4

Cutting a swath across the heart of Asia are an army of delightfully intense, spicy ways with mince, sometimes described as dry curries, from Pakistan's keema to one of Thailand's best-loved dishes, pad krapow. Here is another way with mince from Thailand's south. Khua kling could just as well sit in the chili chapter as it is one of the fiercest dishes I know (of course you can adjust the chili from the merely piercing to the incendiary). However, there is also the balmy, citrus freshness of lemongrass and lime leaves that lifts it. You could use minced pork, chicken or beef, but the recipe here uses crumbled tofu.

500g (1lb 2oz) firm smoked tofu
1½ tablespoons fish sauce or vegetarian fish sauce
2 teaspoons palm sugar or brown sugar
6 lime leaves, vein removed, finely sliced
1 lemongrass stick, trimmed and very finely sliced
1 tablespoon fresh green peppercorns

### FOR THE SPICE PASTE
8 dried red bird's eye chilies
6 (or more) fresh red bird's eye chilies seeds in, roughly chopped
2 lemongrass sticks, trimmed and sliced
4 garlic cloves, roughly chopped
3 small shallots, roughly chopped
3cm (1¼ inches) galangal, skin scrubbed
2cm (¾ inch) fresh turmeric, peeled, or 1 teaspoon ground turmeric

1 teaspoon black peppercorns
1 teaspoon fine sea salt
½ teaspoon shrimp paste (optional)

Toast the dried chilies in a dry pan, stirring for a few moments to crisp. Using scissors, snip off the tops and shake out and discard the seeds. Snip into small pieces and soak in hot water for 15 minutes. Drain.

Grind together all the ingredients for the spice paste, including the dried chilies, until fairly smooth. If using a blender, add a splash of water to help the blades turn.

Heat a wok over a medium heat. Scape in the spice paste and stir-fry for a minute or two, until sweetly fragrant and the rawness has gone. As there is no oil, you will need to keep it moving and scraping the bottom so it doesn't burn. If it starts sticking too much, add a splash of water.

Crumble the tofu into the wok and stir-fry, mixing everything well, breaking down the lumps and scraping the base. Once warmed through for a couple of minutes, mix in the fish sauce and palm sugar. Taste for seasoning. It should be fiercely hot and salty.

Stir through the lime leaves, lemongrass and green peppercorns and remove from the heat. Eat with rice as a foil to the strong flavors.

## EAT WITH

Jasmine rice, crunchy vegetables

# MUSHROOM RENDANG

Rendang jamur ～～～～～～～～～～～～～～～ Indonesia

**Serves 4 as part of a spread**

The steamy rainforests of Sumatra are the only place where orangutans, rhinos, tigers and elephants coexist. Indonesia's most westerly island was also once the heart of a spice empire, a hub for Indian and Arab traders and the entry point of Islam to Indonesia. You can taste the legacy in the food, where fresh spice pastes (bumbu) are combined with ingredients like nutmeg, coriander seed, cinnamon and star anise.

Rendang is one of the most complexly flavored of all Indonesian dishes. Though most usually associated with meat, rendang is actually a cooking style. It is about reducing spiced coconut milk until incredibly concentrated and caramelized; there was once a sauce but the vanishing of it is key. You can also halt the cooking at an earlier stage called kalio, where a little more sauce remains, as in this vegetarian rendang.

150ml (generous ½ cup) coconut cream
1 tablespoon coconut oil or neutral oil
3 lime leaves, bruised
1 lemongrass stick, bruised
1 cinnamon stick
1 scant teaspoon fine sea salt
375g (13oz) oyster mushrooms
2 teaspoons palm sugar or brown sugar

*FOR THE SPICE PASTE*
70g (2½oz) shallots, peeled
4 large red chilies, seeds removed
4 garlic cloves, peeled
2.5cm (1 inch) galangal, skin scrubbed
2.5cm (1 inch) ginger, peeled
½ teaspoon freshly grated nutmeg

2.5cm (1 inch) fresh turmeric, peeled,
  or ¾ teaspoon ground turmeric
Pinch of ground cloves

Roughly chop all the spice paste ingredients and blend with a splash of the coconut cream in a food processor until smooth.

Heat a wok or large frying pan over a medium heat, then add the oil. Scrape in the spice paste and fry, stirring often, for about 5 minutes to cook out the raw aromatics and make them fragrant. Add the remaining coconut cream, lime leaves, lemongrass, cinnamon and salt. Bring to the boil, stirring to stop the cream splitting. Lower the heat and cook at a slow–medium bubble for 10 minutes, until thick and rich.

Add the mushrooms and palm sugar and turn up the heat. Cook, stirring nearly constantly, for 10 minutes. As the mushrooms cook, they will release water, thinning the sauce. This will then reduce and start to caramelize. Leave to rest for half an hour or more before serving to develop the flavors. It should be served at a warm room temperature rather than hot.

## EAT WITH
Rendang's umami depth and unctuous richness needs rice as a foil, and ideally would be served as part of a spread of Indonesian dishes. The perfect meal should be balanced with different elements that are rich and creamy (this), fresh and tangy, dry and aromatic, as well as a thrillingly fiery chili sambal and something with crunch.

# BARBECUED LEMONGRASS SKEWERS

Ua si khai ～～～～～～～～～～～～～～～～～～～～～～～～～～～～～～ Laos

Makes 8

With the notion of kebabs locked in their minds, early spice traders ploughed the seaways west to east, east to west. In each port, the concept of skewered morsels was hungrily shared and evolved. In South East Asia, they morphed into Indonesian sate, Thai satay, Vietnamese nem nuong, and these marvelous Laotian stuffed lemongrass. You create a cage in stems in which to capture sausage-like meat, infusing it with incredible flavor both as it grills and when you eat it messily with your fingers.

Lemongrass can be brittle, so it is easier to stuff them if slightly softened. I do this by freezing overnight then defrosting, which makes them more pliable.

8 lemongrass sticks, frozen and defrosted
    (see introduction)
200g (7oz) minced pork
10g (¼oz) cilantro stems and leaves,
    finely chopped
2 lime leaves, vein removed, finely shredded
1 tablespoon fish sauce
1 shallot, finely chopped
2 garlic cloves, minced

Cut into the lemongrass sticks lengthways, making several long slits and keeping the top and bottom intact. You should be able to push the ends together so that the layers separate to make a cage.

Put all the remaining ingredients in a bowl with a small pinch of fine sea salt. Mix together well to make a paste, then divide the mixture into eight. With moist hands, stuff into the lemongrass cages, packing in firmly and shaping each like a rugby ball.

Heat a barbecue or griddle pan. Grill the stuffed lemongrass, turning as needed, for 10–15 minutes or until the outside is charred and the pork inside is cooked through and juicy. A meat thermometer should read 74°C (165°F). Eat with your fingers, chewing on the lemongrass stems as you go.

## EAT WITH
Makes a particularly good partner for Crunchy greens with roasted chili jeow (page 130)

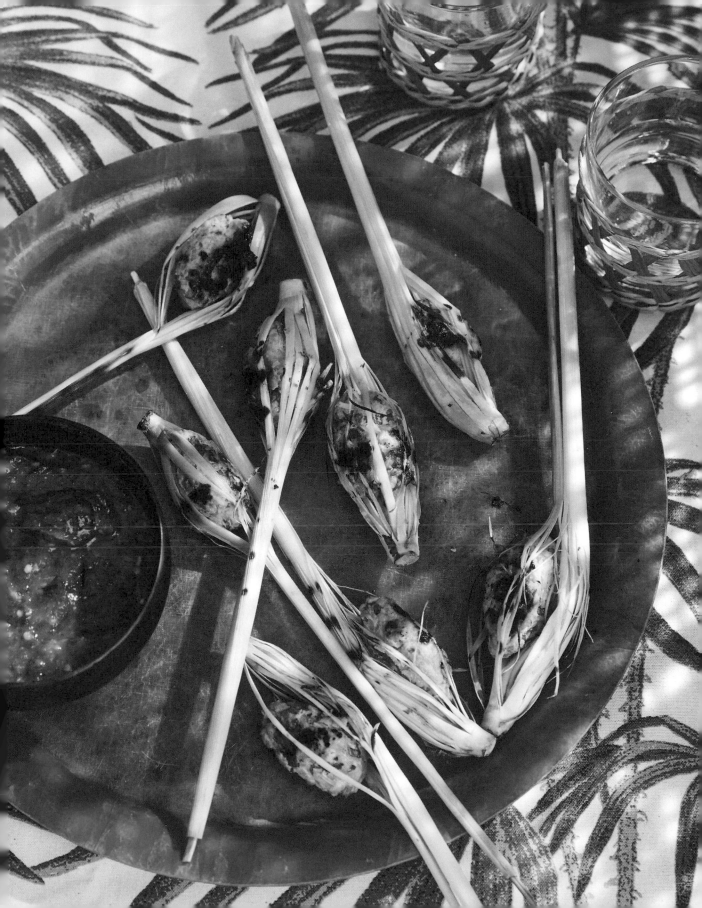

# MASSAMAN BEEF CURRY

Gang massaman ⟿⟿⟿⟿⟿⟿⟿⟿⟿⟿⟿⟿⟿⟿⟿ Thailand

**Serves 4**

One of Thailand's most complex and bewitching curries has a history interwoven with trade, religion, kings and explorers, only adding to its allure. Gang massaman means "curry of the Muslims," reflecting its roots in the Thai Muslim community. Sweet spices not typically used in other Thai curries— cardamom, cinnamon, cloves, mace and star anise —are combined with local flavors of lemongrass, galangal and fish sauce.

Stories differ—it may have originated in the seventeenth-century court of Ayutthuya, where the royal family had Persian roots. Or perhaps the influence came with Muslim spice traders; crossovers can be seen with Malaysian curries as well as the nut-based braises of Persia. It certainly became a dish favored in the courts of Siam and inspired King Rama II to write:

"Massaman curry is like a lover, as peppery and aromatic as the cumin seed. Its exciting allure would arouse any man."

This recipe requires work in gathering the ingredients and pounding the spice paste. After that it is a simple preparation of beef, potatoes and peanuts simmered slowly in spiced coconut milk. Choose stewing beef with a good fat marbling to keep it tender. The result is mild but heavily perfumed. It should start sour in the mouth, then develop to a rounded sweet-savory.

400ml (1½ cups) coconut milk
450g (1lb) beef chuck, cut into 3cm
    (1¼ inch) chunks
1 teaspoon fine sea salt
400g (14oz) waxy potatoes, cut into 3cm
    (1½ inch) chunks
4 small shallots, peeled and halved
4 green cardamom pods, bruised
1 star anise
1 tablespoon palm sugar or brown sugar
1 tablespoon tamarind paste
1 tablespoon fish sauce
60g (½ cup) roasted peanuts

*FOR THE SPICE PASTE*
1 tablespoon coriander seeds
1 teaspoon cumin seeds
2 green cardamom pods
1 star anise
2 cloves
1 teaspoon ground cinnamon
½ teaspoon ground mace
5 dried red Thai chilies
4 small shallots, peeled
6 garlic cloves, peeled
2 lemongrass sticks, tender heart only
3cm (1¼ inches) galangal, skin scrubbed, sliced

For the spice paste, heat a wok or frying pan and dry roast the coriander, cumin, cardamom, star anise and cloves until they smell toasty. Use a pestle and mortar to grind them to a fine powder (discard the papery cardamom pods if you catch them, but don't worry unduly). Mix in the cinnamon and mace.

Heat the wok again and dry stir-fry the chilies, shallots, garlic, lemongrass and galangal for a few minutes until everything is softened and lightly charred—the chilies will need removing first. Snip the ends off the chilies, shake out and discard the seeds, then crumble into the spices. Thinly slice the lemongrass and roughly chop the galangal, shallots and garlic. Put all the charred aromatics into the mortar with the spices and pound to a paste (or use a food processor).

To make the curry, heat a large casserole pan and add a few tablespoons of the coconut milk (ideally the cream from the top of the tin). Scrape in the spice paste and stir-fry for a minute.

Stir in the beef and salt and cook in the spice paste for a few minutes to get some color on the meat. Pour in the remaining coconut milk along with half the tin full of water (200ml/generous ¾ cup) and scrape up any sticky browned bits from the bottom of the pan. Bring to a simmer, then reduce the heat to low, cover and leave to simmer for at least 1½ hours, or more, as long, slow cooking ensures melting tenderness. Add the potatoes, shallots, cardamom, star anise, palm sugar, tamarind and fish sauce. Thin the sauce with a little water only if needed and return to a slow boil. Simmer, partially covered, for a further 1 hour, or until both the beef and potatoes are completely tender and the sauce is rich and creamy. About 10 minutes before the end, add the peanuts. Taste for seasoning: it should start sour then build to sweet-savory. You can adjust the tamarind, palm sugar and fish sauce as needed.

## EAT WITH

Jasmine rice, crisp-fried shallots, stir-fried greens, prawn crackers

Or Crunchy Thai salad: Mix shredded cucumber, carrot and mange tout (snow peas) with bean sprouts and a few sliced spring onions (scallions). Make a dressing with 100ml (scant ½ cup) rice vinegar, 2 tablespoons sugar, 1 tablespoon fish sauce, a minced garlic clove and a sliced chili. Add cilantro leaves at the end if you like.

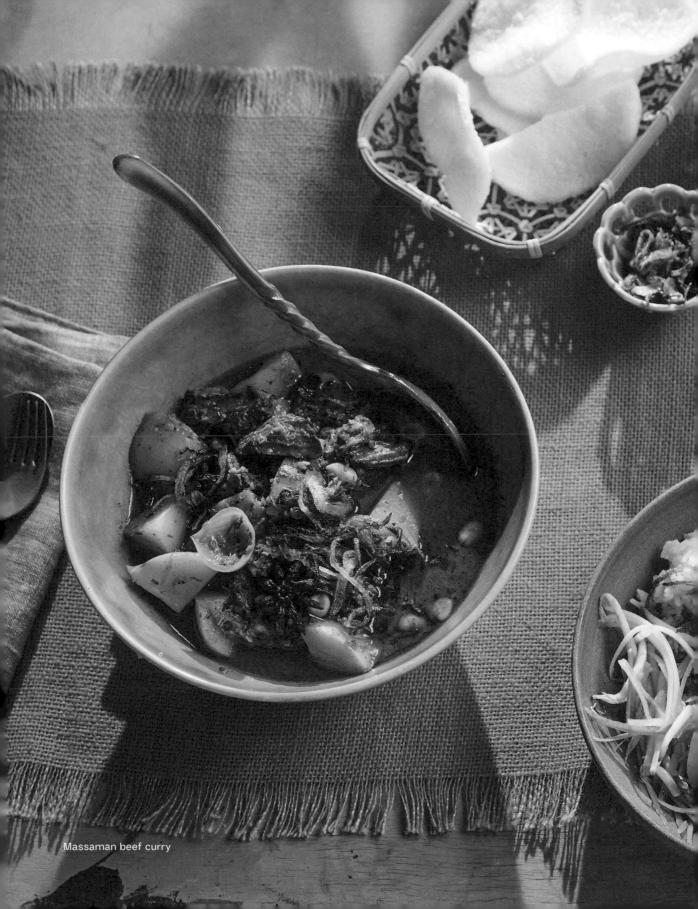

Massaman beef curry

# TURMERIC &
# TAMARIND JAMU

Jamu kunyit ~~~~~~~~~~~~~~~~~~~~~~~~~~~~~~~~~~~~~~~~~~~~~~~~~~~ Indonesia

Serves 4–6

In the royal courts of Java more than a thousand years ago, Indonesian princesses were drinking spicy tonics called jamu, said to sustain eternal youth and beauty. Such flights of fancy aside, they are still widely taken today, both as powerful herbal medicines and for their health-giving properties. The earthy bitterness of turmeric is celebrated in this electric orange elixir—thunder and wonder in the mouth.

100g (3¹/₂oz) fresh turmeric
30g (1oz) ginger
1 tablespoon tamarind paste
40g (¹/₄ cup) palm sugar or brown sugar
Juice of a lime

Brush the turmeric and ginger roots clean (no need to peel) and roughly chop. Put in a blender with 800ml (3¹/₄ cups) water and whiz to semi-smoothness.

Pour the orange liquid into a pan and add the tamarind and palm sugar. Cover, bring slowly to the boil and simmer for 10 minutes.

Remove from the heat and leave to cool before adding the lime juice. Strain through a fine sieve, gently pressing the pulp to extract the juice. Adjust sweetness to taste and thin with water if you want a gentler drink.

# EARTHY NOTES

CUMIN LOVES

CORIANDER

Food of the Indian subcontinent has a broad split created by ancient trade routes. The dishes of the East and South reveal strong links to Malaysia and Indonesia as ideas and flavors traveled in both directions with the boats that ploughed the waters between them. There is heavy use of vegetables, rice, seafood and coconut, and tastes lean toward the hot and sour. Spice imports include star anise and mace, joining native cinnamon, black pepper and green cardamom.

In the North, the prominent culinary influence is from Central Asia. The regions are joined by the overland trade through Afghanistan and the lasting influence of the Mughal Empire that bound them together. Meats, yogurts, breads and samosas are popular and the spicing is complex, focusing on warm fragrance over raw heat, with garam masala being favored.

Naturally, within this are dizzying regional variations, from the taste for tartness in west and central India or the mustardy cooking of East India and Bangladesh, to the sweet spices of Pakistan and zesty heat of Sri Lanka. What unites them all is a reliance on a complex, earthy spice base.

## Cumin, in particular, lends an essential sunbaked earthiness to food,

a practice that stretches across to North African and Levantine cooking. It is the second most popular spice in the world today, after black pepper. The seeds should be toasted to elicit their nuttiness and the flavor-enhancing sulfurous compounds also found in roast beef and cruciferous vegetables. Whole mustard seeds need toasting, too, to bring out the earthy, popcorn-like notes behind their pungent heat. Other members of the earthy family include turmeric, nigella and fenugreek, all celebrated in Indian cooking.

## Earthiness acts to bind other flavors together and give depth.

It will balance sweet spices, like cinnamon, and bring out the woodiness in black pepper. Coriander seed is cumin's classic companion, the pungent bitterness of the cumin seeds dancing with the floral brightness of coriander. Successful marriages require parallels as well as counterbalances, and this pair share the citrusy compound cymene, making theirs the perfect union.

The foundations of many Indian dishes are laid by a combination of cumin, coriander, turmeric, chili and ginger. And so, these have been collected together, often with fenugreek added to the mix, to form curry powder. It was a nineteenth-century Anglo-Indian invention, when powders in shades of yellow (mild), russet and red (hot) became widely available in Britain. The nuance of Indian cookery was overlooked.

In South Asia, separate spices are ground daily, giving each dish the individuality it demands. Traditionally, they were crushed by hand on a flat grindstone and wealthy households would employ a dedicated spice grinder, called a masalchi; today a mechanical

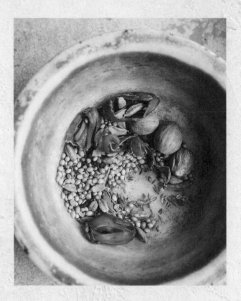

"wet–dry grinder" might suffice. There are also premade spice blends called masalas, each with a distinct purpose: garam masala (a warming, finishing spice); panch phoron (a nutty, five–seed mixture); gunpowder (a firecracker of earthy chili); chaat masala (a salty–sour blend for snacks); Sri Lankan curry powders (darkly roasted for meat, lighter for vegetables); and bottle masala of Mumbai's Christian community (a complex blend of up to 30 spices, stored in green glass bottles).

A reason for using spices individually is that each takes a different time to release its flavors.

## Our cumin–coriander seeds duo is slow-releasing, so needs a good sizzle in oil, whereas ground turmeric is fast-releasing and a short, sharp heating is better.

Ephemeral spices like nutmeg will be lost if employed too early. Add everything together and you risk raw, burnt or muted spice. However, there is a place for convenient curry powders if used properly. Be sure to stir the powder into fat, not liquid, and cook to draw out and disperse the fragrant oils. (Indian kadai pans are bowl-like so oil can pool at the bottom to fry spices well, without needing too much fat.) If cooking a paste of onion, ginger and garlic first, wait until the moisture has evaporated and the oil starts to exude, so the earthy spice base doesn't simmer but can fry until deeply aromatic. Now you have the perfect earthy base on which to build other layers of flavor.

# CURRY & CONQUERORS

Let's consider curry. This broad-brush term is used for food cloaked in a hotly spiced sauce originating from the Indian sub-continent. Yet no such word exists in any Indian language and, as we've already explored, curry powder is not used in its supposed country of origin.

The generic label is one originally imposed by the British, coming by way of early Portuguese settlers who described the spiced dishes Indians ate with rice as "carree." This they had adapted from various languages in the south of India, including the Tamil kari, meaning "gravy." Thus, you will not find the word "curry" used in South Asia; each of the countless dishes has a unique name befitting their distinct personalities. But travel to many other parts of the world and you'll find local curries, often named as such, showing the vast web of inspiration Indian food has spun around the globe.

## From the name to the flavors, curry's story is intertwined with the movement of people through trade, migration and conquest.

India (using its pre-partition definition, incorporating modern-day Pakistan and Bangladesh), has since time immemorial borne the brunt of invaders from the Yuezhi to the Brits. Conquerors always leave their mark on culture—on religion, design, language and food—regardless of whether their strategy is integration or colonization. But India has never relinquished its customs, only added to them layer on layer, so each wave of influence served to add brilliant complexity to the culinary traditions.

Two external influences were key: Islam and the Europeans. Arab spice traders had long skipped the shores carrying pepperberries and cinnamon curls east and west, but by 800 AD they turned their attention from peaceful trade to conquest and control. North India came under Islamic rule in the twelfth century and stayed that way for more than 500 years. Delicate Persian and Arab cooking styles fused with loud local flavors, creating a cuisine known today as Mughal after the grandest Muslim dynasty. Indians fell for the perfumed cooking of these pleasure-seeking medieval courts, which left a legacy of sauces opulent with silky ground nuts, rich cream, browned onions and incense-like spice.

Europeans began arriving in the late fifteenth century, initially for the spice trade but, once again, attention soon turned to acquisition, most notably by the British Raj but also by the Portuguese, Dutch and French. There were some modest culinary footprints—bread rolls, vindaloo, tomato soup—but it was the inadvertent introduction of new European and American ingredients that had the greatest transformation on the gastronomic landscape. Potatoes, tomatoes, cabbage, cauliflower, corn, pumpkins, beans, cashew nuts and, above all, chilies were all adopted enthusiastically. European

cooking techniques, however, were ignored and the raw materials quickly subsumed into spicy local cookery. Gandhi declared, "I never saw a boiled potato in India. It is needless to say that India would far outbid France in cooking vegetables nicely."

Other early sways on Indian food include Arab merchants who married locals on the Malabar Coast and showed their wives how to cook mandi in underground clay ovens; Jewish settlers who brought Middle Eastern tastes to Kerala, including sewing rice with nuts; Persian Shi'ites who braised lamb with tamarind-soured beans in Golconda; and Syrian Christians, who passed on word of Irish stew to Tamil Nadu.

Meanwhile, a sophisticated vegetarian cuisine was developing in Hindu temples, where flavors leaned toward the earthy and aromatic. All the incoming layers of influence piled onto local Hindu traditions and had to filter through the complex food rules of religion and caste. Ayurveda too had great impact as this Indian science of life underpins the way of eating. The idea is to balance "hot" foods (e.g. pepper) and "cool" (e.g. fennel), striving to achieve the six essential tastes: pungent, salty, sweet, sour, astringent and bitter. Spices play a lead role as they can tip the balance and harmonize flavors. Imagine the sweet warmth of cinnamon, the bitter earthiness of cumin or the sour fruitiness of amchoor.

## Just as new ingredients and ideas landed and blended to form one of the world's great cuisines, Indian culinary influence rippled out across the waters to the far reaches of the earth to transform again in myriad ways.

The initial wave of Indianization spread across South East Asia for almost two millennia with traders and religious practitioners, starting around 200 BC. The seafaring Gujaratis introduced spice blends and curries to the Malaysian peninsula, both punchy masalas and pale kormas. In their new home they were accented with Chinese ingredients, such as star anise and oyster sauce, as well as homegrown galangal and velvety coconut milk. Sumatra's key position in the spice routes saw its curries combining earthy spices not much used in the rest of Indonesia, with the tropical aromas of lemongrass and lime leaves. Thailand has kebabs (renamed satay), biryanis and curries that show the ancient trading ties, transformed for the hot-and-sour local palate, while Myanmar reveals its long history of exchange with India in dishes combining curry powder with the umami-kick of fish sauce.

The next great propulsion taking India's cuisine international was driven by the British. During the time of the Empire, Brits fell in enduring love with Indian food. They diluted curries to suit their tastes, with spices both hot and fragrant toned down, and regional variations blurred. The initial template for a British curry was a rather unappetizing stew made with ghee, curry powder, lots of onions and often fruit, but the food took on a life of its own in the UK and has developed over the years to become an interesting, pan-Indian inspired cuisine. The British took their curries with them to the colonies and

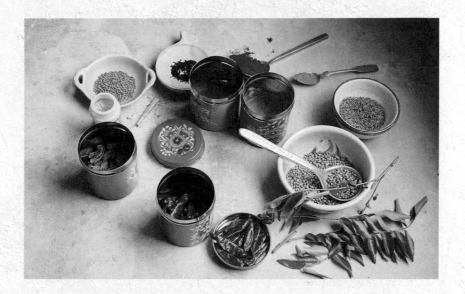

so you'll find scattered culinary legacies, such as some Anglo-Indian curries in Malaysia and a starting point for Australian curries.

Another wide-reaching, but inadvertent means of spreading Indian flavors was via the indentured laborers sent around the world. Unthinking of the seeds of division and resentment they were sowing, European colonists sent workers to sugar and rubber plantations as far afield as South Africa, Uganda, Malaysia, Vietnam, Mauritius, Jamaica, Trinidad and Fiji. Many stayed on to form diasporas. In their new lands, people had to abandon caste restrictions and cook without familiar ingredients,

**but food culture is something people tend to cling to, a thread linking new lives to old. So, curries adapted and evolved, creating distinctive identities in Africa, the Caribbean and beyond.**

A happier inheritance from this migration is the aromatic trails of curry we can follow around the world, enriching the culinary landscape for us all.

# SMOKY AUBERGINE BHARTA

Baingan bharta ～～～～～～～～～～～～～～～～～～～～～～ India

Serves 2—4

Alchemy happens when aubergine is cooked long enough for it to slump, its squeaky flesh transformed to delightful silkiness. If you char it over flames, the fire-fanged smokiness takes it to another level still. Irresistible.

The smoky aubergine purées that have caught the spotlight are from the Middle East: baba ghanoush, mutabal, mirza ghasemi. But aubergines are an Indian native, taken west by Persians who in turn introduced them to the Arab world. This is a recipe from the Punjab region of India, where the spicing adds an exciting dimension. It doesn't seem a stretch to imagine the technique of fire-roasting aubergines traveled with traders crossing east and west, perhaps those following overland routes, as you can also find similar purées in central China, doused with soy sauce, vinegar and chili oil.

2 medium aubergines (eggplants)
2½ tablespoons neutral oil
1 onion, finely chopped
3 garlic cloves, finely chopped
1cm (½ inch) ginger, peeled and minced (1 teaspoon)
2 teaspoons ground coriander
1 teaspoon garam masala
½ teaspoon ground cumin
½ teaspoon Kashmiri chili powder
½ teaspoon ground turmeric
400g (14oz) ripe tomatoes, chopped, or good tinned chopped tomatoes
Squeeze of lime
Small handful cilantro leaves

Put the aubergines directly into the flames of two gas burners and cook, turning frequently, for about 12 minutes. They are ready when the skin has blackened and the flesh has collapsed completely. Alternatively, rub with oil and cook in the oven on its hottest setting for 40—60 minutes, until very tender. Leave to cool, then peel and discard the skin.

Heat the oil in a frying pan. Fry the onion slowly until soft, then add the garlic and ginger and cook for a couple of minutes longer.

Stir in all the spices and a generous pinch of salt. Add the tomatoes, turn up the heat a little and cook for 5—10 minutes until the red deepens and the fat starts to separate from the sauce.

Roughly chop the aubergine flesh and add to the pan, mashing a little into the sauce with a spoon. Cook together on a medium—low heat for another 5 minutes, stirring often. Taste for salt and brighten the flavors with a squeeze of lime juice.

Serve with a verdant scattering of cilantro.

## EAT WITH
Hot roti to scoop up the bharta

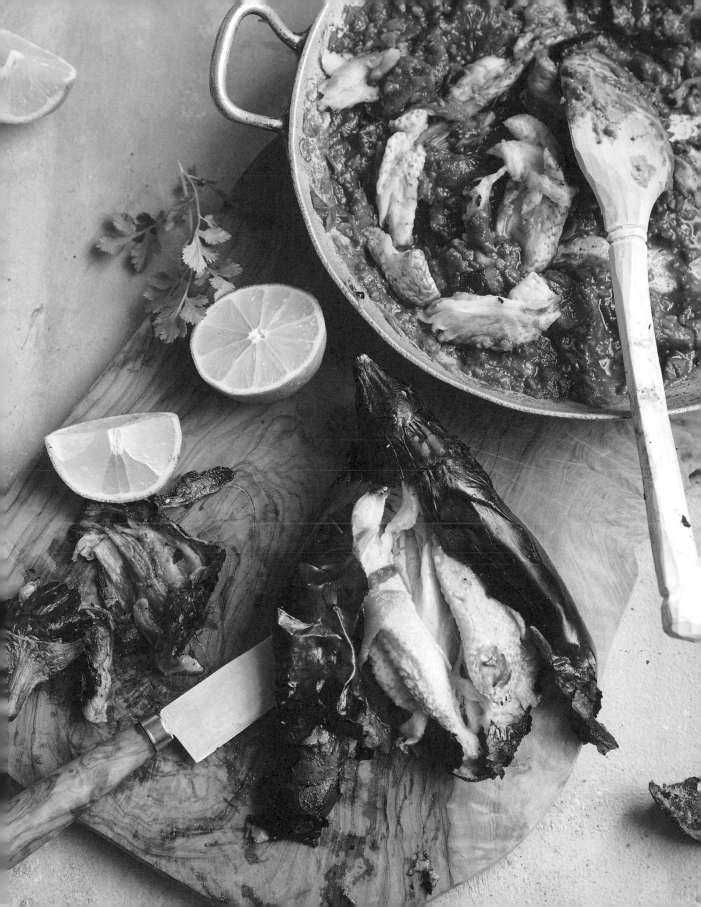

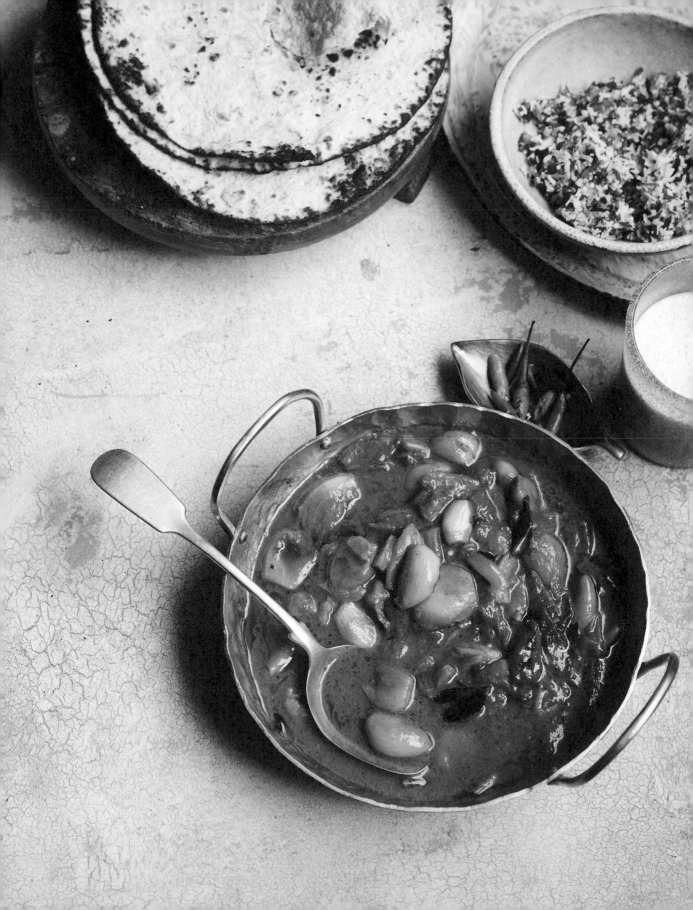

# GARLIC CLOVE CURRY

### Serves 4 or more as a side

A real treat for garlic fiends. Poaching in a spiced coconut gravy mellows and sweetens the cloves and they take on the floral muskiness of curry leaves and brown sugar notes of fenugreek.

Get ready for obscene quantities of garlic, around five heads, depending on size. If you are lucky, you can find peeled frozen garlic in some Asian or health food shops. Otherwise, here is a tip to make the peeling less laborious: Break apart the heads with the heel of your hand and drop them all into a large pan for which you have a lid (or use two large metal bowls, lip to lip). Cover and shake vigorously until the cloves have freed themselves from their papery jackets. It is not infallible, working better with some garlic than others, but enormously satisfying when it does.

250g (9oz) garlic cloves (about 5 heads)
1 large onion
2 tablespoons neutral oil
10 fresh curry leaves
3/4 teaspoon fine sea salt
2 tomatoes, chopped
2 green chilies, slit lengthways
2 teaspoons curry powder
1/2 teaspoon fenugreek seeds
1/2 teaspoon ground turmeric
1/2 teaspoon Kashmiri chili powder
200ml (generous 3/4 cup) coconut milk
12cm (41/2 inch) pandan leaf (optional)

Peel or defrost the garlic cloves (see introduction). Trim the onion, halve lengthways then slice lengthways again into wide petals.

Heat the oil in a saucepan over a medium–high heat. Add the onion, curry leaves and salt and fry until the onion softens, then starts to turn golden and sticky. Add the garlic cloves and cook for a few minutes, to sear the outsides. Add the tomato, chilies and spices and cook for about 5 minutes so the tomato breaks down into a sauce.

Pour in the coconut milk with the pandan and bring to a simmer. Cook on a low heat for around 30 minutes, being careful not to stir too much as the garlic softens. You may need to add a little water toward the end. Taste a clove—it should be very soft, sweet and any harsh rawness cooked out. The timing will depend on the age and size of your garlic cloves, so taste is the best judge. Start checking at about 25 minutes and be ready to cook for 45 minutes, if needed.

This is a dish that works well being made in advance. Serve warm rather than piping hot.

## EAT WITH

Rice or roti and other vegetarian dishes, such as dal

Consider also a Mint sambal: Grind together in a food processor 30g (1/3 cup) grated coconut, leaves from a small bunch of mint, 1/2 red onion, 1 garlic clove, 3 green chilies with or without their seeds, and a pinch of salt. Add a squeeze of lime juice and a little water to loosen the blades.

# CARROT & BEETS WITH TARKA

~~~~~~~~~~~~~~~~~~~~~~~~~~~~~~~~~~~~~~~~~~~~~~~~~~~~~~~~

Serves 4 as a side

Sanskrit reveals that the tarka technique has been in use for thousands of years and still forms the foundation of Indian cookery. Spices are bloomed in hot oil, which unlocks their aromas to infuse them throughout food. Ancient wisdom is backed by science, as most spice flavor compounds are soluble in fat but not water.

The technique is endlessly adaptable and can be used at the beginning of a dish or as a finishing flourish. The latter is most often added to lentil dals or cooked vegetables (raw vegetables are largely unfound in Indian cooking) but I like this Keralan pairing of the fresh, sweet crunch of carrots, barely cooked by the hot oil, with the hot and earthy spices. I add beet too, as the paintbox colors are irresistible.

4 large carrots, peeled
2 large raw beets, peeled
Juice of a lemon
1 teaspoon grated jaggery or honey
Handful cilantro leaves

FOR THE TARKA
4 tablespoons neutral oil
1 teaspoon black mustard seeds
1 teaspoon cumin seeds
½ teaspoon chili flakes
4 fresh curry leaves

Coarsely grate the carrot and beets into separate bowls (keeping them apart to stop the beets tinting everything lurid pink). Toss each with lemon, jaggery and a good pinch of salt.

To make the tarka, heat the oil in a small frying pan. When shimmering, add the mustard seeds, which should start to fizzle and pop. Quickly add the cumin, chili and curry leaves, sizzle for a few moments, then swiftly but carefully pour the hot oil straight over the carrots. Toss together.

At the last moment, mix the carrot and beets and strew with cilantro.

ALOO BHUJIA

Aloo bhujia ～～～～～～～～～～～～～～～～～～～～～～～～～～～～～～ Pakistan

Serves 1–2 as a side or snack

I learned this way with potatoes under the tutelage of my friend Saliha Mahmood Ahmed. She achieves the seemingly impossible, utterly irresistible combination of crisp and melting with a clever technique. The potatoes move from frying to steaming and back to frying in one pan, emerging anointed in golden oil and crusted with spice. Fenugreek leaves (methi) lend a key flavor. Different from the pungent, bittersweet seeds, the leaves have a quiet grassiness rather like fennel or celery.

Aloo bhujia made the Saturday breakfasts of Saliha's childhood, with paratha and eggs fried sunny-side up. There could be few better ways to start a weekend, though I also love them as a greedy snack for one, scattered with the hot-sour spice mix chaat masala in place of the herbs.

2 medium potatoes, scrubbed
1 tablespoon ghee or neutral oil
½ teaspoon nigella seeds
½ teaspoon cumin seeds
½ teaspoon ground turmeric
½ teaspoon chili flakes
1 teaspoon dried fenugreek leaves (methi)
Handful cilantro leaves

You will need a large non-stick frying pan and a heavy lid that will fit inside it like a weight, rather than sit on top.

Slice the potatoes finely and evenly, ideally with a mandolin or food processor, into discs about 1.5–2mm (¹⁄₁₆ inch) thick.

Boil the kettle.

Over a medium–high heat, melt the ghee in the frying pan. Add the nigella, cumin, turmeric and chili and let the spices bubble and fizz in the hot fat. Tip in the potatoes and the fenugreek leaves, stir well to coat each slice in the golden oil, then flatten and push down the potatoes onto the base of the pan.

Pour over 175ml (¾ cup) of the recently boiled water and sprinkle with salt. Cover with the weighty lid and leave to cook for 12–15 minutes. The water will bubble up the sides of the lid, reducing away until the potatoes begin to sizzle and fry. You can remove the lid for the last few minutes once the potatoes are tender, carefully lifting a slice to check underneath. They are ready when the bottoms are well browned and crisp.

Tip onto a plate and sprinkle with flaky salt and cilantro.

EAT WITH
Fried eggs, paratha, chili pickle

BEET MALLUM

Serves 4 as a side

A beautiful magenta bowlful that occupies the notional middle ground between cooked salad and relish. It makes the perfect earthily sweet counterpoint when you have a tableful of resolutely brown curries.

250g (9oz) cooked beet
2 tablespoons neutral oil
8 fresh curry leaves
½ teaspoon black mustard seeds
½ teaspoon coarsely ground black pepper
1 small red onion, sliced
3 garlic cloves, sliced
½–1 green finger chili, seeds in, chopped
60g (1 cup) grated coconut, fresh or desiccated
½ teaspoon fine sea salt
Squeeze of lime
Cilantro or mint leaves, to serve

Cut the beet into rounds, then slice again to make thin strips. Save any juices they give off.

Heat the oil in a frying pan over medium–high heat. Add the curry leaves, mustard seeds and pepper and let them splutter in the heat. Add the onion, garlic and chili and stir-fry to soften.

Add the beet, beet juice, grated coconut and salt. If using desiccated coconut, add a splash of water to rehydrate it. Cook for a couple of minutes, giving a chance for the flavors to mingle and the beet to stain the coconut a livid pink.

Stir in the lime juice and taste for seasoning. Serve with a green scattering of cilantro or mint.

EAT WITH
Makes a fine pairing for Sri Lankan pumpkin curry (page 210)

CAULIFLOWER & POMEGRANATE PILAF

Gobi pilau ～～～～～～～～～～～～～～～～～～～～～～～～～～ India

Serves 4–6

I present to you a treasure-trove of tasty morsels, waiting to be unearthed from a mound of fragrant rice. The bounty here is cauliflower, browned and buttery, and beautiful sultanas, like edible topaz. Turmeric lends its Midas touch to the spice-swollen rice grains, offset by a flourish of glassy, sweet-sour pomegranate jewels. This dish is delicate by design to showcase the floral flavor of rice, in contrast to the loudness of a biryani (page 118).

400g (2 cups) basmati rice
2 medium cauliflowers (600g/1lb 5oz)
4 tablespoons ghee
4 garlic cloves, minced
3cm (1¼ inches) ginger, peeled and minced
 (1 tablespoon)
¾ teaspoon fine sea salt
2 teaspoons garam masala
5 green cardamom pods, bruised
1 cinnamon stick
1 teaspoon ground turmeric
30g (scant ¼ cup) golden sultanas (optional)
Seeds of a pomegranate
Handful toasted flaked almonds

FOR THE GREEN CHUTNEY
120g (4¼oz) cilantro
80g (½ cup) blanched almonds
2 green finger chilies
Juice of a lemon
2 teaspoons brown sugar
1 teaspoon fine sea salt

Wash the rice in several changes of cold water and leave to soak.

Make the chutney by blending all the ingredients together to a vibrant green paste—remove the chili seeds if you want less heat.

Break the cauliflower into very small florets, discarding the core. Heat 3 tablespoons of the ghee in a large frying pan over a medium–high heat. Add the cauliflower and fry, stirring only occasionally. When tinged with brown on all sides, turn down the heat and add the garlic, ginger, salt and a tablespoon of water. Stir-fry for a few minutes until tender with just a little bite. Stir in the garam masala and a spoonful of the green chutney, then remove from the heat and set aside.

Heat the remaining tablespoon of ghee in a large pan and sizzle the cardamom and cinnamon for a couple of minutes. Drain the rice and stir it through. Pour in 625ml (2½ cups) water and add the turmeric. Bring to a rolling boil, then turn the heat down to the lowest setting and cover the rice. Cook for 12 minutes then turn off the heat.

Fold the spiced cauliflower and golden sultanas through the rice and clamp the lid back on. Leave to sit for 10 minutes. You can do the same if you like, though you may need to use the time to wheedle seeds from your pomegranate. Serve the pilaf strewn with pomegranate seeds and flaked almonds and the remaining green chutney alongside. Goes wonderfully with yogurt or a raita.

RED LENTIL DAL WITH PANCH PHORON

Serves 2—4 as a side

Panch phoron is a five-spice mixture used in Bengal, Bangladesh and Nepal. Whole spice seeds are mixed in equal quantities, each bringing something: musky earth from cumin; bitter brown sugar from fenugreek; aniseed from fennel; charred onion from nigella; and a nutty heat from mustard (or sometimes radhuni is used instead).

The secret is that the spices must sing. As they toast in the hot oil, they will sizzle, splutter and pop, removing bitterness and releasing the mellow fragrance.

This recipe, and the advice about the spices singing, was shared with me by my children's Nepalese nanny, Doma. There is an austere simplicity to the dal, spice-stained the yellow of a Buddhist monk's robes. Yet, the small quantity of panch phoron brings an unexpected, haunting quality to the earthy lentils. As your tooth bites on a seed of fenugreek, or perhaps fennel, different flavors wash over each mouthful.

200g (1 cup) split red lentils
½ teaspoon ground turmeric
½ teaspoon fine sea salt
3 teaspoons neutral oil

FOR THE PANCH PHORON
¼ teaspoon cumin seeds
¼ teaspoon nigella seeds
¼ teaspoon mustard seeds
¼ teaspoon fennel seeds
¼ teaspoon fenugreek seeds

Boil the kettle. Wash the lentils in a sieve then put in a small pan with the turmeric, salt and 1 teaspoon of the oil. Add 500ml (2 cups) water from the freshly boiled kettle and boil gently for 10 minutes, until tender and starting to collapse. Remove from the heat without draining.

Mix together the spices to make the panch phoron.

In a frying pan, heat the remaining 2 teaspoons of oil and add the panch phoron. When the spices sizzle and pop and the aroma hits you, add the lentils and their cooking liquid. You can top up with more hot water if you want a thinner dal.

Simmer for a few minutes and the dal is ready. Taste for seasoning.

EAT WITH
Potato cut into sticks and fried with cumin seeds and turmeric

Spinach stir-fried with garlic and turmeric

Basmati rice

EVERY WEEK TOMATO LENTILS

~~~~~~~~~~~~~~~~~~~~~~~~~~~~~~~~~~~~~~~~~~~~~~~~~~~~~~~~~~~~~~~~~~~

### Serves 4

Full of earthy heat, a substantial pot of lentils to bring succoring comfort. This is the one recipe I cook every week and is what I crave most after a few days away from home. It would be audacious to use the label dal as I draw on British store cupboard ingredients and a one-pot method without a finishing tarka. However, the lentils are certainly Indian-inspired, following in a long tradition of dals traveling and adapting to new homes.

If you embrace them into your every week, here are some variations to consider: Fenugreek seeds or a pinch of asafoetida can be added to the spices. A slit chili or a dried Kashmiri chili in with the tomatoes adds punch. Fresh greens wilted in at the end make a complete meal. Ghee or butter stirred in with the lemon adds richness. Or swap the lemon for a spoon of tamarind paste balanced with jaggery or sugar for a sweet-sour finish.

1 teaspoon black mustard seeds

2 tablespoons neutral oil

1 large onion, chopped

30g (1oz) cilantro

4 garlic cloves, minced

3cm (1¼ inches) ginger, peeled and minced (1 tablespoon)

½ teaspoon chili flakes

1 tablespoon curry powder

8 curry leaves

400g (14oz) tin chopped tomatoes

200g (1 cup) split red lentils, well washed

Juice of ½ a lemon

Set a large pan over a medium heat, add the mustard seeds and let them start to pop. Add the oil and onion and cook for about 10 minutes, until soft and starting to caramelize.

Meanwhile, cut the stems off the cilantro, discard any particularly thick, tough ones and finely slice the rest. Set the leaves aside for later.

Add the cilantro stems, garlic and ginger to the onion and cook for a couple of minutes. Stir in the chili flakes, curry powder and curry leaves and let the fragrance hit you.

Pour in the tin of tomatoes, then fill the tin with water and add this too. Finally mix in the lentils and a teaspoon of salt. Bring to a bubble, lower the heat and cover with a lid. Simmer for 25 minutes.

Leave to cool just a little before stirring in the lemon juice. Taste for seasoning—a pinch of sugar may be needed to bring out the flavors. Serve strewn with the cilantro leaves.

## EAT WITH

Rice, naan or poppadums

Sizzling ginger raita (page 61) makes a good accompaniment. Or make Chaat masala raita by mixing a teaspoon of chaat masala, a pinch of salt and sugar, and some chopped cilantro or mint into a bowl of yogurt

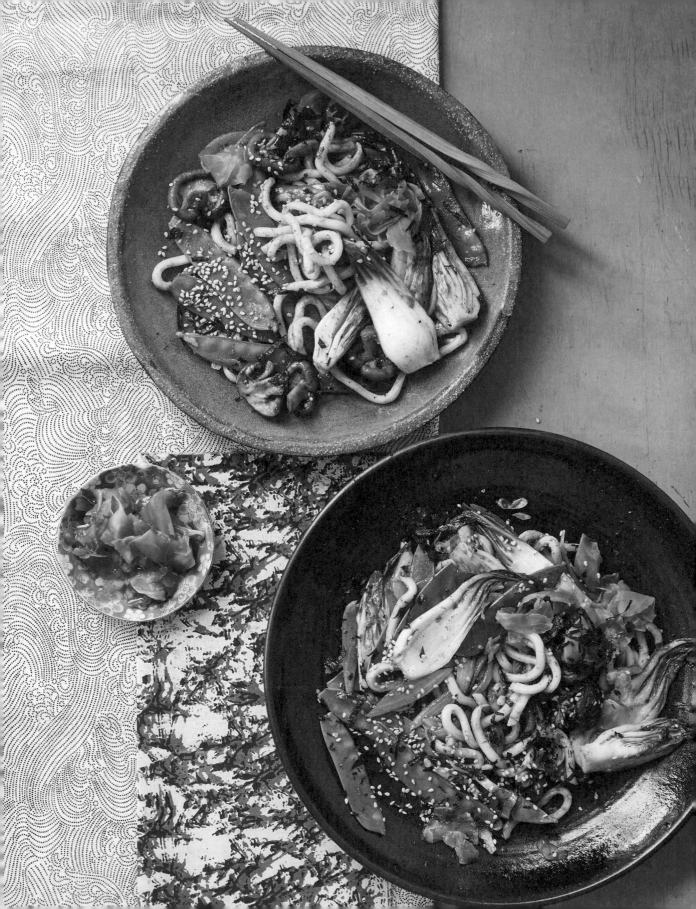

# CURRIED UDON NOODLES

Yaki udon ～～～～～～～～～～～～～～～～～～～～～～～～～～～ Japan

Serves 2

A quick and immensely satisfying one-wok meal. Get cooking now and you could be eating in 15 minutes, or read on for a little history.

In the past 150 years, Japan has become a nation of curry lovers with a heavily Japanized influence on the Indian flavors. Curray, as it is locally known, is served donburi-style over rice with pickles, cooked into rich noodle soups or stuffed into the slightly sweet buns of every convenience store. It is also a favorite for school lunches and the home cook with whole supermarket aisles dedicated to provisions, including curry spice blends sold in mild, medium and (only nominally) hot. Much like Western curry powders, the base of these is turmeric, coriander and cumin, with aroma from spices including cardamom, cloves and fennel. Unique to Japan are caramel slabs called curry roux. Made from fat, flour, curry powder and soy sauce, these melt in the pan to a smooth brown sauce.

A couple of theories for curry's introduction to the country could explain the flour-thickened sauces. It may have crossed from Shanghai, where there was a large Indian population, the flour-thickener being an influence from Chinese cookery. Or it could have been introduced via the British, who held India under colonial rule and were themselves fusing Indian flavors with roux-based stews. Either way, the habit is now fully ingrained in Japanese cuisine, acting as comfort food that can be eaten without the need of ceremony.

Chewy udon noodles might be curried either in a thick soup (using curry roux) or quickly stir-fried yaki-style (with curry powder) as here. The bitterness of the bok choy plays off beautifully against the gloss of the salty-sweet, earthy-spiced mirin.

1 tablespoon neutral oil
1 onion, thickly sliced
8 shiitake mushrooms, sliced
50g (2oz) mange tout (snow peas)
2 baby bok choy, quartered
3 spring onions (scallions), cut at an angle
    into 3cm (1¼ inch) pieces
2 garlic cloves, minced
300g (10½oz) fresh udon noodles
    (or 200g/7oz dried, cooked)
1 teaspoon toasted sesame oil
2 scant teaspoons curry powder
Grinding of black pepper
3 tablespoons mirin
2 tablespoons Japanese soy sauce
Juice of ½ a lime

*OPTIONAL TOPPINGS*
**Pink pickled ginger**
**Aonori (dried seaweed powder) or shredded nori**
**Toasted sesame seeds**

Heat the wok, then add the oil and onion and fry to soften. Add the shiitake, mange tout, bok choy and spring onions and cook for 5 minutes more over a medium–high heat, stirring frequently. Add the garlic and cook for just a minute longer.

Untangle the noodles into the wok then toss through the sesame oil, curry powder and a generous grinding of black pepper. Add the mirin and soy sauce and let the noodles warm through and soak up most of the sauce. Spritz in the lime juice and remove from the heat. Portion into bowls and, if using, scatter with the toppings.

# SPICED BEEF MARTABAK

Martabak ∿∿∿∿∿∿∿∿∿∿∿∿∿∿∿∿∿∿∿∿∿∿∿∿∿∿∿∿ Indonesia

Makes 14

These crunchy pastry envelopes stuffed with a juicy meat filling are one of Indonesia's most popular street food snacks. Their origins are thought to be halfway around the earth in the Indian communities of Yemen, from where they spread with traders across the Muslim world, adapting significantly to the flavors of each port. The name is universal, a lingering linguistic clue to the shared origin, whether you are snacking in Bangkok, Brunei or Kuwait.

Watching kaki lima vendors make savory martabak is pure performance art as they deftly stretch dough until translucently thin, then fold it around the filling. I have an easy cheat for those of us less adroit, using wonton wrappers, which crisp and bubble beautifully in the hot oil.

Neutral oil, for shallow frying
2 shallots, finely chopped
2 garlic cloves, finely chopped
1cm (½ inch) ginger, peeled and minced
   (1 teaspoon)
½ teaspoon ground coriander
¼ teaspoon ground cumin
¼ teaspoon ground turmeric
½ teaspoon ground chili
250g (9oz) minced beef
½ teaspoon fine sea salt
2 large eggs, beaten
3 spring onions (scallions), finely sliced
Handful celery leaves or parsley leaves, chopped
28 wonton wrappers (approx. 280g/10oz)

Heat 1 tablespoon of oil in a frying pan over a medium heat. Cook the shallot, garlic and ginger to soften. Stir through the spices so you are hit by their fragrance. Add the beef and salt, breaking up the mince and stir-frying until brown and cooked through. Cool, or chill if making in advance.

When you are ready to cook the martabak, stir the eggs, spring onions and herbs into the filling. Lay a few wonton wrappers on a flat surface. Spread a spoonful of filling on each square and lay another square on top. It should lie flat with the filling almost to the edge. Press the edges so they are more or less sealed. Repeat to use up all the ingredients.

In a large frying pan, heat enough oil for shallow frying over a medium heat until shimmering. Fry the martabak in batches for about 1 minute on each side. They should be blistered and golden. Drain on a paper towel and serve at once.

## EAT WITH

A good chili sambal or dipping sauce is essential. You could try the Ginger chili sambal (page 63)

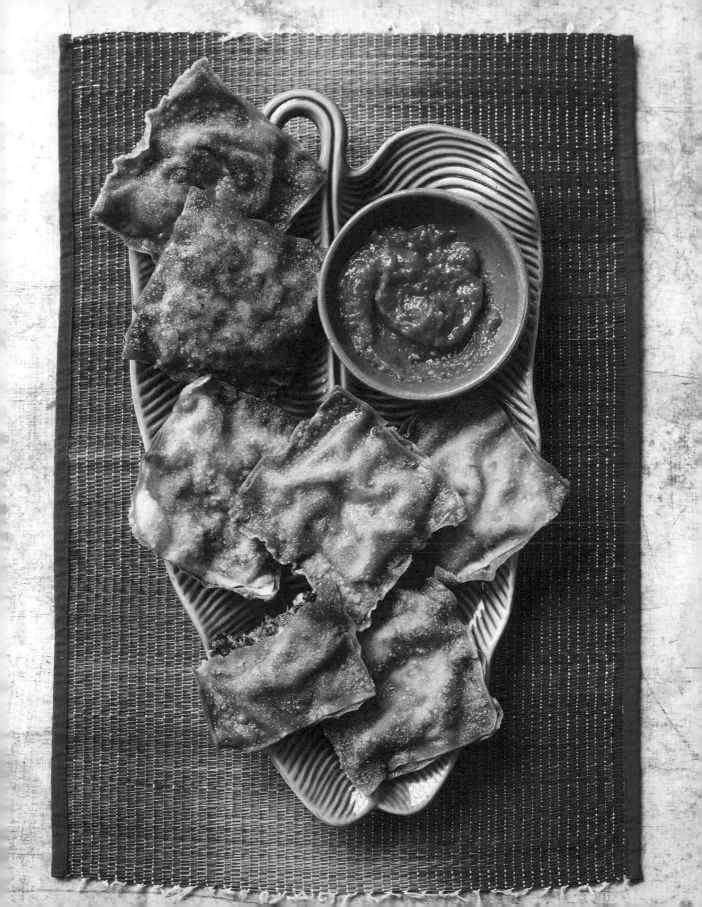

# CILANTRO & YOGURT FISH

Dhania machli ∼∼∼∼∼∼∼∼∼∼∼∼∼∼∼∼∼∼∼∼∼∼ Kenya/India

Serves 4

Yogurt is one of the world's most ancient foods. Its health benefits were noted in Indian Ayurvedic scripts dating from 6000 BC; the ancient Greeks pinned its use to "barbarous nations"; and the mellifluous "land of milk and honey" in the Bible is thought to be a reference to yogurt.

Its use in cooking diffused across Central Asia and northern India, acting as both a tenderizer and tangy flavor enhancer. (Move further south in Asia and coconut milk trumps dairy.) It is embraced in Gujarat in the form of a gently sweet soup, and in Bengal where light but creamy yogurt fish is a favorite dish. The habit made its onward journey by boat, traveling with the spice traders to East Africa, where a Muslim Indian community settled.

Here, generous amounts of cilantro with green chilies and cooling, silky yogurt make a particularly good combination. Earthy, hot and fresh.

100g (3½oz) cilantro

3 green finger chilies seeds in, roughly chopped

1 large tomato, roughly chopped

1 tablespoon tomato paste (concentrated purée)

1 tablespoon lemon juice

1½ teaspoons fine sea salt

600g (1lb 5oz) firm white fish fillets, in large chunks

3 tablespoons neutral oil

3cm (1¼ inches) ginger, peeled and minced (1 tablespoon)

6 garlic cloves, minced

200g (¾ cup) yogurt

Set aside a handful of cilantro leaves to use at the end, and remove any very thick stems, keeping the smaller ones. Roughly chop and put into a blender with the chili, tomato, tomato paste, lemon juice, 1 teaspoon of the salt and 200ml (generous ¾ cup) water. Blitz to a green paste.

Sprinkle the remaining ½ teaspoon of salt over the fish and leave to cure for 10 minutes, then rinse under cold water.

Meanwhile, heat the oil in a high-sided frying pan and cook the ginger and garlic together to lose the rawness. Pour in the cilantro mixture and bubble together for 10 minutes. It will lose its vibrancy but intensify in flavor.

Spoon in the yogurt gradually, stirring as you go to prevent it splitting. Simmer for a minute longer to get a sauce the texture of thick (double) cream —thin with a splash of water if needed.

Add the fish and stir to coat. Cover the pan and cook gently for 3–5 minutes until the fish is just starting to flake but not fall apart. Serve scattered with fresh cilantro..

## EAT WITH

Rice or Indian breads

# CUMIN &
# TAMARIND WATER

Zeera pani ～～～～～～～～～～～～～～～～～～～～～～～～～～～～ India

**Serves 4**

A quintessential Indian summer refresher—tangy and sour with a background salty sweetness. It is herbal and earthy too from mint and cumin, both known for their cooling properties. You could add a pinch of ground chili, as tamarind and mint both love spice.

1 teaspoon cumin seeds
1½–2½ tablespoons sugar
¼ teaspoon fine sea salt
3 tablespoons tamarind paste
Juice of a lime
Handful mint leaves
1 liter (4 cups) cold soda water
Ice, to serve

In a dry pan, toast the cumin to release its nutty, lemony notes, then grind to a powder with a pestle and mortar.

Tip into a jug with the sugar, sea salt, tamarind and the lime juice. Stir briefly and leave a while to let the sugar dissolve.

Crush the mint leaves in your hands to release the oils and drop these into the jug. Top up with soda water, muddle everything together and serve with ice.

SPICE

CRE

SCENDO

HEADY FLAVORS

& COMPLEX BLENDS

The Indian Mughal Empire was a champion of arts and exquisite architecture, reaching its zenith with the Taj Mahal. The Mughals were also masters of complex spice blends where many spices, often sweet and warming ones, were added at later stages of cooking, their interplay creating food as beautiful, heady and exhilarating as the art. This was building on an ancient Hindu foundation of pungent spice use, but refined with the delicacy and fragrance of Persian influence.

The tradition spread along the belt of Islam from Indonesia to Africa, particularly shaping food in Malaysia and Sumatra where Indian traders left a legacy of cooking that is more intricately spiced than in the rest of South East Asia. It also spread to the Arabian Peninsula and East Africa, where South Asian immigrants brought their intoxicating spice blends to be assimilated and adapted into new forms.

## Spice mixes are all about balance, the parts working together like an orchestra.

Each spice house or cook will have their own blends and magic, but there is a common thread you can follow through many spice routes countries. Let's grind some heroes of the spice world: peppercorns, nutmeg, cloves, cinnamon, cardamom and cumin. If we add coriander seed, mace and fennel, we make India's garam masala. Keep the coriander but swap in paprika, and we have baharat from the Middle East, or fenugreek for Somali xawaash. If instead we add turmeric and crushed rose petals, we arrive at the Persian spice mix of advieh.

Spices are usually roasted before blending to tease out and transform their essential oils. A gentle roasting will help amalgamate and balance the flavors, though some are best added uncooked, such as the mellow prettiness of fennel seeds. You can really taste the roasting in some spice mixes, such as dark Sri Lankan curry powders and Ethiopian blends, where the seeds are roasted for a long time to develop a deep, almost smoky nuttiness.

Early European mixtures, lost to history, echoed the fragrance of those from the East, but with added sweetness even in savory cooking. Scappi, chef to Pope Pius V, ground brown sugar, saffron and grains of paradise alongside the other "fine spices" of nutmeg, cinnamon, dried ginger and cloves.

Some of the most beguiling mixtures play with textures or have more distinct flavor profiles. Egyptian dukka has a nubbiness from roasted nuts; Bengali panch phoron uses only whole spices; South Indian gunpowder includes roasted lentils; and toasted rice gives an extra nuttiness to Sri Lankan curry powders. Chinese five spice is particularly distinctive for its woody, aniseed profile, while Hindi chaat masala is sour and fruity from dried mango and pomegranate seeds with sulfurous notes of black salt—a complete seasoning to kick tastebuds to life.

# SRI LANKAN PUMPKIN CURRY

Wattakka ～～～～～～～～～～～～～～～～～～～～～～ Sri Lanka

**Serves 4**

One of the most memorable meals of my life was a pumpkin curry eaten late at night after arriving in the mountain-ringed city of Kandy. The explosive flavors were the perfect antidote to a long, dusty bus journey. Sri Lankans are truly masters of spicing, using native cinnamon alongside myriad others for deep complexity. Here is my attempt to recreate that meal. The sweetly earthy curry is paired, as it was that night, with a fresh and vibrant coconut sambal.

### FOR THE CURRY
700g (1lb 9oz) Delica pumpkin or butternut squash
400g (14oz) sweet potato
2 tablespoons neutral oil
1 teaspoon black mustard seeds
1 teaspoon cumin seeds
6 curry leaves
1 red onion, finely sliced
5 garlic cloves, finely sliced
2 green finger chilies seeds in, finely sliced
1 teaspoon curry powder
1 teaspoon ground cinnamon
½ teaspoon freshly grated nutmeg
½ teaspoon ground turmeric
200ml (generous ¾ cup) coconut milk
1 teaspoon fine sea salt
Juice of a lime

### FOR THE COCONUT SAMBAL
75g (1 cup) grated coconut or rehydrated
   desiccated coconut
Large handful cilantro leaves,
   finely chopped
½ teaspoon fine sea salt
Juice of 1–2 limes
1 green finger chili, sliced (optional)

Red rice or Coconut & green chili flatbreads
   (page 141), to serve (optional)

Prepare the pumpkin by removing the seeds and cutting into 3cm (1¼ inch) chunks. You can keep any thin skin on for more texture or peel if you prefer. Peel the sweet potato and cut into 4cm (1½ inch) chunks.

Heat the oil in a casserole pan over a medium–high heat. Scatter in the mustard seeds, cumin seeds and curry leaves and let them splutter and pop. Add the onion and cook for 5 minutes to soften before adding the garlic and chili and cooking for a few minutes longer.

Stir in the ground spices, waiting for the fragrance to hit you. Add the coconut milk, salt and 100ml (scant ½ cup) water. Stir in the pumpkin and sweet potato and bring to a bubble. Cover, turn the heat down and simmer, stirring occasionally, for about 25–35 minutes, until tender. Rest with the lid on for 15 minutes to let the flavors develop. Taste for seasoning and finish with a squeeze of lime juice.

For the coconut sambal, mix all the ingredients together and taste for seasoning. Serve alongside the curry with the rice or flatbreads, if you like.

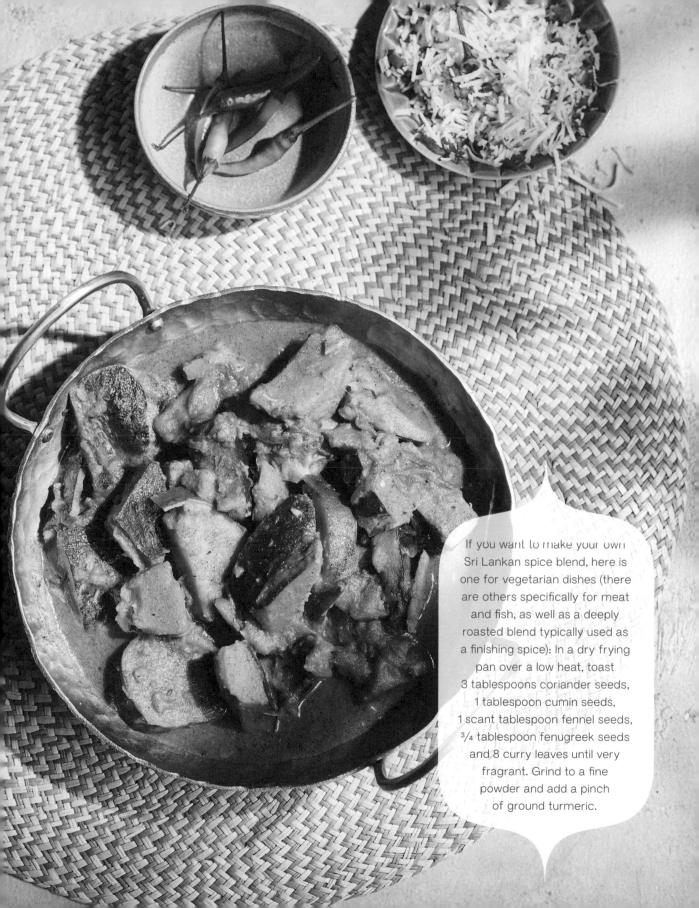

If you want to make your own Sri Lankan spice blend, here is one for vegetarian dishes (there are others specifically for meat and fish, as well as a deeply roasted blend typically used as a finishing spice): In a dry frying pan over a low heat, toast 3 tablespoons coriander seeds, 1 tablespoon cumin seeds, 1 scant tablespoon fennel seeds, ¾ tablespoon fenugreek seeds and 8 curry leaves until very fragrant. Grind to a fine powder and add a pinch of ground turmeric.

# ROASTED MALAI BROCCOLI WITH CASHEW & CARDAMOM

Malai broccoli ～～～～～～～～～～～～～～～～～～～～～～～～～～ India

**Serves 4 as a side**

This is a vegetable side with real character. Broccoli, tender but still with a little bite, is cloaked in a thick, nutty cream and a whisper of green cardamom. In the hot oven, mimicking the heat of a tandoor, everything begins to caramelize and char.

2 heads of broccoli
150g (1 cup) raw cashew nuts
100ml (scant ½ cup) thick (double) cream
100g (⅓ cup) Greek-style (strained) yogurt
2 garlic cloves
8 green cardamom pods, seeds only
1 teaspoon garam masala
1 teaspoon fine sea salt
½ teaspoon ground black pepper

Heat the oven to 200°C (400°F) and line two large baking trays with baking paper.

Cut the broccoli into small florets and put into a large mixing bowl.

In a blender, combine the remaining ingredients and whiz to a creamy paste—it doesn't matter if it's not completely smooth. Scrape into the bowl and turn everything well so the spiced cream gets into all the broccoli crevices.

Spread out on the baking trays and roast for 20 minutes, turning the pieces halfway through. The broccoli should be just tender with a good char on the edges.

## EAT WITH

Perfect as an accompaniment to spiced roast chicken, or a bowl of rice and dal, or just on its own in a quiet, happy moment

# AUBERGINE & TOASTED COCONUT CURRY

Pajerie terung ～～～～～～～～～～～～～～～～～～～～～～～～ Malaysia

**Serves 2 or 4 as a side**

This celebratory Malaysian dish is notable for its quantity of fragrant spices: cumin, coriander, turmeric and ginger provide supporting base notes, on top of which sweetly sing the sopranos: cinnamon, cardamom, cloves, fennel and star anise. The recipe starts with making a coconut paste called kerisik, toasted buff brown to bring a nutty, caramelized richness. I like the silky savoriness of aubergine, a gentle foil for the strident spicing, but wedges of pineapple could be used in its place.

4 tablespoons grated coconut or rehydrated
   desiccated coconut
2 tablespoons neutral oil
1 cinnamon or cassia stick
5 green cardamom pods, bruised
3 cloves
2 star anise
1 large aubergine (eggplant), cut into thin wedges
1 teaspoon palm sugar or brown sugar
1 teaspoon fine sea salt
2 teaspoons tamarind paste

*FOR THE SPICE PASTE*
4 small shallots, roughly chopped
5 garlic cloves, roughly chopped
3cm (1¼ inches) ginger, peeled and chopped
1½ tablespoons ground coriander
½ tablespoon ground cumin
½ tablespoon ground fennel seed
½ tablespoon ground turmeric
1 teaspoon ground chili (or to taste)

Toast the grated coconut in a dry frying pan over a low heat, stirring often until it turns an even, deep nutty brown. While still warm, use a pestle and mortar to pound the coconut to a paste. (A small high-speed blender will also work if you have one but can be a little tricky with these small quantities; adding a little water and scraping as you go will help.) Set aside.

Put all the ingredients for the spice paste into a blender—if you used it for the coconut, there is no need to rinse it. Add a little water to help the blades turn and blend.

Heat the oil in a frying pan over a medium heat and scrape in the spice paste. Fry until very aromatic and the rawness has gone. Add the whole spices and aubergine and turn to coat everything well. Pour over just enough water to cover. Mix in the toasted coconut paste, sugar, salt and tamarind.

Bring to the boil, then turn the heat down a little. Cook, uncovered, for 20–30 minutes, turning the aubergine occasionally to submerge it in its sludgy bath. It is ready when very tender, soft enough to cut with a wooden spoon, and the sauce is rich and creamy. Taste for seasoning—it may need more salt and/or extra tamarind paste to brighten.

## EAT WITH

Spiced butter rice: Sizzle a cinnamon stick, star anise, 3 cloves and 3 green cardamom pods in a generous knob of butter and pour over cooked rice

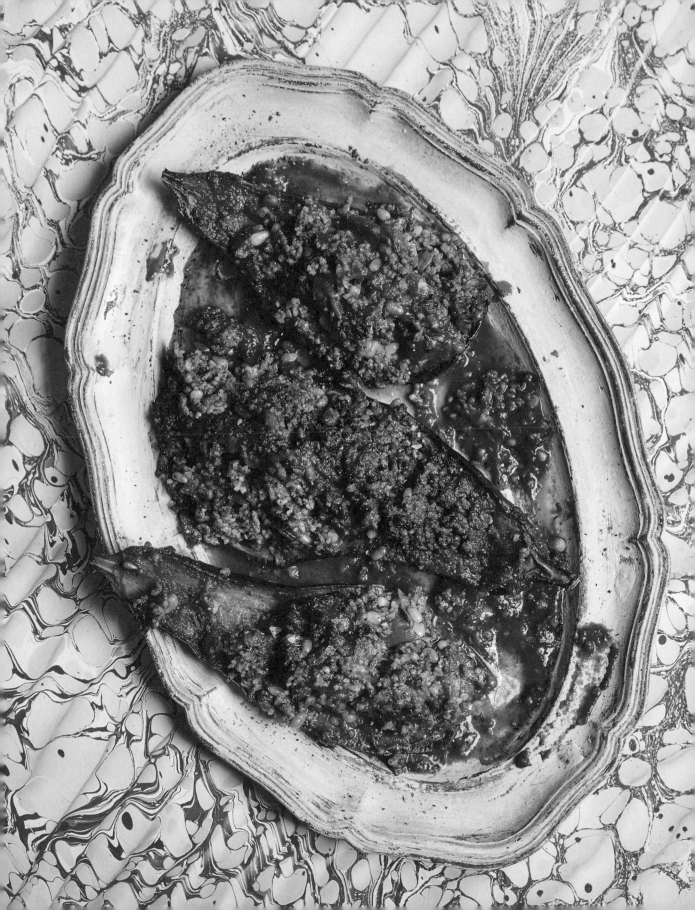

# THE SHEIK OF STUFFED VEGETABLES

Sheikh al-mahshi ~~~~~~~~~~~~~~~~~~~~~~~~~~~~~~~~~~~~~~~~~~~~~ Lebanon

Serves 4

Stuffing vegetables is a Persian tradition that was adopted by the Ottomans and swept across their far-reaching empire. Today, you can find every plant being stuffed in a host of countries and in countless wonderful versions, from vine leaves to zucchini, tomatoes to quince. In Lebanon, meat-stuffed aubergines scattered with pine nuts have been named Sheik of them all, and for years have been one of my favorite things to cook. Traditionally the aubergines are fried first, but I skip a step and bake them. Just be sure there is enough moisture in the dish to soften the aubergines; they should be silky-fleshed and infused with sweet spices.

2 large aubergines (eggplants)
60g (¼ cup) tomato paste (concentrated purée)
2 tablespoons sugar
2 tablespoons olive oil
Juice of a lemon

*FOR THE STUFFING*
2 tablespoons olive oil
1 onion, finely chopped
250g (9oz) minced beef, lamb or a mixture
1 teaspoon Lebanese seven spice/baharat (optional)
1 teaspoon ground allspice
1 teaspoon ground cinnamon
4 tablespoons pine nuts
4 tomatoes, chopped
3 tablespoons bulgur wheat

To make the stuffing, heat the olive oil in a frying pan and soften the onion. Add the minced meat and break up with a spoon, allowing it to brown. Scatter over the spices and pine nuts and cook for another couple of minutes then add the tomatoes and season. Cook for 15 minutes. Taste for seasoning then stir through the bulgur wheat.

Heat the oven to 170°C (340°F).

Slice the aubergines lengthways and scoop out a pocket from the middle of each one (save the middles for another use). Sit in an oven dish and fill each hollow with the stuffing—they will spill over generously.

Mix together the tomato paste, sugar, olive oil and lemon juice. Season with salt and pepper and thin with 200ml (generous ¾ cup) water. Pour over the stuffed aubergines and cover with foil. Bake for 1 hour. Remove the foil, baste the aubergines in their tomatoey juices and return to the oven for a final 15 minutes.

## EAT WITH
A salad dressed with olive oil, lemon, a pinch of sumac and plenty of soft herbs

# TURKISH WINTER VEGETABLES

Türlü ~~~~~~~~~~~~~~~~~~~~~~~~~~~~~~~~~~~~~~~~~~~~~~~~ Turkey

**Serves 4 as a substantial side**

Türlü comes from the old Turkic word for "assortment," reflecting that this dish is made with a medley of vegetables, sometimes with the addition of meat. Traditionally they are baked together in a clay pot, though I like to roast them spread out, allowing the flavors to concentrate and sweeten in the heat of the oven. This is a beautiful display of spicing, a gentle dance of floral coriander seeds, smoky pul biber and sweet warmth from cinnamon and allspice.

1 aubergine (eggplant)
300g (10½oz) squash, seeds removed
1 onion, peeled
2 potatoes, scrubbed
3 carrots, scrubbed
2 celery stalks
6 garlic cloves, peeled
3 tablespoons olive oil
2 teaspoons coriander seeds
2 teaspoons pul biber
½ teaspoon ground cinnamon
½ teaspoon ground allspice
250ml (1 cup) tomato passata (puréed tomatoes)
175g (6oz) cooked chickpeas, from a jar or tin
Parsley, mint and dill, to serve

Heat the oven to 210°C (410°F).

Cut the aubergine, squash and onion into wedges of similar size. Cut the potatoes into 2cm (¾ inch) cubes. Thickly slice the carrots, celery and garlic. Put all the vegetables into a large bowl and toss with the olive oil, spices, salt and pepper. Transfer to two large roasting trays—they should lie well-spaced in a single layer so they roast rather than steam.

Roast for around 45 minutes, gently shuffling the vegetables in the tray halfway through and swapping the trays in the oven. When everything is tender with crisp and charred bits at the edges, tip all the vegetables onto one of the trays. Season the passata and gently stir through the vegetables along with the chickpeas. Return to the oven for 10 minutes.

Tumble onto a serving dish, sprinkling with more salt and pepper if needed, along with a very generous scattering of the fresh herbs.

## EAT WITH
Lamb roasted with cumin

Or as a vegetarian main course with seasoned

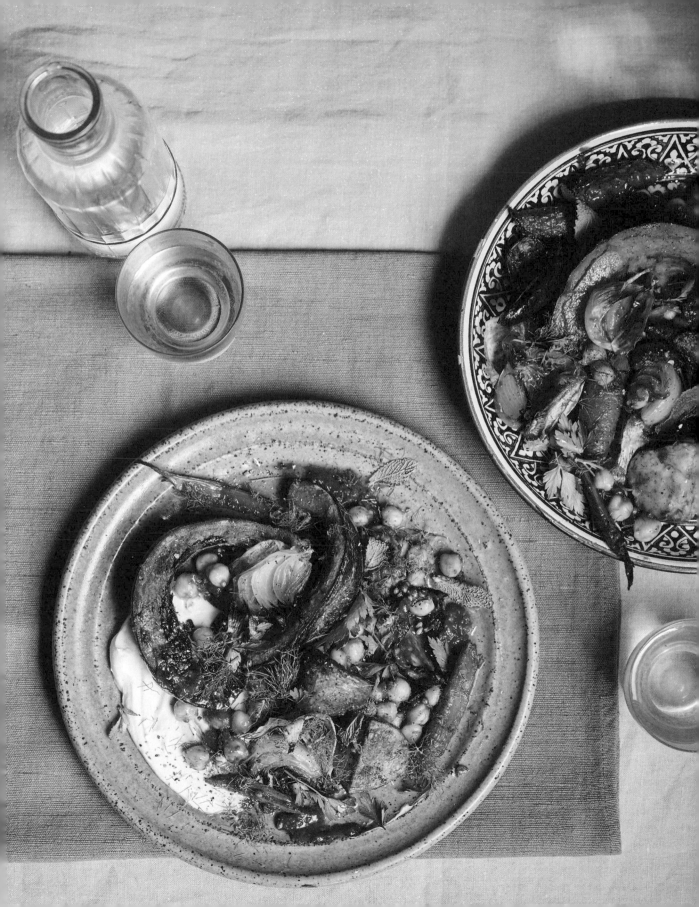

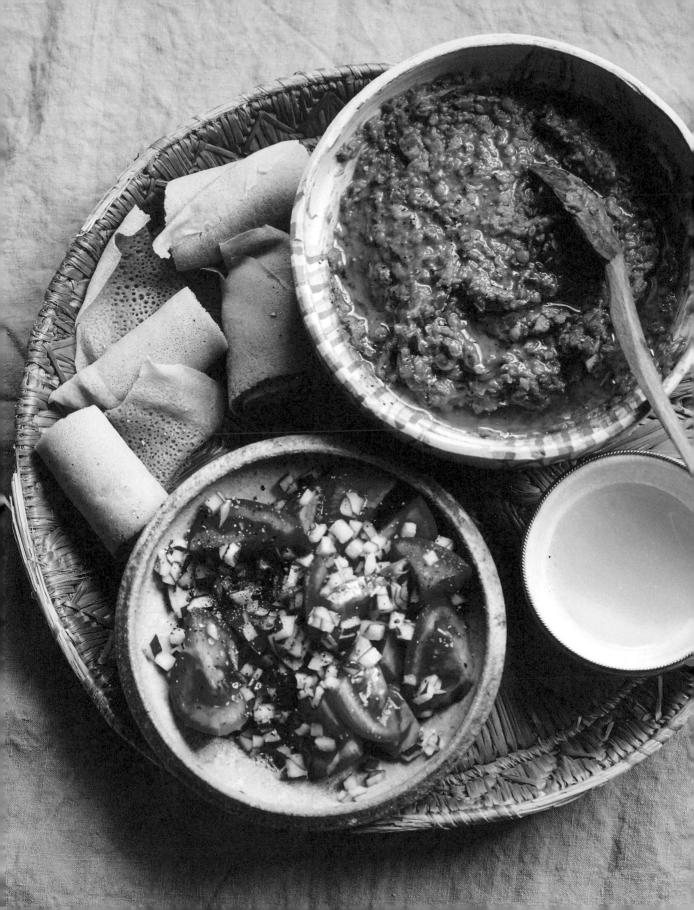

# MISIR WAT

Serves 4

Two bewitching spice blends are at play here. The first is a spice-infused butter, used as both the base and finisher for the lentils to add richness and floral-eucalyptus notes from pods known as Ethiopian cardamom, korekima. The second is berbere, a chorus of ground chili, onion, fenugreek and sweet spices. Ingredients vary from village to village but the end result is always fiery. I buy it pre-prepared as berbere production is highly ritualized, best made by wet ingredients being slightly fermented over several days before being sun-dried and ground to a powder. Zewditu Yohannes, an acclaimed musician and talented cook, shared her delightfully spicy recipe with me. You must try it.

### FOR THE NITE KIBBEH (SPICED BUTTER)
125g (½ cup) unsalted butter
½ red onion, chopped
1 garlic clove, sliced
3cm (1¼ inch) ginger, chopped
½ teaspoon korekima or 4 green cardamom
  pods, bruised
½ teaspoon black peppercorns
¼ teaspoon ground turmeric

### FOR THE MISIR WAT
2 tablespoons neutral oil
2 red onions, finely chopped
4 tablespoons berbere
1 teaspoon fine sea salt
6 tablespoons finely chopped tinned tomatoes
300g (1½ cups) split red lentils, well washed
7 garlic cloves, minced
5cm (2 inches) ginger, peeled and minced
  (1½ tablespoons)

### FOR THE ETHIOPIAN SALAD
2 ripe tomatoes, chopped
½ red onion, finely chopped
2 garlic cloves, finely chopped
2 green finger chilies, finely chopped
1 tablespoon extra-virgin olive oil
Juice of ½ a lemon

Ethiopian injera bread, to serve (optional)

Put all the nite kibbeh ingredients in a small pan and melt over a low heat. Simmer gently for about 20 minutes. The butter solids should separate but be sure they don't burn. Leave to cool and infuse, but not solidify. Strain through a fine sieve or muslin to remove both the foam and aromatics.

For the misir wat, heat the oil and 2 tablespoons of the nite kibbeh over a medium–high heat. Add the onion and soften. Stir in the berbere and salt and fry, stirring until aromatic. Add the tomatoes and cook for a few minutes until rich and dark—keep stirring. Stir in the lentils, wet from washing, and lower the heat. Cover and cook for 3 minutes. Stir, then add 600ml (2⅓ cups) water. Cover, bring to the boil and cook at a lively bubble for 10 minutes. Mix in the garlic, ginger and a splash of water if it looks too thick. Cover and cook for 5 minutes.

Meanwhile, combine all the ingredients for the salad, waiting until the last moment before adding the lemon juice. Season with salt.

Either drizzle melted nite kibbeh over each serving or stir a tablespoon of it into the pot. Eat by scooping up with the injera bread and serve the salsa-like salad alongside.

# SINDHI SPICE-CRUSTED FISH

Palla machli ～～～～～～～～～～～～～～～～～～～ Pakistan

**Serves 4**

Sindh province of Pakistan was the country's gateway to the spice trade in the seventeenth century. This heritage has left a tapestry of culinary influences, with threads from Central Asian and Mughal cookery along with ideas and ingredients brought in with maritime trade. Tartness and fragrance are both prized, so you will find food sewn with dried pomegranates, plums and mangos and perfumed with rose petals.

This dish is usually made with palla, a river fish, but sea bass makes a good substitute. A sprinkling of chaat masala at the end adds a sour zing that complements the more delicate, earthy and peppery spice crust on the fish.

1 tablespoon ground coriander
2 teaspoons fennel seeds, crushed
2 teaspoons ground turmeric
1 teaspoon Kashmiri chili powder
1 teaspoon fine sea salt
2 tablespoons rice flour or plain flour
4 large white fish fillets, such as palla
   or sea bass, skin removed
2 garlic cloves, crushed or grated
Oil, for frying
1 teaspoon chaat masala (optional)

In a bowl, mix together the spices, salt and flour.

Rub the fish fillets with the crushed or grated garlic, then turn to coat well in the spiced flour. Press firmly to help the flour stick, but shake off any excess.

Heat a heavy-based frying pan over a medium heat until you see a wisp of smoke. Add enough oil to just coat the base of the pan and carefully slide in the fish fillets. Shake lightly to move the fish, then leave to cook for 3–4 minutes, pressing down gently. The crust should be golden. If it browns too quickly, remove from the heat briefly. Flip and cook on the other side for another minute.

Drain on a paper towel and serve at once. Dust with chaat masala if you'd like an extra salty-sour tang.

## EAT WITH
Fried potatoes, green chutney, radish salad

A quick green chutney: Blend together a bunch of cilantro with 1 large tomato, 1 green chili, 1 garlic clove and a good pinch of salt and sugar.

Pakistani radish salad: Finely slice daikon or radishes (maybe including a few leaves for color). Mix with fine moons of red onion and dry-roasted cumin seeds. Dress with lemon juice and a pinch of salt

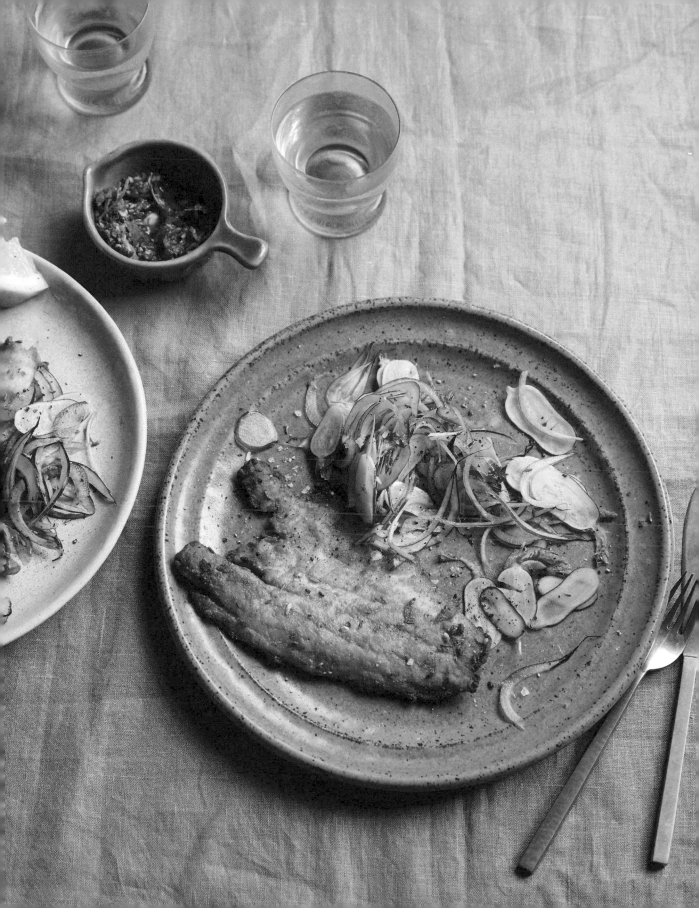

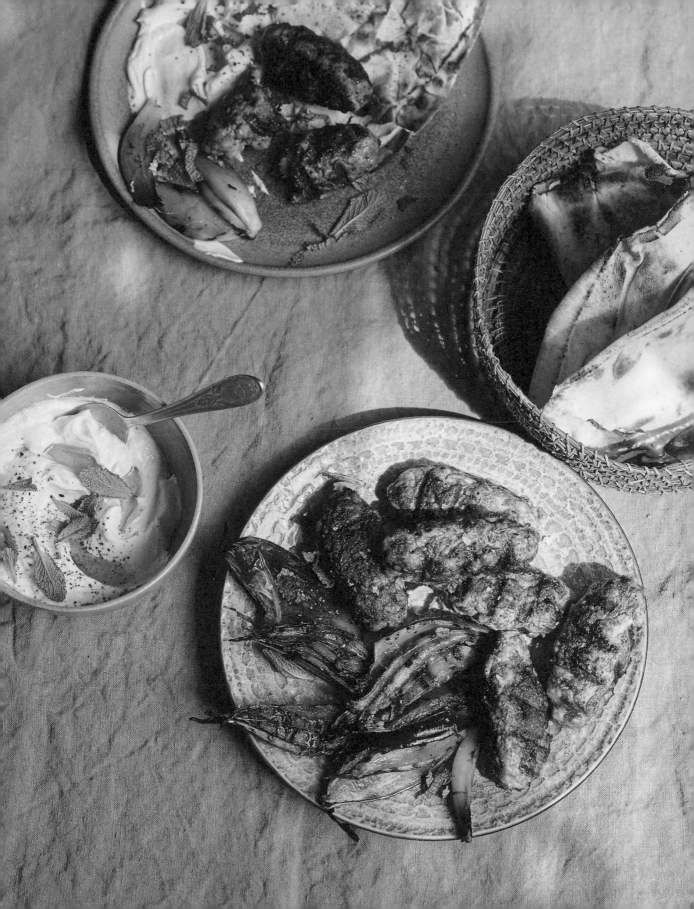

# MINCED CHICKEN KEBABS WITH SWEET SPICES

Kafta ~~~~~~~~~~~~~~~~~~~~~~~~~~~~~~~~~~~~~~~~~~ Lebanon

Serves 4

There is just enough spice to enchant, not overwhelm, in these delightful minced chicken kebabs. This is an easy and popular recipe, especially good when the meat picks up a little char from the grill and perfect for a summer barbecue. You will find versions across Lebanon and the Arabian Peninsula, most usually made with lamb but I like the delicacy of chicken.

Baharat simply means "spices" and blends vary regionally in the Middle East, sometimes mild and smoky, sometimes sweet and fragrant. You can buy ready mixes or if you want to make your own baharat blend just for this recipe, combine ½ teaspoon each of ground paprika, cumin and coriander, ¼ teaspoon each of ground pepper, cinnamon, green cardamom, nutmeg and allspice, and ⅛ teaspoon each of ground cloves and chili,

500g (1lb 2oz) skinless, boneless chicken thighs
3 teaspoons baharat spice mix (see introduction)
1 teaspoon fine sea salt
2 medium firm tomatoes, coarsely grated and squeezed dry
1 small onion, coarsely grated and squeezed dry
2 garlic cloves, minced
2 tablespoons finely chopped parsley
Neutral oil, for brushing

Cut the chicken into large chunks, keeping on some fat to ensure succulent kebabs. Put into a food processor with all the other ingredients. Pulse chop to mince the meat and bring everything together—go gently as you want the chicken well minced but not textureless.

With oiled hands, divide the mixture into 12 and roll and compress into flattened sausage shapes, about 2cm (¾ inch) thick. They will be soft, but chill in the fridge for half an hour or more to help them firm up and hold their shape.

Heat a griddle pan over medium–high heat and brush with oil. Grill the kebabs for 12–15 minutes, turning once, or until the outsides are lightly charred and the chicken is cooked through but still tender. If you are checking with a meat thermometer, it should reach 74°C (165°F).

## EAT WITH

Pita or flatbread, minted yogurt, grilled onions and tomatoes

Minted yogurt. Mix a small minced garlic clove and a good pinch of salt into a bowl of yogurt. Stir through finely chopped mint leaves and a squeeze of lemon juice

# REDRAWING THE WORLD

There is an island so small and forgotten it is often left off today's atlases altogether but once Rhun was writ large on naval maps, for

**this fragrant isle of nutmeg was the most desired place on earth.**

Such fabulous wealth could come from controlling the spice trade that the volcanic island, a speck in the Banda Sea of eastern Indonesia, was considered a fair exchange for another strategic island on the opposite side of the globe: Manhattan.

Old World maps held many blanks and seas drifting off over unknown horizons, revealing as much about the perspective of the cartographer as the lay of the land. A twelfth-century Muslim chart, Tabula Rogeriana, depicted with some accuracy the entirety of Eurasia and the crown of Africa set in a striated indigo sea. As masters of early trade, Arabs had the most complete picture of the known world. A full shape of the African continent appears for the first time in 1489 Italian cartography, the knowledge fresh from Portuguese spice seekers rounding the Cape of Good Hope, and soon after the Americas joined as the Old World and New World discovered each other. An illustrated Thai map from the 1776 Traiphum shows the south at the top, with Thailand's jagged shores below cloud-like spice islands, the destination for a European ship and a Chinese junk shown battling through swirling waters. So much of this discovery, and redrawing of maps, was done in the name of spice.

As the Europeans entered the spice race in the fifteenth century, they did so with their sights on the greatest prize: nutmeg, which grew only on the ten tiny Banda Islands. Said to cure illness, illicit desire and induce hallucinations, it took the Spanish to the Americas, the Portuguese around Africa and, rather eccentrically, the route decided on by the English was due north over the pole, where their ships were promptly crushed by ice floes in the Arctic winter. Decades of swashbuckling adventures and misadventures followed, evolving into the unstoppable force of European colonization. This was a period typified by avarice, ego, piracy, double dealing, disrespect, battles, bloodshed and barbarity.

Even when voyages were eventually successful in reaching the islands, there were hidden coral reefs to splinter ships in the tempestuous waters, and locals rumored to be cannibals. In fact, the Bandanese were skilled and sophisticated traders, key players in the spice routes for centuries, and they effectively repelled European intruders for many years. The Portuguese were the first to arrive to the region and the first deterred. The Dutch landed in 1599 and, with a taste of riches from the flotillas of nutmeg sent back home, soon changed their goal from trade to conquest. Years of battles between foreign nations ensued and the island of Rhun came under English power to become its very first colony. The Dutch eventually wrested control and sought to monopolize the

nutmeg trade through ruthless brutality. Frustrated by the English threat and local resistance, in 1621 they turned their policy to subjugation and the population was decimated by massacre and ensuing famine. The Dutch ordered every nutmeg tree on Rhun chopped down. In 1667, a peace treaty was signed: the English ceded Rhun, while the Dutch gave up New Amsterdam, which the English renamed New York. Nutmeg had been traded for the Big Apple and a huge shift in global power began.

Throughout it all, the resilience of the local people remained. Though they endured destruction of their precious spice crops and massacre of their population, they bided time until they could take back control of their nutmeg. Their regional dominance outlasted the colonial nutmeg craze and no memorial to the history stands today on the jungle-tangled islands. Once more they are quiet and languorously scented with spice.

# A NOTE ON NUTMEG JAM

In the Banda Islands, nutmeg fruit is used in sweets, pickles or turned into jam. I tried this with the fresh nutmeg photographed for this book. While the raw fruit has little fragrance to hint at the wonder within, once cooking the scent is sharp and unmistakable. To make a blushing, syrupy marmalade, finely slice the firm flesh into crescents. Barely top with water, cover and simmer for 30 minutes to soften. Add an equal weight of sugar and cook uncovered over a medium—low heat, occasionally stirring, for a further 30 minutes or until the consistency you'd like. Pot in a sterilized jar.

# JASMINE TEA-SMOKED CHICKEN

Xun ji 〰〰〰〰〰〰〰〰〰〰〰〰〰〰〰〰〰〰〰〰〰〰〰〰〰 China

### Serves 2

Using just a wok, you can smoke poultry, fish or tofu easily at home. Cook your main ingredient first, then create a smoky chamber in the wok where tea and spice imbue it with an amazing intensity of flavor. Here I have added star anise into the mix. You could also use any of the other elements of Chinese five spice: a crumbled stick of cassia, whole fennel seeds, cloves or Sichuan peppercorns. This dish is wonderful with steamed Chinese pancakes or lotus buns, spring onions (scallions), cucumber and plum sauce.

*FOR THE SICHUAN PEPPER SALT*
1/2 teaspoon Sichuan peppercorns
1 teaspoon fine sea salt

*FOR THE SMOKED CHICKEN*
2 skinless, boneless chicken breasts
3 tablespoons loose-leaf jasmine tea
1/2 teaspoon sesame oil
2 tablespoons jasmine rice
2 tablespoons brown sugar
1 star anise, broken into pieces

Use only the prickly husks of the Sichuan peppercorns, discarding any glossy black seeds. Toast together with the salt in a wok over a medium–low heat, stirring until the peppercorns start to smoke and the salt is slightly discolored. Grind to a powder.

Rub the chicken breasts with half the Sichuan pepper salt. If you have time, do this the day before cooking and refrigerate overnight for exceptionally tender meat. Otherwise, proceed to steaming.

Place a steamer over a pot of boiling water. Add 1 tablespoon of tea to the water. Put the chicken on a plate in the steamer, cover with a lid, reduce the heat to medium and steam for 12–15 minutes, depending on the size of the breasts. Remove and brush all over with sesame oil.

Line a wok or pan with tin foil. Evenly scatter in the remaining tea, raw rice, sugar and star anise. Sit a rack or trivet above the mixture and put the chicken breasts on top. Cover the pan tightly and place over a high heat. When a wisp of smoke starts to escape, turn the heat down low and smoke for 5 minutes. Turn off the heat without lifting the lid and leave for 20 minutes longer. The chicken breasts should be cooked through and juicy, the outsides a gorgeous tobacco brown.

Leave to rest before serving thinly sliced, hot or cold, with the remaining Sichuan pepper salt (to taste). I like to wrap the slices in steamed pancakes with shreds of spring onion (scallion), cucumber and some plum sauce.

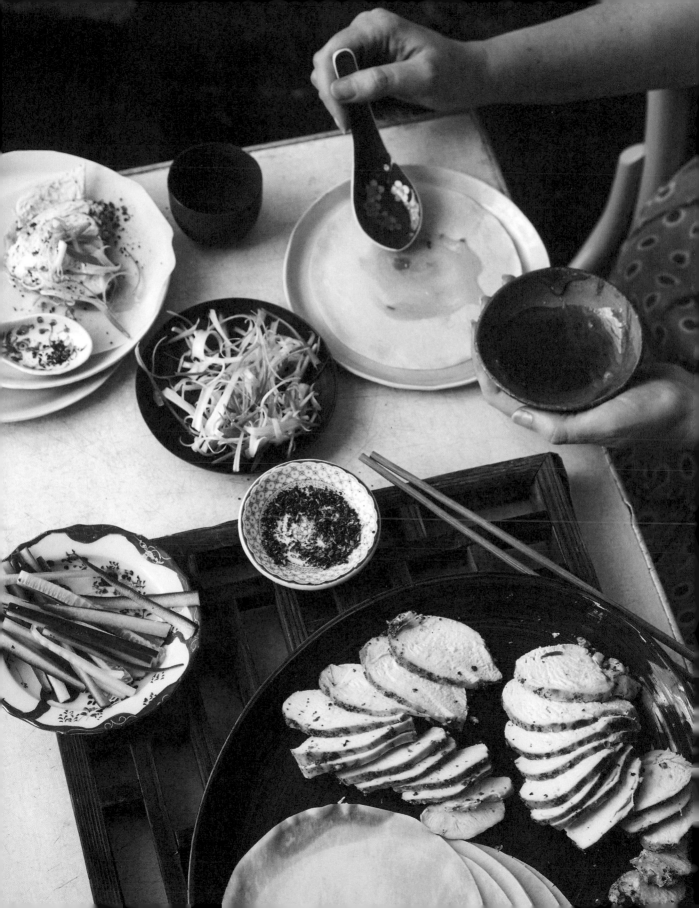

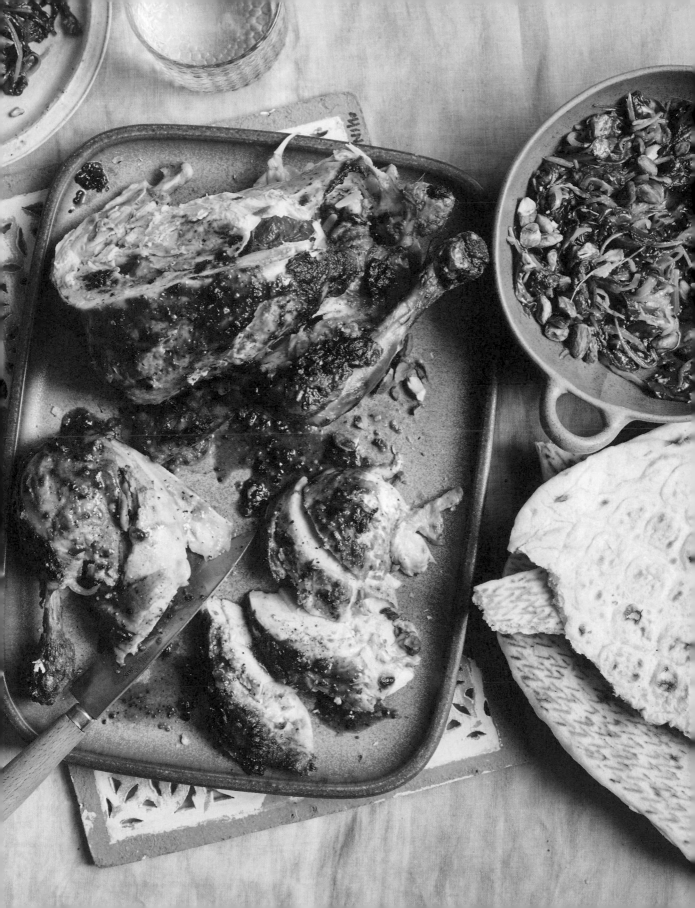

# TANDOORI ROAST CHICKEN

Tandoori murgh ⌇⌇⌇⌇⌇⌇⌇⌇⌇⌇⌇⌇⌇⌇⌇⌇⌇⌇⌇⌇⌇⌇⌇⌇⌇ India

**Serves 4**

Tandoori chicken is a jewel in the crown of North Indian cuisine, the dish we know today being a twentieth-century creation founded on an ancient past. There is evidence of chickens being roasted in clay ovens as early as 3000 BC and the spiced yogurt marinade has become synonymous with the tandoor oven (though this is necessarily cooked without one). I must give thanks to Roopa Gulati for inspiring my version; she is a spice maestro and the marinade is hers. This is truly one of my favorite things to cook and eat.

1.4kg (3lb 2oz) chicken

*FOR MARINADE 1*
2 teaspoons black peppercorns, cracked
2 teaspoons fine sea salt
1 teaspoon Kashmiri chili powder
3/4 teaspoon ground turmeric
60ml (1/4 cup) white vinegar
1 tablespoon neutral oil

*FOR MARINADE 2*
150g (generous 1/2 cup) Greek-style
   (strained) yogurt
3cm (11/4 inches) ginger, peeled and minced
   (1 tablespoon)
6 garlic cloves, finely chopped
2 green chilies, seeds in, finely chopped
1/2 teaspoon garam masala
1/2 teaspoon ground cumin

Cut two deep slashes across each chicken breast, thigh and drumsticks. Sit the chicken in a snug-fitting roasting tin.

Mix all the ingredients for the first marinade together then pour evenly over the chicken. Set aside while you make the second marinade.

Whisk together all the ingredients for the second marinade, then spoon over the chicken, making sure it is well coated. Cover and put in the fridge overnight to marinate. Bring the chicken to room temperature before roasting.

Heat the oven to 200°C (400°F).

Roast for 1 hour–11/4 hours, spooning over the marinade and collected roasting juices a couple of times during cooking. If it is browning too fast, loosely cover with tin foil. It is ready when the juices run clear or a meat thermometer reads 74°C (165°F).

Rest before serving.

## EAT WITH

Naan bread and perhaps some Aphrodisiac greens (page 60)

You could also add Aloo jeera: Coat a large frying pan with oil and sizzle a heaped teaspoon of cumin seeds. Add 550g (1lb 4oz) new potatoes cut into 1cm (1/2 inch) dice and stir-fry for a couple of minutes. Sprinkle in 1/2 teaspoon ground turmeric and 1/2 teaspoon ground chili. Lower the heat, cover and cook for about 10 minutes or until tender, stirring once or twice. Season with salt.

# GRIDDLED PITA STUFFED WITH SUMAC-SPICED MEAT

Arayes ~~~~~~~~~~~~~~~~~~~~~~~~~~~~~~~~ Middle East and Levant

## Serves 4

A wonderful addition to the kebab culinary canon and a reversal of the usual order of things, as meat is wedged into pita bread before being griddled. In Arabic, arayes means "brides" and here she is, the delicately spiced filling, enveloped in the arms of her groom, the bread. The marriage is undeniably burger-like but even quicker to prepare and with enticing sour and smoky notes from the sumac and paprika.

These kebabs work well made in advance and packed up to cook on a campfire, if you are that way inclined.

450g (1lb) beef or lamb mince
1 heaped tablespoon tomato paste
  (concentrated purée)
1 heaped tablespoon pine nuts, toasted
1 heaped teaspoon ground sumac
1 heaped teaspoon smoked paprika
3/4 teaspoon ground allspice
3/4 teaspoon fine sea salt
3 tablespoons finely chopped parsley
4 large pita breads
Olive oil, for brushing
Pomegranate molasses, to serve

Mix together the minced meat, tomato paste, pine nuts, spices, salt and parsley.

Cut the pita breads down one side and spread the filling in each in a thin and even layer. Brush the outsides with olive oil.

Heat a griddle pan to medium–high. Grill the pitas, pressing down with a spatula and flipping occasionally. A quarter turn in the pan will give you crisscross markings. They will probably take about 8–10 minutes in total, depending on your bread and how rare you like your meat. The pita should be well toasted and the meat cooked to a juicy pink or well done.

Serve drizzled with pomegranate molasses.

## EAT WITH

Crunchy salad with tomatoes, herbs and perhaps a tahini dressing. You can make one by mixing Greek-style (strained) yogurt with a minced garlic clove, a few spoonfuls of tahini and seasoning with salt

# RICE & SPICE

~~~~~~~~~~~~~~~~~~~~~~~~~~~~~~~~~~~~~~~~~~~

All serve 4–6

Plain white rice is a canvas on which to paint a meal, perhaps with a turmeric-tinted curry, emerald vegetables and scarlet slash of chili sauce. Sometimes, though, you might want something a little showier, so here is a panoply of ways for rice to step forward to co-star alongside any of the recipes in this book. Spices have a wonderful ability to work together, so look for one or two overlaps in flavor, then be bold with your pairings.

CARAMELIZED ONION RICE

Vagharela chawal ~~~~~~~~~~~~ India

From the Parsi community of Gujarat, a bewitching marriage of browned onions, cinnamon, black cardamom, black pepper and cumin.

Wash then soak 400g (2 cups) basmati rice while you caramelize the onions. Heat 2 tablespoons ghee or oil and add 1 cinnamon stick, 2 bruised black cardamom pods, 10 black peppercorns and 1 teaspoon cumin seeds. Sizzle until fragrant then add 2 thinly sliced onions and ³/₄ teaspoon fine sea salt. Cook slowly and patiently as the onion softens and starts to brown. Add 1 tablespoon sugar and continue to cook, stirring often, to a deep-brown tangle. Add the drained rice into the onions with 625ml (2¹/₂ cups) water. Bring to a rolling boil, then turn down the heat to a whisper and cover. Steam for 12 minutes, remove from the heat and rest for another 10 minutes. Gently fluff with a fork before serving.

YELLOW COCONUT RICE

Nasi kuning ~~~~~~~~~~~~ Indonesia

Grains swollen with creamy coconut milk and stained a mellow yellow, this rice is at its most splendid when served shaped into a tumpeng, a volcano-like cone.

Wash 350g (1³/₄ cups) jasmine rice well, then steam for 10 minutes to par-cook. Meanwhile, blitz 4cm (1¹/₂ inches) galangal, 3cm (1¹/₄ inches) fresh turmeric (or ³/₄ teaspoon ground), 2cm (³/₄ inch) ginger, 3 small shallots and 3 garlic cloves in a blender with 300ml (1¹/₄ cups) water. Strain to keep the brilliant orange liquid. Add this to a pan with 200ml (generous ³/₄ cup) coconut milk, a stick of bruised lemongrass, 1 tablespoon oil and ¹/₂ teaspoon fine sea salt. Bring to the boil, then stir in the rice, cover and turn off the heat. After 10 minutes it should have absorbed the coconutty broth and be ready to eat.

TOMATO RICE WITH TOASTED CASHEWS

Nasi tomato ～～～～～～～ Malaysia

Rice with personality—all heady spice, tart tomato depth and nut crunch. It is often served with Malaysian chicken curry.

Wash then soak 400g (2 cups) basmati rice while you make the spice base. Heat 2 tablespoons ghee or butter over a low heat and add 1 cinnamon stick, 1 star anise, 3 whole cloves and 4 bruised green cardamom pods. When sizzling and aromatic, add 1 chopped onion, 2 minced garlic cloves, 2 teaspoons freshly minced ginger and 1 pandan leaf snipped into a few pieces. Cook to soften the onion, then stir in 2 tablespoons tomato passata (puréed tomatoes) and ½ teaspoon fine sea salt. Drain the rice and add to the pan with 625ml (2½ cups) water. Stir gently and bring to a rolling boil. Cover, turn the heat to the lowest and leave to steam for 12 minutes. Turn off the heat without lifting the lid and leave for another 10 minutes. Fluff with a fork. Serve scattered with toasted cashew nuts.

LIME & SPICE RICE

Naranga choru ～～～～～～～ India

Earthy spices offset by tangy lime, a delightful mingling from the Malabari Jews of Kerala. Spice and monsoon winds brought both Jewish and Chinese communities to this cosmopolitan region of India from the early centuries AD.

Wash 400g (2 cups) basmati rice well, leaving to soak for half an hour if you have the time. Drain and put in a pan with 625ml (2½ cups) water and ½ teaspoon ground turmeric. Bring to a rolling boil, then cover and turn the heat right down. Cook for 12 minutes, then turn off the heat and leave undisturbed for another 10 minutes. Meanwhile, heat 2 tablespoons oil and add 1 teaspoon black mustard seeds. When they pop, add 1 teaspoon coriander seeds, ¼ teaspoon cumin seeds and ¼ teaspoon cracked black pepper, 2 minced garlic cloves, 1 teaspoon freshly minced ginger, 1 finely chopped green finger chili and a handful of peanuts. Sizzle gently until fragrant. When the rice is ready, fork through the spice mix along with the juice of a lime.

SWEET RICE FOR SAVORY FOOD

Muhammar ～～～～～～～～～～ Bahrain

Many rice dishes from Arab and Arab-influenced cuisines are sweet. Muhammar, originally made by pearl divers, is perfumed with treacly date syrup, cardamom and rose water. For contrast, it is typically served alongside grilled fish rubbed with ginger, turmeric, lemon, garlic and chili. The heady sweetness makes the rice stretch further, so this will happily feed 6.

Wash 400g (2 cups) basmati rice and soak for 30 minutes. Infuse a crumbled pinch of saffron strands and 2 teaspoons pre-ground cardamom or the freshly ground seeds of 6 green pods in 1–3 tablespoons rose water (depending on its strength). Drain the rice and stir into a pan with 575ml (2⅓ cups) water, 100ml (scant ½ cup) date syrup and ½ teaspoon fine sea salt. Bring to the boil, then cover and turn down the heat low to steam for 12 minutes. Turn off the heat, sprinkle over the spiced rose water and quickly but gently fork through. Cover again and leave to steam off the heat for a final 15 minutes. Drizzle with melted ghee or butter before serving, if you wish.

KHICHDI

Khichdi ～～～～～～～～～～ India

This Indian rice and lentil blend inspired both Anglo-Indian kedgeree and Egyptian koshari. It is gentle and succoring and pairs well with dishes with intense or tangy sauces.

Wash 250g (1¼ cups) basmati rice and 150g (¾ cup) split red lentils, then soak in a bowl of cold water. Heat 4 tablespoons oil, add 1 heaped teaspoon cumin seeds and sizzle. Stir in 2 sliced onions, 2 minced garlic cloves and 2 teaspoons freshly minced ginger. Cook until softened. Drain the rice and lentils and add to the pan with 625ml (2½ cups) water. Bring to a rolling boil, then cover and turn down the heat to its lowest. Steam for 12 minutes, then turn off the heat without lifting the lid and sit for another 10 minutes. Fork through before serving, with the optional addition of a handful of blanched green peas.

PANDAN-SCENTED JASMINE RICE

Fragrant, balmy jasmine rice to accompany South East Asian dishes. There are few better ways to scent a kitchen.

Wash 400g (2 cups) jasmine rice well. Put in a pan with 625ml (2½ cups) water and 2 knotted pandan leaves. Bring to a rolling boil, then turn down the heat to the lowest setting and cover. Steam for 15 minutes, then turn off the heat and, resisting the urge to peek inside, leave for another 10 minutes. Gently fluff with a fork before serving.

JEWELED RICE

Javaher polow ～～～～～～～～～ Iran

A truly spectacular, saffron-streaked,
piled with emerald nibs of pistachios, garnets of
candied orange zest, almond pearls and rubies of
pomegranates, barberries and sour cherries.

Wash 400g (2 cups) basmati rice and soak in
a bowl with 75g (2½oz) barberries. In another
bowl, soak a crumbled pinch of saffron strands
in 2 tablespoons orange blossom water. Pare the
zest of half an orange, cut into thin slivers and
boil for 1 minute to reduce its bitterness. Put
2 tablespoons sugar in a pan with a good glug
of water. Heat to dissolve the sugar, then add
the orange zest and cook the liquid down to a
syrup. Add the saffron-infused orange blossom
water and remove from the heat. Mix in the
drained rice and barberries, and 75g (2½oz) each
of almond nibs, pistachio nibs and dried sour
cherries. Top up with 625ml (2½ cups) water and
bring to a rolling boil. Turn down the heat to the
lowest setting and cover. Steam for 12 minutes,
then turn off the heat and leave undisturbed for
another 10 minutes. Gently fluff with a fork and
rain over pomegranate seeds before serving.

CARROT PILAF

Pilau ～～～～～～～～～ Middle East

Versions of this sunset-flecked rice are made
across Yemen, Saudi Arabia and Iraq. Its delicacy
makes it a good match for recipes in the Fragrant
& Floral chapter.

Wash, then soak 400g (2 cups) basmati rice.
Heat 2 tablespoons oil and soften 1 thinly sliced
onion. Add 3–4 grated carrots and cook for
5–10 minutes to soften. Add the drained rice,
3 bruised green cardamom pods, 2 cloves,
1 cinnamon stick and a whole green chili, slit
down one side. Stir together, then top up with
625ml (2½ cups) water. Bring to a rolling boil,
turn down the heat to a whisper, cover and cook
for 12 minutes. Turn off the heat and leave to
steam for 10 minutes before fluffing with a fork.

BASMATI WITH CARDAMOM

From the sublime to the simple, here basmati has
just a whisper of cardamom as an elegant pairing
for both Middle Eastern and South Asian meals.

Wash 400g (2 cups) basmati rice well, leaving
to soak for half an hour if you have the time.
Drain and put in a pan with 625ml (2½ cups)
water with bruised cardamom pods, either
6 green or 3 black, and an optional sprinkling of
ground turmeric if you want a golden tint. Bring to
a rolling boil, then turn down the heat to its lowest
and cover. Steam for 12 minutes, then turn off the
heat without lifting the lid and leave for another
10 minutes. Gently fluff with a fork before serving.

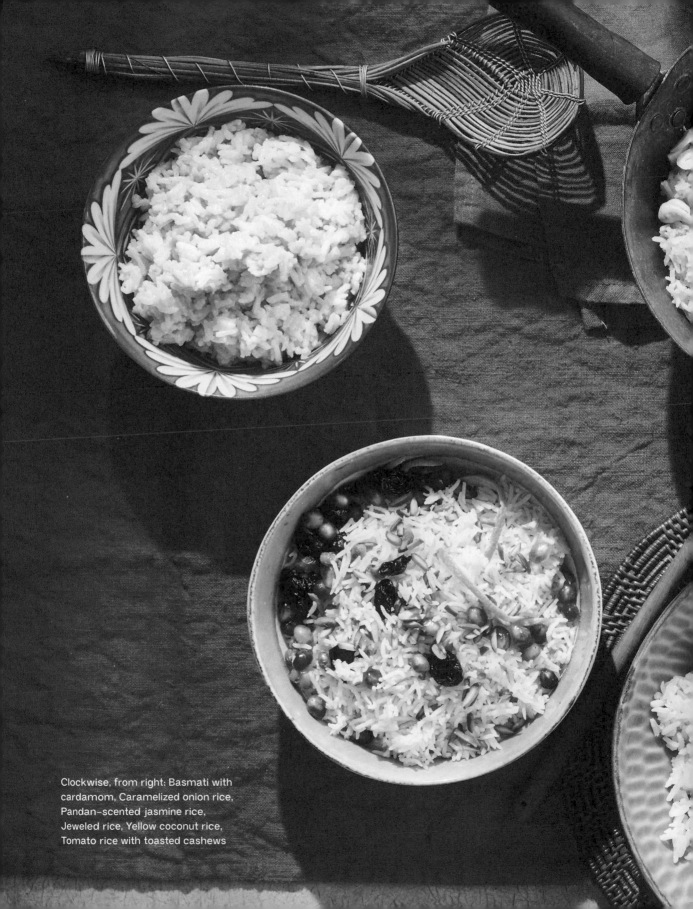

Clockwise, from right: Basmati with
cardamom, Caramelized onion rice,
Pandan–scented jasmine rice,
Jeweled rice, Yellow coconut rice,
Tomato rice with toasted cashews

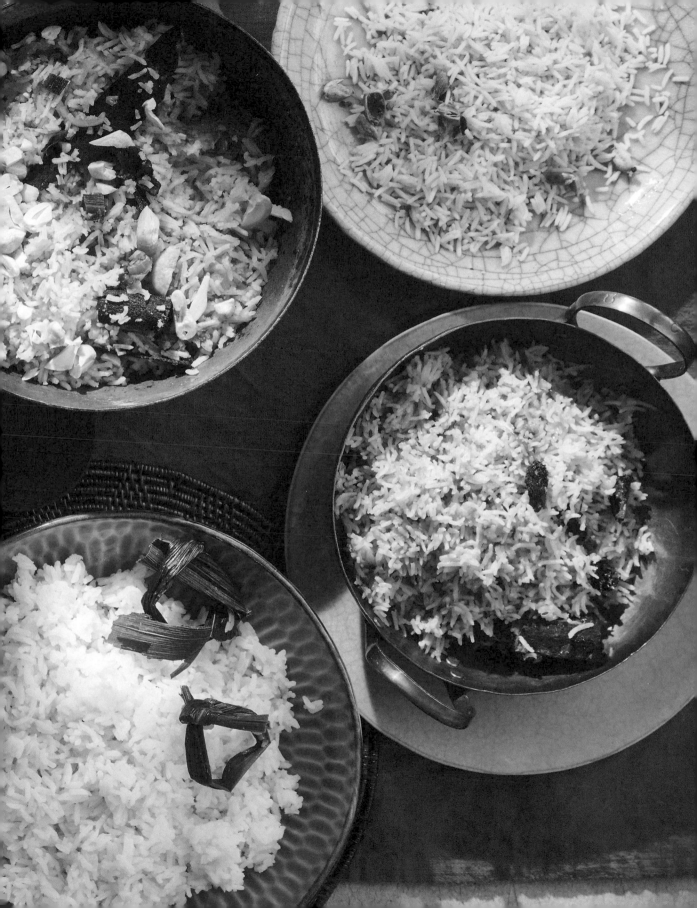

SPICE MISCELLANY

★ "Nutmeg" derives from the Latin for "musky nut" and the tree it grows on, Myristica fragrans, means "mystical fragrance."

★ Its Arabic name translates as "nut of goodness or deliciousness." In early Sanskrit, nutmeg was referred to poetically as a "jasmine-scented seed" and clove as the "divine flower of Lakshmi," goddess of beauty and luxury.

★ Across much of Europe and Asia, cloves are named after nails as the dried flower buds resemble them in shape. Conversely, iron nails have been named for cloves in some languages of their native Indonesia.

★ An archaic name for mustard seed, "eye of newts" is popularly associated with witchcraft since being used in the witches' brew in Shakespeare's Macbeth.

★ Coriander comes from the Greek for "stink bug" because of the similarity between the smell of bedbugs and the spice.

★ The phoenix makes its nest from cinnamon and cassia.

★ A sixth-century Arabic text tells of a mythical land "east of China" that exported the fragrant treasures of musk, aloeswood and cinnamon. Here gold was so abundant it was woven into clothing and leads for dogs.

★ Emperor Nero burnt a year's supply of cinnamon at his wife's funeral to atone for his role in her death.

★ Marc Antony was lured to Cleopatra's palace by the heady aroma of burning cardamom pods. There, Cleopatra bathed in saffron.

★ Alexander the Great used saffron as shampoo.

★ Trimalchio, a first-century character in Satyricon, set to be the crassest tycoon in Rome, used saffron and cumin not only in food but scattered on the floor in a simulation of blonde sawdust.

★ Turmeric was used as yellow dye for the peplums of clothes worn during the Panathenaea, the most important religious feast of ancient Athens.

★ Princesses in eighth-century Javanese courts drank jamu made with turmeric and other spices to seek eternal youth.

★ The curcumin in turmeric and the piperine in black pepper have been shown to work together in tandem as antioxidants and anti-inflammatories.

★ In tropical forests, the pepper plant often grows in the shade of tea and coffee. In fact, there are types of tea with a distinct pepper flavor.

★ It was customary to bestow gifts of peppercorns at the great Roman midwinter festival of Saturnalia.

★ Black pepper is the stalwart of today's Western dining table, but in the nineteenth century, ginger was a more common partner to salt. Fashionable Europeans carried around their own personal nutmeg graters in the seventeenth century and ancient Greeks ground cumin over their plates.

★ Cumin is referenced in both the Old Testament (Isaiah 28:27) and the New Testament (Matthew 23:23) of the Bible.

★ Cumin is good for flatulence, according to Dioscorides.

- Ancient Egyptians chewed on cardamom seeds to freshen their breath. The Han Dynasty in imperial China required courtiers to chew on cloves before addressing their Emperor.

- Star anise is dominant in China's soy-sauced and red-cooking methods. However, it is a relatively modern spice and doesn't appear in early Chinese literature.

- The boy emperor Jing Zong (824–827 AD) was served a chilled tonic called "clear wind rice" made of milk, rice and camphor to cool him in the heat of the Chinese summer.

- Japanese samurai ate chilies in ritual meals before battles to make them feel invincible.

- Saffron was used in ancient potions, sprinkled between sheets and brewed into tea to make a man fall in love.

- In medieval India, one could signal a secret infatuation by giving a bundle of cardamom, nutmeg and cloves wrapped in red thread and sealed with wax.

- The Sanskrit text, the Kama Sutra, recommends the use of warming spices to enhance sexual performance in men: peppercorns, long pepper, ginger.

- In Zanzibar, nutmeg is considered a female aphrodisiac. On their wedding mornings, brides grate it into their porridge.

- Nutmeg is illegal in Saudi Arabia.

- Consumed in large quantities, nutmeg is a hallucinogen.

- Nutmeg necklaces were worn during the plague.

- Unscrupulous spice traders in Connecticut are said to have whittled "nutmegs" out of wood and it is known to this day as "The Nutmeg State." A "wooden nutmeg" became a metaphor for fraudulence in early America.

- The first time Ferdinand Magellan circumnavigated the globe, he lost five ships and 250 men, but his voyage was deemed a success as he returned to Spain with 20,000kg of nutmeg.

- Sixteenth-century nutmeg traders enjoyed a 60,000 percent mark-up and London dockworkers were paid their bonuses in cloves.

- In his Divine Comedy, Dante talks of cloves as a luxury used by frivolous squanderers from Siena for their millionaire roast meat.

- In medieval Italy, confetti meant "candied spices, fruit or nuts" like the colorful sugar almonds brought from the East by Venetian traders. During Lenten carnival, wealthy families would scatter these from their balconies into the eager throngs below.

- When the Visigoths captured Rome, they demanded 3000 pounds of peppercorns as ransom.

- Contrary to received wisdom, spices were never used to conceal rotten meat. Rather, they were historically the most expensive ingredients in the kitchen, there to add opulence and layers of complexity—then as now.

- Saffron is now the world's most valuable spice as the stamens have to be harvested from violet-blue crocuses by hand. One hundred flowers are needed for only one gram of saffron and they must be picked at dawn to preserve the aroma.

TIMELINE

Primitive man discovers that the roots, seeds and barks of aromatic plants can enhance the taste of food.

C.50,000 BC

Black pepper, cardamom, turmeric and mustard are cultivated in India. The seafaring Austronesian people migrate across South East Asia, taking ginger with them from island to island in tiny outrigger boats.

C.3000 BC

Centuries before maps and compasses, cloves make their way from five tiny volcanic islands in the Indonesian archipelago to the deserts of Syria.

C.1700 BC

In Egypt, meat is slow-cooked and infused with spices both local and Asian. Papyrus scrolls classify coriander, cumin and fennel seeds as health-giving. Before being mummified in 1213 BC, Ramses II has Indian peppercorns stuffed up his nose.

C.1500 BC

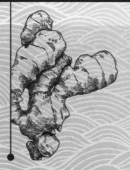

C.5000 BC

Ginger, a plant native to Asia, is growing in Persia. It seems to have spread gradually across the continent through use rather than trade.

C.2000 BC

Start of the spice trade. Cinnamon from Sri Lanka and cassia from China travel west with Arab merchants who layer a sense of mystery around the origin of their wares with fantastical tales. Spices become an exotic and treasured commodity. Phoenicians and Arabs monopolize the spice trade for more than 2000 years. Slave trading in the Indian Ocean also dates from this time. Multidirectional with many operators and peoples involved, the activity is appropriated, developed and further exploited by empires and interveners throughout history.

Under the Graeco-Egyptian dynasty of the Ptolemies, sailors regularly sail east to bring back pepper, ginger and cinnamon. Nutmeg reaches North India from the Banda Islands.

C.300 BC

Early Indian Ayurvedic texts endorse nutmeg, mace, cloves and cardamom for their health benefits. King Dutthagamani of Sri Lanka rewards his workers with "five perfumes for the mouth," one of which was nutmeg.

The Queen of Sheba brings gifts of gold, jewels and spices to King Solomon.

C.1000 BC

C.100 BC

C.500 BC

The expansive Persian Empire reaches its peak, acting as a conduit for culture and its scented, sweet-sour cuisine. Persians produce essential oils from roses, coriander seeds, lilies and saffron. Spices are used in ancient Greek medicine but, with the exception of cinnamon, local herbs are preferred for cooking. In pre-Qin China, local vanillas, cassia and peppers are burnt as incense.

C.200 BC

As the maritime spice routes open, spices from Asia and Europe are introduced to China. Cloves from Indonesia are particularly favored as well as locally grown cassia. China invades Vietnam, where Chinese cooking principles are adopted, and provides a trade passage for cardamom into China. An expedition under imperial envoy Zhang Qian establishes the overland trading passage later known as the Silk Road.

C.800 BC

Cardamom and turmeric, indigenous to India, are grown in the gardens of Babylon.

Spices are used extravagantly in ancient Rome and help create the "first global cuisine'." Apicius writes the first cookbook, *De Re Culinaria*, with a signature dish of pear soufflé seasoned with ground pepper and fish sauce. The Roman Empire controls land routes from east to west and sea trade with India is developed, allowing them to cut out the Arab middleman. As the empire expands, they introduce new regions to Asian spices.

1ST CENTURY

Muhammad works as a merchant before establishing the principles of Islam in the Quran, and he co-owns a shop stocking frankincense, myrrh and Eastern spices. The Arab Empire grows; its first official mission reaches China, and its armies capture Alexandria, the spice capital of the eastern Mediterranean. Austronesian sailors settle the island of Madagascar.

7TH CENTURY

In the Mataram Kingdom of Indonesia, fresh spices are pounded together into herbal medicine tonics called jamu. Nutmeg reaches Western markets for the first time.

8TH CENTURY

4TH CENTURY

Indian ruling dynasties establish trading posts in Malaysia, leaving a lasting influence on local culture and food. This period also sees the emergence of "Indianized" kingdoms around South East Asia and Chinese pilgrims travelling by sea to Buddha's native India. India's cultural and religious influence permeates along the trade routes for centuries, creating what is as Greater India.

5TH CENTURY

Europe sinks into the Dark Ages and trade between Europe and the Middle East dries up. Spices slowly fall out of use in European food.

9TH CENTURY

As Roman trade declines, Arabs wrest back control of the lucrative spice trade. With the rise of Islam, Arabian dhows, which have long sailed the Indian Ocean, see a change of design as they are shaped for battle and conquest, and traffic in humans as well as merchandise. Arab merchants establish trading outposts from India to Malaysia and China.

Spice medicine in China flourishes and new ports are established to meet demand. Trade between China and the Philippines influences Tagalog cooking. The crusades pique European interest in spices again and they become luxury goods and reputed aphrodisiacs. Venice is the port used by Arab merchants to bring spices into Europe.

11TH CENTURY

Muslim Indian spice merchants take their religion with them across South East Asia; Islam spreads out from port cities to replace much of Hindu culture, with reverberations into food. As the Mongol Empire is established, its meat- and dairy- heavy diet incorporates spices from across Asia to make dishes such as roast wolf soup with saffron, turmeric and pepper.

13TH CENTURY

Marco Polo's book stimulates interest in Oriental spices in Italy and prices become increasingly exorbitant. Peppercorns are accepted as currency. When the Black Death reaches Europe, spices are used as both medicines and fumigants. Venice maintains control as the gateway of spice. The Ottoman Empire rises and its fine cuisine has both Persian and Graeco-Roman influences.

14TH CENTURY

12TH CENTURY

Chinese junks reach the Persian Gulf. Northern India comes under Muslim rule and stays that way until the nineteenth century.

15TH CENTURY

Chinese naval exploration reaches its zenith, its merchants settling in foreign ports for peaceful trade and so starting a tradition of Chinatowns and Chinese food in cities around the world. Meanwhile, as demand for spice escalates in Europe, trade is transformed by the European Age of Discovery. Portugal pioneers direct spice trading between Asia and Europe as da Gama rounds the southern tip of Africa to reach India, his men charging the shores shouting, "For Christ and spices." Though Arab merchants also develop more direct sea routes to India, so lowering the price of pepper, the Portuguese succeed in breaking the Venetian–Mamluk monopoly and Europeans turn to Lisbon for their spices. The Portuguese Empire begins. Sponsored by the Spanish court, Columbus sails the blue Atlantic in search of India and instead finds the Americas, allspice and chilies. The latter he names peppers, perhaps to soothe disappointment at not finding the peppercorns he was seeking. From 1493, chili use diffuses through the world.

A century of exploration and empire building. Portugal holds ruthless control over the spice trade as it seizes key ports, including Goa and Malacca, and the Banda Islands in Indonesia, known as the Spice Islands. Along the way, they enslave locals from West Africa, the East Indies and all across eastern Asia. Chinese traders settle around Jakarta. Babur invades India from Central Asia and founds the Mughal Empire. Willoughby and his crew freeze to death as they traverse the North Pole in search of a shortcut to the "spiceries" of Asia. Magellan's expedition circumnavigates the globe and claims the Philippines for Spain. The transatlantic slave trade expands to the Americas, in service of Spanish and Portuguese sugar plantations. Drake follows to circumnavigate the globe and imports spices to England. Meanwhile, in Europe Venice's spice wealth helps finance the Renaissance.

16TH CENTURY

The spice trade has peaked and values begin to fall. European monopolies crumble as new players enter the market, including American spice companies, making millionaires in Salem, Massachusetts. France's Poivre smuggles out nutmeg and clove trees, long the preserve of Indonesia, and transplants them in Mauritius and Réunion, so dramatically increasing supply. The British start growing nutmeg in Penang, Singapore and Grenada, further undermining the trade. The Western world gradually loses interest and turns attention to other ways of generating wealth from colonization and slavery. Fashionable people of Europe favor new exotic commodities: coffee, tobacco and chocolate.

18TH CENTURY

17TH CENTURY

The Dutch and English enter the market, determined to control their own supply of spice. This is achieved through trading companies and war. The British East India Company rises to become an aggressive colonial power. The Brits gain Madras in India where a lasting British love affair with Indian food begins. Pepper now conquered and a steady supply established, all attention turns to nutmeg. The Dutch take control in Indonesia and Malacca and open trade with China. There is a sharp rise in slave trade in the region. Nutmeg sees a 32,000 percent increase in price and in 1667 the British and the Dutch make an exchange for islands on opposite sides of the Earth. The Dutch gain control of Rhun, the Indonesian home of nutmeg, and cede Manhattan to the Brits. Unlike the Portuguese, who had never interfered with the local Asian coastal trade, the Dutch East India Company's ruthless and rapacious policies to inflate spice prices have a dire effect on local people and economies. Chili is making inroads as a new spice but is never considered a viable commodity as it is easy to grow. Spanish galleon trade between Mexico and Manila facilitates the exchange of food crops, bringing chilies, corn and tomatoes to Asia.

World War II is the catalyst for many nations declaring autonomy from oppressive colonial rule. Asian peace treaties, multinational institutions and local trade organizations are formed. After independence, the Indian government encourages growth in the spice industry, enabling small farms to flourish. Air travel transforms the world's trade routes as everything becomes available everywhere. Interest in international cookery picks up and people begin learning about new cuisines, expanding their palettes and spice use.

20TH CENTURY

Turning to the future, adapting and becoming resilient to climate change is the central challenge we face if the trade that has spanned millennia is to be sustainable.

19TH CENTURY

Mystique dispelled and supply now dependable, spices are no longer a display of extravagance. Only those more difficult or unreliable to harvest, such as vanilla pods and saffron, maintain a high value. Sugar becomes the must-have ingredient. Following the abolition of slavery, there is a rise in indentured labor, creating further movement of people around the colonies, especially from India, creating new hubs of Indian-influenced cuisine overseas.

21ST CENTURY

What was once the world's rarest produce has become among the most commonplace. Demand and supply are ever-growing and India is by far the greatest spice producer, yielding over 2.3 million tons each year. Even the remotest forest farmers can track prices at e-auctions on their mobiles. Vietnam is now the leading grower of pepper, still the world's most traded spice, though much of the processing of this and other South East Asian spices is done in India. International food bodies impose strict health and safety regulations on all the produce. As the mystery disappears, scientific discovery proves some of the health benefits supposed by our ancestors.

SOURCES & FURTHER READING

Abraham, Tanya. *Eating with History: Ancient Trade-Influenced Cuisines of Kerala* (Niyogi Books, 2020)

Andrews, Jean. *Peppers: The Domesticated Capsicums* (University of Texas Press, 1995)

Andrews, Jean. *The Pepper Trail: History and Recipes from Around the World* (University of North Texas Press, 1999)

Aye, MiMi. *Mandalay: Recipes and Tales from a Burmese Kitchen* (Bloomsbury, 2019)

Batmanglij, Najmieh. *Silk Road Cooking: A Vegetarian Journey* (Mage, 2002)

Brissenden, Rosemary. *South East Asian Food* (Penguin, 1970)

Collingham, Lizzie. *Curry: A Tale of Cooks and Conquerors* (Vintage Books, 2006)

Dalby, Andrew. *Dangerous Tastes: The Story of Spices* (The British Museum Press, 2000)

Dunlop, Fuchsia. *Every Grain of Rice: Simple Chinese Home Cooking* (Bloomsbury, 2012)

Farrimond, Dr Stuart. *The Science of Spice* (Dorling Kindersley, 2018)

Ford, Eleanor. *Fire Islands: Recipes from Indonesia* (Apollo Publishers, 2019)

Helou, Anissa. *Feast: Food of the Islamic World* (HarperCollins, 2018)

Hildebrand, Caz. *The Grammar of Spice* (Thames and Hudson, 2017)

Islamic Arts Museum Malaysia. *Spice Journeys: Taste and Trade in the Islamic World* (IAMM Publications, 2006)

Jaffrey, Madhur. *Madhur Jaffrey's Ultimate Curry Bible* (Random House, 2003)

Keay, John. *The Spice Route: A History* (John Murray, 2005)

King, Niloufer Ichaporia. *My Bombay Kitchen: Traditional and Modern Parsi Home Cooking* (University of California Press, 2007)

Kuruvita, Peter. *Serendip: My Sri Lankan Kitchen* (Murdoch Books, 2009)

Libro di Cucina (Venice, 1300s)

Mahmood Ahmed, Saliha. *Khazana: A Treasure Trove of Modern Mughal Dishes* (Hodder & Stoughton, 2018)

McFadden, Christine. *Pepper: The Spice that Changed the World* (Absolute Press, 2008)

Milton, Giles. *Nathaniel's Nutmeg: How One Man's Courage Changed the Course of History* (Hodder & Stoughton, 1999)

Nabhan, Gary Paul. *Cumin, Camels and Caravans: A Spice Odyssey* (University of California Press, 2014)

Norman, Jill. *The Complete Book of Spices* (Dorling Kindersley, 1990)

Salloum, Habeeb, & Salloum, Muna, & Salloum Elias, Leila. *Scheherazade's Feasts: Foods of the Medieval Arab World* (University of Pennsylvania Press, 2013)

Solomon, Charmaine. *Encyclopedia of Asian Food* (Periplus Editions, 1998)

Turner, Jack. *Spice: The History of a Temptation* (Harper Perennial, 2004)

Usmani, Sumayya. *Summers Under the Tamarind Tree: Recipes and Memories from Pakistan* (Frances Lincoln, 2016)

Van Esterik, Penny. *Food Culture in Southeast Asia* (Greenwood, 2008)

Viestad, Andreas. *Where Flavor was Born* (Chronicle Books, 2007)

Wright, Clifford A. *The Medieval Spice Trade and the Diffusion of the Chile* (Gastronomica: The Journal of Food and Culture, 2007)

Zumbroich, Thomas J. *From mouth fresheners to erotic perfumes: The evolving socio-cultural significance of nutmeg, mace and cloves in South Asia* (Journal of Indian Medicine, 2012)

ACKNOWLEDGMENTS

Writing *The Nutmeg Trail* coincided with the pandemic. While I dived into spice routes history, the world's trading routes saw a year like no other. 2020 almost brought them to a standstill, just as demand for spices soared with consumers stocking their cupboards for long spells of home cooking.

Today's world moves quickly. Commodities can be freighted from the far side of the earth in a day; anyone can share recipes online with instant global reach; a virus can infiltrate every country within weeks. It struck me that our intricate web of travel and communication is an extension of the trails laid by early spice seekers. Created as a channel for goods, with them always travelled people with their ideas and their diseases. The network laid the foundations for globalization, with all its benefits and perils.

Never more connected yet kept apart from others, I was able to work remotely with many thoughtful, supportive people whose contributions made this book possible. I extend my sincere thanks to them all.

Members of the Murdoch Books team are notable for their warmth and positivity. They deftly combine wild enthusiasm with talent at turning an idea into a book. It has been a pleasure to work with Corinne Roberts a second time; she steers the ship skillfully and with sensitivity. Every correspondence from Justin Wolfers is full of zest and he managed the editorial with deep knowledge and insight alongside Kay Halsey's considerate editing. Kristy Allen and Madeleine Kane came together to create the vibrant, arresting design to transport us to the spice forests, along with map illustrations by Marcela Restrepo.

The book's other cheerleaders are the ever-delightful sales team: Clive Kintoff, Britta Martin-Simon and Jemma Crocker. Also my agent, Heather Holden-Brown, who has been uplifting in her steadfast belief.

Experts have been generous enough to help me with my research. These include Amanda Nicolas, Zewditu Yohannes, Niloufer Ichaporia King, William Jaggard, Roopa Gulati, Saliha Mahmood-Ahmed, William Wongso, Nawang Doma Sherpa, Yolanda Miller, Andrew Chapman, Dayu Putu and Chef Nurry. And I must of course thank the many authors, historians, academics, cooks and bloggers I have read and consulted for their insights and inspiration.

An indispensable group of recipe testers have tested and retested for me. Huge thanks to Nicola Wood, Debbie Stevenson, Kathy George, Viki Paterson, Kathryn Meacher, Fiona Rough, Tony Watson, Jang Kwon, Anne Wander, Marta Biris, Liz Rennie, Stella-Maria Thomas, Chris Kemp, Joanne Dobie, Tanya Cordrey, Merle Ann Cochrane, Susannah Day, Julie Singer, Anne Strachan, Leila Ferguson, Lesley Pringle, Deborah Kendall, Louise Dilworth, TJ Chew, Tracy Carey, Sarah Kelly, Nina Swarbrick, Charly Senior, Jerolina Rankin, Phillipa Coe, Julie Norton, Maria Fisher, Beckie Wingrove, Gill Hogg, Lorraine Mosley, Kim Ferris, Mike Mortimer, Carol Irving, Hayley Evans and Andrea Lee.

Working on the photography is perhaps my favorite part of creating a book. The team of Ola O. Smit, Kitty Coles and Wei Tang was full of vim, joy and artistry and it shines through in every photograph.

As a frustrated traveler kept at home, I traveled back to countries I love and cultures I admire through food, design and ideas. With me at every step was my husband, Sebastian, without whose love, unwavering patience and support I would have been lost at sea. Also, our children, Otto and Sylvia, endlessly game travel companions who bring so much happiness to our every day. Otto, this book is for you.

INDEX

A

acar pickles 89
advieh 42, 101, 120, 209
agarwood 51
Age of Discovery 9, 11, 19, 245
ajwain/ajowan 27
Alexander the Great 12, 117, 240
allspice 12, 22, 24, 37, 72, 128, 245
 baharat 225
 Griddled pita stuffed with sumac-
 spiced meat 232
 The sheik of stuffed vegetables 217
 Turkish winter vegetables 218
Almond milk for wrestlers 122
aloeswood 240
Aloo bhujia 193
aloo jeera 231
amchoor 22, 27, 37, 184
anardana 27
Andaliman pepper 27, 88
anise 27
aniseed 117, 209
annatto 27
Aphrodisiac greens 60
asafoetida 22, 27
 gunpowder 134
asparagus: Green peppercorn asparagus
 77
Aubergine & toasted coconut curry 214
aubergines
 Aubergine & toasted coconut curry 214
 Crunchy greens with roasted chili jeow
 130
 Smoky aubergine bharta 186
 The sheik of stuffed vegetables 217
 Turkish winter vegetables 218
Ayurveda 13, 96, 184, 204, 243

B

baharat 7, 34, 41–2, 101, 209, 225
 Minced chicken kebabs with sweet
 spices 225
Balinese green bean urap 78
balsam 101
Barbecued lemongrass skewers 170
barberries 27, 37
 Jeweled rice 237
Basmati with cardamom 237
bay leaves
 Egyptian "birds' tongues" soup 105
 Venetian chicken with almond milk
 & dates 109
beans
 Balinese green bean urap 78
 Crunchy greens with roasted chili jeow
 130
 Typhoon shelter corn 51
beef
 Griddled pita stuffed with sumac-
 spiced meat 232
 Massaman beef curry 172–3
 Saffron beef kebabs with grilled sumac
 tomatoes 121
 Spiced beef martabak 202
 The sheik of stuffed vegetables 217
Beet mallum 194
beetroots
 Beet mallum 194

Carrot & beet with tarka 190
Benin pepper 29
berbere 7, 34, 41–2, 221
 Misir wat 221
bharta, Smoky aubergine 186
bird's eye chilies *see* chilies
biryani, Coal-smoked 118–19
biwaz 110
black cardamom *see* cardamom
black cumin *see* cumin
black peppercorns *see* pepper
blue fenugreek *see* fenugreek
bok choy: Curried udon noodles 201
bottle masala 182
bread: Coconut & green chili flatbreads
 141
British Raj 74, 133, 183
broccoli: Roasted malai broccoli with
 cashew & cardamom 213
broth, Chongqing hot glass noodle 138
browned onions 118–19
bulgur: The sheik of stuffed vegetables
 217
bumbu 40, 43, 101, 155, 160, 169
Burmese ginger salad 52
buttermilk, Masala 151

C

cabbage
 Burmese ginger salad 52
 carrot thoran 80
 Crunchy, tangy Vietnamese salad 156
cacao 22, 27, 37
Caramelized onion rice 234
caraway seeds 22, 24, 37
 Honeyed meatballs with pistachios 110
cardamom 11, 17–19, 22, 24, 37, 39, 101,
 116–17, 181, 209, 240, 242–3
 advieh 120
 Aubergine & toasted coconut curry 214
 baharat 225
 Basmati with cardamom 237
 black cardamom 117
 Caramelized onion rice 234
 Carrot pilaf 237
 Cashew cream chicken 106
 Cauliflower & pomegranate pilaf 196
 Coal-smoked biryani 118–19
 Egyptian "birds' tongues" soup 105
 Hot & tingly hand-pulled noodles 82–3
 Karak chai 67
 Massaman beef curry 172–3
 nite kibbeh (spiced butter) 221
 Pork shoulder vindaloo 148
 Roasted malai broccoli with cashew
 & cardamom 213
 Rose & saffron lassi 122
 Royal saffron paneer 102
 Sichuan spiced chili oil 137
 Slow-roast lamb with advieh & fragrant
 rice 120
 spiced butter rice 214
 Steamed egg custard with crispy chili
 oil 137
 Sweet rice for savory food 236
 Tomato rice with toasted cashews 235
 Uyghur seven spice 82–3
carob 27

Carrot & beet with tarka 190
Carrot pilaf 237
carrot thoran 80
carrots
 acar pickles 89
 Carrot & with tarka 190
 Carrot pilaf 237
 carrot thoran 80
 crunchy Thai salad 173
 Crunchy, tangy Vietnamese salad 156
 Turkish winter vegetables 218
Cashew cream chicken 106
Cashew nut & lemongrass curry 159
cassia 12, 22, 24, 37, 101, 240, 242–3
 Aubergine & toasted coconut curry 214
 Cashew cream chicken 106
 Red-cooked duck breasts 113
cauliflower
 Cauliflower & pomegranate pilaf 196
 Gobi chili 133
 Cauliflower & pomegranate pilaf 196
celery
 Chongqing hot glass noodle broth 138
 Egyptian "birds' tongues" soup 105
 Turkish winter vegetables 218
chaat masala 27, 33, 41–2, 90, 182, 209
 chaat masala raita 198
chai, Karak 67
cheese *see* paneer
cherries: Jeweled rice 237
chicken
 Cashew cream chicken 106
 Devil's curry 146–7
 Egyptian "birds' tongues" soup 105
 Honeyed meatballs with pistachios 110
 Jasmine tea-smoked chicken 228
 Keralan black pepper chicken 81
 Minced chicken kebabs with sweet
 spices 225
 Minced chicken with mirin & pink
 pickled ginger 58
 Salted chicken with green ginger & red
 chili 54–5
 Tandoori roast chicken 231
 Venetian chicken with almond milk
 & dates 109
chickpeas
 Burmese ginger salad 52
 Turkish winter vegetables 218
chili ginger dressing 156
chilies 12, 22, 24, 37, 117, 127–9, 155, 181–3,
 245–6
 acar pickles 89
 Aloo bhujia 193
 aloo jeera 231
 Aubergine & toasted coconut curry 214
 baharat 225
 Balinese green bean urap 78
 Beet mallum 194
 bird's eye chilies 129
 Burmese ginger salad 52
 Carrot & beet with tarka 190
 Carrot pilaf 237
 carrot thoran 80
 Cashew cream chicken 106
 Cashew nut & lemongrass curry 159
 Cauliflower & pomegranate pilaf 196
 chili ginger dressing 156

Chongqing hot glass noodle broth 138
Cilantro & yogurt fish 204
Coal-smoked biryani 118–19
Coconut & green chili flatbreads 141
coconut sambal 210
Crunchy greens with roasted chili jeow 130
Crunchy, tangy Vietnamese salad 156
Devil's curry 146–7
dressing 173
Egg & bacon rougaille 64
Ethiopian salad 221
Every week tomato lentils 198
Garlic clove curry 189
Gobi chili 133
green chilies 129
green chutney 196
Green coconut hot sauce 142
Green peppercorn asparagus 77
Grilled mackerel with ginger chili sambal 63
gunpowder 134
Gunpowder okra 134
Hot-&-sour tomato rasam 74
Hot & tingly hand-pulled noodles 82–3
Indonesian seafood gulai 160–1
jeow 130
kachumber 107
Kashmiri chilies 129
Keralan black pepper chicken 81
Lime & spice rice 235
lunumiris (Sri Lankan chili paste) 141
Masala buttermilk 151
Massaman beef curry 172–3
mint sambal 189
Moules au combava 164
Mouth-tingling potatoes 88
Mushroom rendang 169
pomegranate raita 93
Pork shoulder vindaloo 148
quick green chutney 222
red chili sauce 54–5
red chilies 129
Rica rica prawns 145
Royal saffron paneer 102
Salted chicken with green ginger & red chili 54–5
sambal 63
Sichuan spiced chili oil 137
Sindhi spice-crusted fish 222
Smoky aubergine bharta 186
sour-and-spice pineapple relish 145
Spiced beef martabak 202
Spicy stir-fried tofu with lime leaves 168
Sri Lankan pumpkin curry 210
Steamed egg custard with crispy chili oil 137
Steamed fish parcels with lemongrass 167
Tandoori roast chicken 231
tarka 190
Turkish winter vegetables 218
Typhoon shelter corn 51
Chinese five spice 7, 40, 43, 101, 209, 228
Sticky-sweet peppered pork 86
Chongqing hot glass noodle broth 138
choy sum: stir-fried ginger greens 66
chutneys
green chutney 196
quick green chutney 222
cinnamon 7, 11–12, 17, 21–2, 24, 37–8, 101, 117, 128, 181, 183–4, 209, 240, 242–3

advieh 120
Aubergine & toasted coconut curry 214
baharat 225
Caramelized onion rice 234
Carrot pilaf 237
Cashew cream chicken 106
Cashew nut & lemongrass curry 159
Cauliflower & pomegranate pilaf 196
Coal-smoked biryani 118–19
Hot & tingly hand-pulled noodles 82–3
Massaman beef curry 172–3
Mushroom rendang 169
Pork shoulder vindaloo 148
Red-cooked duck breasts 113
Slow-roast lamb with advieh & fragrant rice 120
spiced butter rice 214
Sri Lankan pumpkin curry 210
The sheik of stuffed vegetables 217
Tomato rice with toasted cashews 235
Turkish winter vegetables 218
Uyghur seven spice 82–3
Venetian chicken with almond milk & dates 109
cloves 7, 11–12, 19, 22, 24, 37–8, 101, 116–17, 128, 209, 240, 242–3, 246
Aubergine & toasted coconut curry 214
baharat 225
Carrot pilaf 237
Cashew cream chicken 106
Coal-smoked biryani 118–19
Duck with vanilla 114
Egyptian "birds' tongues" soup 105
Hot & tingly hand-pulled noodles 82–3
Massaman beef curry 172–3
Mushroom rendang 169
Nutmeg & pepper pork 89
Pork shoulder vindaloo 148
Royal saffron paneer 102
spiced butter rice 214
Tomato rice with toasted cashews 235
Uyghur seven spice 82–3
Venetian chicken with almond milk & dates 109
Coal-smoked biryani 118–19
coconut
Aubergine & toasted coconut curry 214
Balinese green bean urap 78
Beet mallum 194
carrot thoran 80
Cashew nut & lemongrass curry 159
Coconut & green chili flatbreads 141
coconut sambal 210
Garlic clove curry 189
Green coconut hot sauce 142
Indonesian seafood gulai 160–1
Massaman beef curry 172–3
mint sambal 189
Mouth-tingling potatoes 88
Mushroom rendang 169
Sri Lankan pumpkin curry 210
Yellow coconut rice 234
Coconut & green chili flatbreads 141
coconut sambal 210
colonization 8–9, 11, 13, 67, 183, 185, 201, 226, 246–7
Columbus, Christopher 24, 72, 127, 245
coriander seeds 11–12, 22, 24, 37, 39, 101, 117, 181–2, 209, 240, 242–3
advieh 120
Aubergine & toasted coconut curry 214
baharat 225

Balinese green bean urap 78
Coal-smoked biryani 118–19
Honeyed meatballs with pistachios 110
Kebabs for Babur 92
Lime & spice rice 235
Massaman beef curry 172–3
Mouth-tingling potatoes 88
Pork shoulder vindaloo 148
Sindhi spice-crusted fish 222
Slow-roast lamb with advieh & fragrant rice 120
Smoky aubergine bharta 186
Spiced beef martabak 202
Sri Lankan curry powder 211
Steamed fish parcels with lemongrass 167
Turkish winter vegetables 218
Venetian chicken with almond milk & dates 109
corn: Typhoon shelter corn 51
Crunchy greens with roasted chili jeow 130
crunchy Thai salad 173
Crunchy, tangy Vietnamese salad 156
cubeb pepper 29, 71, 78
cucumber salad 55
cucumbers
acar pickles 89
Crunchy greens with roasted chili jeow 130
crunchy Thai salad 173
cucumber salad 55
kachumber 107
cumin 7, 11–12, 22, 24, 37, 39, 117, 181–2, 184, 209, 240, 242
advieh 120
Aloo bhujia 193
aloo jeera 231
Aphrodisiac greens 60
Aubergine & toasted coconut curry 214
baharat 225
black cumin 27
Caramelized onion rice 234
Carrot & beet with tarka 190
Coal-smoked biryani 118–19
Cumin & tamarind water 205
Egg & bacon rougaille 64
Honeyed meatballs with pistachios 110
Hot-&-sour tomato rasam 74
Hot & tingly hand-pulled noodles 82–3
Kebabs for Babur 92
Khichdi 236
Lime & spice rice 235
Massaman beef curry 172–3
Pakistani radish salad 222
panch phoron 197
pomegranate raita 93
Pork shoulder vindaloo 148
Red lentil dal with panch phoron 197
Sizzling ginger raita 61
Slow-roast lamb with advieh & fragrant rice 120
Smoky aubergine bharta 186
Spiced beef martabak 202
Sri Lankan pumpkin curry 210
Sri Lankan curry powder 211
Tandoori roast chicken 231
tarka 190
Uyghur seven spice 82–3
Cumin & tamarind water 205
curcumin 240
Curried udon noodles 201

curries 183–5
 Aubergine & toasted coconut curry 214
 Cashew nut & lemongrass curry 159
 Devil's curry 146–7
 Every week tomato lentils 198
 Garlic clove curry 189
 green curry paste 43
 Indonesian seafood gulai 160–1
 Massaman beef curry 172–3
 Misir wat 221
 Mushroom rendang 169
 Pork shoulder vindaloo 148
 Red lentil dal with panch phoron 107
 Royal saffron paneer 102
 Smoky aubergine bharta 186
 Sri Lankan pumpkin curry 210
curry leaves 22, 24, 37
 Beet mallum 194
 Carrot & beet with tarka 190
 carrot thoran 80
 Cashew nut & lemongrass curry 159
 Every week tomato lentils 198
 Garlic clove curry 189
 gunpowder 134
 Gunpowder okra 134
 Hot-&-sour tomato rasam 74
 Sizzling ginger raita 61
 Sri Lankan pumpkin curry 210
 Sri Lankan curry powder 211
 tarka 190
curry powders 182–3
 Sri Lankan curry powders 43, 182, 209, 211
custard, Steamed egg, with crispy chili oil 137

D
daikon
 Crunchy greens with roasted chili jeow 130
 Pakistani radish salad 222
dal, Red lentil, with panch phoron 197
Dark Ages 18, 244
date syrup
 Sweet rice for savory food 236
 Venetian chicken with almond milk & dates 109
dates: Venetian chicken with almond milk & dates 109
Devil's curry 146–7
dill seeds 28
dressings 52, 55 , 173
 chili ginger dressing 156
dried lime 28
drinks
 Almond milk for wrestlers 122
 Cumin & tamarind water 205
 Fiery long pepper tea 96
 Karak chai 67
 Masala buttermilk 151
 Rose & saffron lassi 122
 Turmeric & tamarind jamu 176
duck
 Duck with vanilla 114
 Red-cooked duck breasts 113
Duck with vanilla 114
dukkah 42, 209

E
Egg & bacon rougaille 64
eggplant *see* aubergines

eggs
 Egg & bacon rougaille 64
 Minced chicken with mirin & pink pickled ginger 58
 Steamed egg custard with crispy chili oil 137
 Steamed fish parcels with lemongrass 167
Egyptian "birds' tongues" soup 105
Ethiopian salad 221
Every week tomato lentils 198

F
fennel seeds 22, 25, 37, 209, 242
 Almond milk for wrestlers 122
 Aubergine & toasted coconut curry 214
 Coal-smoked biryani 118–19
 Keralan black pepper chicken 81
 panch phoron 197
 Red lentil dal with panch phoron 197
 Sindhi spice-crusted fish 222
 Sri Lankan curry powder 211
fenugreek 22, 25, 37, 181, 209
 Aloo bhujia 193
 Aphrodisiac greens 60
 blue fenugreek 27
 Garlic clove curry 189
 panch phoron 197
 Red lentil dal with panch phoron 197
 Sri Lankan curry powder 211
Fiery long pepper tea 96
fish
 Cilantro & yogurt fish 204
 Grilled mackerel with ginger chili sambal 63
 Indonesian seafood gulai 160–1
 lunumiris (Sri Lankan chili paste) 141
 Sindhi spice-crusted fish 222
 Steamed fish parcels with lemongrass 167
flatbreads, Coconut & green chili 141
flower essences 25
 see also kewra, orange blossom water, roses, rose water
frankincense 28, 101, 142, 244

G
galangal 22, 25, 37, 155, 184
 Balinese green bean urap 78
 Devil's curry 146–7
 Massaman beef curry 172–3
 Mushroom rendang 169
 Spicy stir-fried tofu with lime leaves 168
 Steamed fish parcels with lemongrass 167
 Yellow coconut rice 234
garam masala 7, 33–4, 41–2, 181–2, 209
 Cauliflower & pomegranate pilaf 196
 Keralan black pepper chicken 81
 Roasted malai broccoli with cashew & cardamom 213
 Smoky aubergine bharta 186
 Tandoori roast chicken 231
Garlic clove curry 189
garlic, peeling tip 189
ginger 11–12, 17–18, 22, 25, 36–8, 49, 117, 128, 155, 181–2, 209, 240, 242–3
 Aphrodisiac greens 60
 Aubergine & toasted coconut curry 214
 Balinese green bean urap 78
 Burmese ginger salad 52
 Cashew cream chicken 106

 Cashew nut & lemongrass curry 159
 Cauliflower & pomegranate pilaf 196
 chili ginger dressing 156
 Cilantro & yogurt fish 204
 Coal-smoked biryani 118–19
 Crunchy, tangy Vietnamese salad 156
 Devil's curry 146–7
 Duck with vanilla 114
 Egg & bacon rougaille 64
 Every week tomato lentils 198
 Fiery long pepper tea 96
 Gobi chili 133
 green ginger sauce 54–5
 Grilled mackerel with ginger chili sambal 63
 Gunpowder okra 134
 Indonesian seafood gulai 160–1
 Karak chai 67
 Kebabs for Babur 92
 Keralan black pepper chicken 81
 Khichdi 236
 Lime & spice rice 235
 Masala buttermilk 151
 Minced chicken with mirin & pink pickled ginger 58
 Misir wat 221
 Moules au combava 164
 Mushroom rendang 169
 nite kibbeh (spiced butter) 221
 Pork shoulder vindaloo 148
 Red-cooked duck breasts 113
 Rica rica prawns 145
 Salted chicken with green ginger & red chili 54–5
 sambal 63
 Scallops with ginger & black pepper 95
 Silken tofu with gingered soy sauce 66
 Sizzling ginger raita 61
 Smoky aubergine bharta 186
 Spiced beef martabak 202
 Steamed fish parcels with lemongrass 167
 stir-fried ginger greens 66
 Tandoori roast chicken 231
 Tomato rice with toasted cashews 235
 Turmeric & tamarind jamu 176
 Typhoon shelter corn 51
 Venetian chicken with almond milk & dates 109
 Yellow coconut rice 234
Cilantro & yogurt fish 204
Gobi chili 133
grains of paradise 17, 28–9, 72, 209
grains of Selim 28–9
green chilies *see* chilies
green chutney 196
Green coconut hot sauce 142
green curry paste 43
green ginger sauce 54–5
Green peppercorn asparagus 77
green peppercorns *see* pepper
Griddled pita stuffed with sumac-spiced meat 232
Grilled mackerel with ginger chili sambal 63
gulai, Indonesian seafood 160–1
gunpowder 134, 182, 209
Gunpowder okra 134

H
Honeyed meatballs with pistachios 110
Hot-&-sour tomato rasam 74
Hot & tingly hand-pulled noodles 82–3

I

Indian pepper 72
Indonesian pepper 72
Indonesian seafood gulai 160–1

J

Jamaican pepper *see* allspice
jamu, Turmeric & tamarind 176
Jasmine tea-smoked chicken 228
jeow 130
Jeweled rice 237
juniper berries 25, 37

K

kachumber 107
kaffir lime *see* makrut lime
Kama Sutra 60, 241
Karak chai 67
Kashmiri chilies *see* chilies
kebabs
 Kebabs for Babur 92
 Minced chicken kebabs with sweet
 spices 225
 Saffron beef kebabs with grilled sumac
 tomatoes 121
 the kebab empire 90–1
Kebabs for Babur 92
kencur: Steamed fish parcels with
 lemongrass 167
Keralan black pepper chicken 81
kewra 117
 Coal-smoked biryani 118–19
 Royal saffron paneer 102
Khichdi 236

L

lamb
 Coal-smoked biryani 118–19
 Griddled pita stuffed with sumac-
 spiced meat 232
 Honeyed meatballs with pistachios 110
 Kebabs for Babur 92
 Slow-roast lamb with advieh & fragrant
 rice 120
lassi, Rose & saffron 122
lemon myrtle 28
lemongrass 25, 37, 39, 116, 155, 184
 Barbecued lemongrass skewers 170
 Cashew nut & lemongrass curry 159
 Devil's curry 146–7
 Indonesian seafood gulai 160–1
 Massaman beef curry 172–3
 Mushroom rendang 169
 Spicy stir-fried tofu with lime leaves 168
 Steamed fish parcels with lemongrass
 167
 Yellow coconut rice 234
lentils
 Every week tomato lentils 198
 gunpowder 134
 Gunpowder okra 134
 Khichdi 236
 Misir wat 221
 Red lentil dal with panch phoron 197
licorice 12, 22, 28, 37
Lime & spice rice 235
lime leaves 22, 25, 37, 116, 155, 184,
 Balinese green bean urap 78
 Barbecued lemongrass skewers 170
 Indonesian seafood gulai 160–1
 Moules au combava 164

Mushroom rendang 169
Rica rica prawns 145
Spicy stir-fried tofu with lime leaves 168
Steamed fish parcels with lemongrass
 167
limes
 Balinese green bean urap 78
 Burmese ginger salad 52
 chili ginger dressing 156
 coconut sambal 210
 Crunchy greens with roasted chili jeow
 130
 Crunchy, tangy Vietnamese salad 156
 Cumin & tamarind water 205
 Curried udon noodles 201
 dressing 52
 Indonesian seafood gulai 160–1
 jeow 130
 kachumber 107
 Lime & spice rice 235
 lunumiris (Sri Lankan chili paste) 141
 mint sambal 189
 Mouth-tingling potatoes 88
 Rica rica prawns 145
 Saffron beef kebabs with grilled sumac
 tomatoes 121
 Sri Lankan pumpkin curry 210
 Turmeric & tamarind jamu 176
 see also makrut lime
long pepper 21, 28, 71, 78, 96, 241
 Balinese green bean urap 78
 Fiery long pepper tea 96
lunumiris (Sri Lankan chili paste) 141

M

mace 7, 12, 17, 25, 37, 89, 116–17, 181, 209,
 243,
 Coal-smoked biryani 118–19
 Massaman beef curry 172–3
 Nutmeg & pepper pork 89
mahleb 28
makrut lime
 Moules au combava 164
 see also lime leaves
Malabar pepper 72
Malaysian pepper 72
mallum, Beet 194
mange tout
 crunchy Thai salad 173
 Curried udon noodles 201
marinades 231
Maritime Silk Road *see* Silk Road, spice
 routes
martabak, Spiced beef 202
Masala buttermilk 151
Massaman beef curry 172–3
mastic 22, 28
 Egyptian "birds' tongues" soup 105
methi *see* fenugreek
Minced chicken kebabs with sweet spices
 225
Minced chicken with mirin & pink pickled
 ginger 58
mint sambal 189
minted yogurt 225
Misir wat 221
Moules au combava 164
Mouth-tingling potatoes 88
Mughals 18, 90, 92, 101–2, 109, 116, 118,
 128, 181, 183, 209, 222, 246
Mushroom rendang 169

mushrooms
 Curried udon noodles 201
 Mushroom rendang 169
musk 12, 101, 240
mussels: Moules au combava 164
mustard seeds 22, 25, 37, 155, 181, 240,
 242
 Beet mallum 194
 carrot thoran 80
 Devil's curry 146–7
 Every week tomato lentils 198
 Hot-&-sour tomato rasam 74
 Lime & spice rice 235
 panch phoron 197
 Pork shoulder vindaloo 148
 Red lentil dal with panch phoron 197
 Sri Lankan pumpkin curry 210
 tarka 190

N

Nero 101, 240
nigella seeds 22, 28, 37, 181
 Aloo bhujia 193
 panch phoron 197
 Red lentil dal with panch phoron 197
nite kibbeh (spiced butter) 221
noodles
 Chongqing hot glass noodle broth 138
 Curried udon noodles 201
 hand-pulled noodles 82–3
 Hot & tingly hand-pulled noodles 82–3
nutmeg 7, 9, 11–12, 14, 17–19, 22, 26, 36–8,
 64, 89, 116, 128, 182, 209, 226–7, 240,
 243–4, 246
 advieh 120
 baharat 225
 Balinese green bean urap 78
 Mushroom rendang 169
 Nutmeg & pepper pork 89
 nutmeg jam 227
 Slow-roast lamb with advieh & fragrant
 rice 120
 Sri Lankan pumpkin curry 210
 Venetian chicken with almond milk
 & dates 109
Nutmeg & pepper pork 89
nutmeg jam 227
nuts
 Almond milk for wrestlers 122
 Aphrodisiac greens 60
 Burmese ginger salad 52
 Cashew cream chicken 106
 Cashew nut & lemongrass curry 159
 Cauliflower & pomegranate pilaf 196
 Chongqing hot glass noodle broth 138
 Crunchy, tangy Vietnamese salad 156
 Devil's curry 146–7
 green chutney 196
 Honeyed meatballs with pistachios 110
 Jeweled rice 237
 Lime & spice rice 235
 Massaman beef curry 172–3
 Roasted malai broccoli with cashew
 & cardamom 213
 Slow-roast lamb with advieh & fragrant
 rice 120
 Steamed fish parcels with lemongrass
 167
 Tomato rice with toasted cashews 235
 Venetian chicken with almond milk
 & dates 109

O

oil, Sichuan spiced chili 137
okra: Gunpowder okra 134
onions
 browned onions 118–19
 Caramelized onion rice 234
orange blossom water: Jeweled rice 237
oranges: Jeweled rice 237

P

Pakistani radish salad 222
panch phoron 43, 182, 197, 209
 panch phoron bitter greens 102
pandan leaves 28
 Pandan-scented jasmine rice 236
 Tomato rice with toasted cashews 235
Pandan-scented jasmine rice 236
paneer: Royal saffron paneer 102
pasta: Egyptian "birds' tongues" soup 105
peas: Burmese ginger salad 52
pepper 7, 11–12, 14, 18–19, 22, 26, 29,
 36–8, 71–2, 78, 81, 90, 95, 117, 127–8,
 181, 183–4, 209, 240–7
 advieh 120
 Almond milk for wrestlers 122
 Andaliman pepper 27, 88
 baharat 225
 Balinese green bean urap 78
 Beet mallum 194
 Benin pepper 29
 black peppercorns 11, 33, 71–2, 90, 127,
 181, 240, 242
 Caramelized onion rice 234
 Coal-smoked biryani 118–19
 cubeb pepper 29, 71, 78
 Green peppercorn asparagus 77
 green peppercorns 26, 71, 77
 gunpowder 134
 Gunpowder okra 134
 Honeyed meatballs with pistachios 110
 Hot-&-sour tomato rasam 74
 Hot & tingly hand-pulled noodles 82–3
 Indian pepper 7, 72
 Indonesian pepper 72
 kachumber 107
 Kebabs for Babur 92
 Keralan black pepper chicken 81
 Lime & spice rice 235
 Malabar pepper 72
 Malaysian pepper 72
 nite kibbeh (spiced butter) 221
 Nutmeg & pepper pork 89
 Pork shoulder vindaloo 148
 red peppercorns 71–2
 Roasted malai broccoli with cashew
 & cardamom 213
 Saffron beef kebabs with grilled sumac
 tomatoes 121
 Sarawak pepper 72
 Scallops with ginger & black pepper 95
 Slow-roast lamb with advieh & fragrant
 rice 120
 Spicy stir-fried tofu with lime leaves 168
 spinach and pine nuts 108
 Sticky-sweet peppered pork 86
 Tandoori roast chicken 231
 Tellicherry pepper 72
 Uyghur seven spice 82–3
 white peppercorns 26, 71
 see also long pepper, pink peppercorns,
 sansho pepper, Sichuan pepper,
 teppal

pilafs
 Carrot pilaf 237
 Cauliflower & pomegranate pilaf 196
pineapple: sour-and-spice pineapple
 relish 145
pink peppercorns 29, 72, 114
piperine 72, 77, 240
pita, Griddled, stuffed with sumac-spiced
 meat 232
Poivre, Pierre 64, 246
Polo, Marco 72, 245
pomegranate
 biwaz 110
 Cauliflower & pomegranate pilaf 196
 Jeweled rice 237
 pomegranate raita 93
pomegranate raita 93
pork
 Barbecued lemongrass skewers 170
 Egg & bacon rougaille 64
 Nutmeg & pepper pork 89
 Pork shoulder vindaloo 148
 Sticky-sweet peppered pork 86
Pork shoulder vindaloo 148
potatoes
 Aloo bhujia 193
 aloo jeera 231
 Devil's curry 146–7
 Massaman beef curry 172–3
 Mouth-tingling potatoes 88
 Turkish winter vegetables 218
prawns
 Indonesian seafood gulai 160–1
 Rica rica prawns 145
pul biber *see* chilies
pumpkin: Sri Lankan pumpkin curry 210

Q

quick green chutney 222

R

radishes: Pakistani radish salad 222
raitas
 chaat masala raita 198
 pomegranate raita 93
rasam, Hot-&-sour tomato 74
red chili sauce 54–5
red chilies *see* chilies
Red lentil dal with panch phoron 197
red peppercorns 71–2
Red-cooked duck breasts 113
relish, sour-and-spice pineapple 145
rempah 43
Rica rica prawns 145
rice
 Basmati with cardamom 237
 Caramelized onion rice 234
 Carrot pilaf 237
 Cauliflower & pomegranate pilaf 196
 Coal-smoked biryani 118–19
 Jasmine tea-smoked chicken 228
 Jeweled rice 237
 Khichdi 236
 Lime & spice rice 235
 Pandan-scented jasmine rice 236
 Salted chicken with green ginger & red
 chili 54–5
 Slow-roast lamb with advieh & fragrant
 rice 120
 spice and rice 116–17
 spiced butter rice 214
 Sweet rice for savory food 236

 Tomato rice with toasted cashews 235
 Yellow coconut rice 234
Rice & spice 234–7
Roasted malai broccoli with cashew &
 cardamom 213
Rose & saffron lassi 122
roses 22, 26, 37, 101, 209, 243
 advieh 120
 Slow-roast lamb with advieh & fragrant
 rice 120
rose water 101, 128
 Coal-smoked biryani 118–19
 Honeyed meatballs with pistachios 110
 Rose & saffron lassi 122
 Royal saffron paneer 102
 Slow-roast lamb with advieh & fragrant
 rice 120
 Sweet rice for savory food 236
rougaille, Egg & bacon 64
Royal saffron paneer 102

S

saffron 11–12, 19, 22, 26, 37, 39, 101,
 116–17, 128, 209, 240, 243, 245, 247
 Coal-smoked biryani 118–19
 Honeyed meatballs with pistachios 110
 Jeweled rice 237
 Rose & saffron lassi 122
 Royal saffron paneer 102
 Saffron beef kebabs with grilled sumac
 tomatoes 121
 Sweet rice for savory food 236
 Venetian chicken with almond milk
 & dates 109
Saffron beef kebabs with grilled sumac
 tomatoes 121
salads
 Balinese green bean urap 78
 Beet mallum 194
 Burmese ginger salad 52
 Carrot & beet with tarka 190
 carrot thoran 80
 Crunchy greens with roasted chili jeow
 130
 crunchy Thai salad 173
 Crunchy, tangy Vietnamese salad 156
 cucumber salad 55
 Ethiopian salad 221
 kachumber 107
 Pakistani radish salad 222
salt, Sichuan pepper 228
Salted chicken with green ginger & red
 chili 54–5
sambals
 coconut sambal 210
 ginger chili sambal 63
 mint sambal 189
sandalwood 101
sansho pepper 29, 88
Sarawak pepper 72
sauces
 Green coconut hot sauce 142
 green ginger sauce 54–5
 jeow 130
 red chili sauce 54–5
Scallops with ginger & black pepper 95
screwpine *see* kewra, pandan leaves
seafood *see* mussels, prawns, scallops,
 squid
shichimi togarashi 33, 40, 43
Sichuan pepper 22, 26, 37, 71, 138
 Chongqing hot glass noodle broth 138

Hot & tingly hand-pulled noodles 82–3
Jasmine tea-smoked chicken 228
Mouth-tingling potatoes 88
Sichuan pepper salt 228
Sichuan spiced oil 137
Steamed egg custard with crispy chili oil 137
Sichuan pepper salt 228
Sichuan spiced chili oil 137
Silk Road 8, 11, 45, 82, 116, 243
Silken tofu with gingered soy sauce 66
silphium 29
Sindhi spice-crusted fish 222
Sizzling ginger raita 61
skewers, Barbecued lemongrass 170
Slow-roast lamb with advieh & fragrant rice 120
smoked chicken 228
smoked yogurt 119
Smoky aubergine bharta 186
soup, Egyptian "birds' tongues" 105
sour-and-spice pineapple relish 145
spice and rice 116–17
spice blends 17, 33–34, 40–3, 90, 181–2, 184, 209
 advieh 42, 101, 120, 209
 baharat 7, 34, 41–2, 101, 209, 225
 berbere 7, 34, 41–2, 221
 bumbu 40, 43, 101, 155, 160, 169
 chaat masala 27, 33, 41–2, 90, 182, 209
 Chinese five spice 7, 40, 43, 101, 209, 228
 curry powder 182–3
 dukkah 42, 209
 garam masala 7, 33–4, 41–2, 181–2, 209
 gunpowder 134, 182, 209
 panch phoron 43, 182, 197, 209
 rempah 43
 shichimi togarashi 33, 40, 43
 Sri Lankan curry powders 43, 182, 209, 211
 seasonings 82–3, 138
 Uyghur seven spice 43, 82–3
 xawaash 42
spice pastes 33, 78, 88, 145, 146–8, 155, 160, 164, 167, 168, 169, 172–3, 214
spice routes 8, 11–14, 17–18, 45, 49, 51, 64, 82, 90, 92, 109, 116, 133, 181, 184, 209, 226, 243–6,
spice trade 7–9, 11–12, 17–19, 71, 78, 101, 106, 127–8, 133, 142, 146, 148, 172, 186, 202, 222, 183, 184, 209, 226, 242, 244–7
 redrawing the world 226–7
Spiced beef martabak 202
spiced butter (nite kibbeh) 221
spiced butter rice 214
spices
 anatomy of 22
 combining 34
 cooking with 32–4
 flavor profiles 36–9
 glossary 24–29
 ground 33
 miscellany 240–1
 signature spices around the world 40–1
 spices blends around the world 42–3
 timeline 242–7
 what is a spice 21
 whole 32
 see also spice blends, spice pastes
Spicy stir-fried tofu with lime leaves 168

spinach
 Aphrodisiac greens 60
 Balinese green bean urap 78
 Mouth-tingling potatoes 88
 spinach and pine nuts 108
spinach and pine nuts 108
squash: Turkish winter vegetables 218
squid: Indonesian seafood gulai 160–1
Sri Lankan chili paste (lunumiris) 141
Sri Lankan curry powders 43, 182, 209, 211
Sri Lankan pumpkin curry 210
star anise 7, 13, 22, 26, 37–8, 181, 184
 Aubergine & toasted coconut curry 214
 Hot & tingly hand-pulled noodles 82–3
 Jasmine tea-smoked chicken 228
 Massaman beef curry 172–3
 Red-cooked duck breasts 113
 spiced butter rice 214
 Tomato rice with toasted cashews 235
 Uyghur seven spice 82–3
Steamed egg custard with crispy chili oil 137
Steamed fish parcels with lemongrass 167
Sticky-sweet peppered pork 86
stir-fried ginger greens 66
sumac 22, 26, 37
 biwaz 110
 Griddled pita stuffed with sumac-spiced meat 232
 Saffron beef kebabs with grilled sumac tomatoes 121
sweet flag 29
sweet potatoes: Sri Lankan pumpkin curry 210
Sweet rice for savory food 236
sweetcorn *see* corn

T
tailed pepper *see* cubeb pepper
tamarind 12, 22, 26, 37
 Aubergine & toasted coconut curry 214
 Cumin & tamarind water 205
 Hot-&-sour tomato rasam 74
 Indonesian seafood gulai 160–1
 Massaman beef curry 172–3
 Mouth-tingling potatoes 88
 Pork shoulder vindaloo 148
 Steamed fish parcels with lemongrass 167
 Turmeric & tamarind jamu 176
Tandoori roast chicken 231
tarka 190
Tasmanian pepperberry 29
tea
 Fiery long pepper tea 96
 Jasmine tea-smoked chicken 228
 Karak chai 67
Tellicherry pepper 72
teppal 29, 88
Mouth-tingling potatoes 88
The sheik of stuffed vegetables 217
tofu
 Silken tofu with gingered soy sauce 66
 Spicy stir-fried tofu with lime leaves 168
Tomato rice with toasted cashews 235
tomatoes
 Egg & bacon rougaille 64
 Hot-&-sour tomato rasam 74
 Saffron beef kebabs with grilled sumac tomatoes 121
 sambal 63

Tomato rice with toasted cashews 235
Turkish winter vegetables 218
Turkish winter vegetables 218
turmeric 12, 22, 26, 37, 39, 155, 181–2, 209, 240, 242–3, 245
 Aloo bhujia 193
 aloo jeera 231
 Aubergine & toasted coconut curry 214
 Balinese green bean urap 78
 carrot thoran 80
 Cashew nut & lemongrass curry 159
 Cauliflower & pomegranate pilaf 196
 Devil's curry 146–7
 Garlic clove curry 189
 Hot-&-sour tomato rasam 74
 Indonesian seafood gulai 160–1
 Keralan black pepper chicken 81
 Lime & spice rice 235
 Moules au combava 164
 Mouth-tingling potatoes 88
 Mushroom rendang 169
 nite kibbeh (spiced butter) 221
 Pork shoulder vindaloo 148
 Red lentil dal with panch phoron 197
 Royal saffron paneer 102
 Sindhi spice-crusted fish 222
 Smoky aubergine bharta 186
 Spiced beef martabak 202
 Spicy stir-fried tofu with lime leaves 168
 Sri Lankan pumpkin curry 210
 Sri Lankan curry powder 211
 Steamed fish parcels with lemongrass 167
 Tandoori roast chicken 231
 Turmeric & tamarind jamu 176
 Yellow coconut rice 234
Turmeric & tamarind jamu 176
Typhoon shelter corn 51

U
urap, Balinese green bean 78
Uyghur seven spice 43, 82–3

V
vanilla 19, 22, 26, 37, 114, 128, 243, 247
 Duck with vanilla 114
Venetian chicken with almond milk & dates 109

W
wattleseed 29
white peppercorns *see* pepper

X
xawaash 42

Y
Yellow coconut rice 234
yogurt, minted 225
yogurt, smoked 119

Z
zhaicai: Chongqing hot glass noodle broth 138

Eleanor Ford is a vvvcook and food writer.
Having lived in Indonesia and Hong Kong, she set off
to travel and learn about the world's food cultures
and traditions. Her first book, *Samarkand*, was named
a book of the year 2016 by *The Guardian* and *Food52*.
It also won the Guild of Food Writers Award for Food
and Travel 2017. Her second book, *Fire Islands*,
received two Gourmand World Cookbook awards;
was named Food and Drink Book of the Year
at the Edward Stanford Travel Writing Awards;
won Der Deutsche Kochbuchpreis Bronze; and
was awarded the Regional Cookbook first prize
at The Guild of Food Writers Awards 2020.
Eleanor now lives in London with her young
family and an unreasonable collection of spices.
@eleanorfordfood

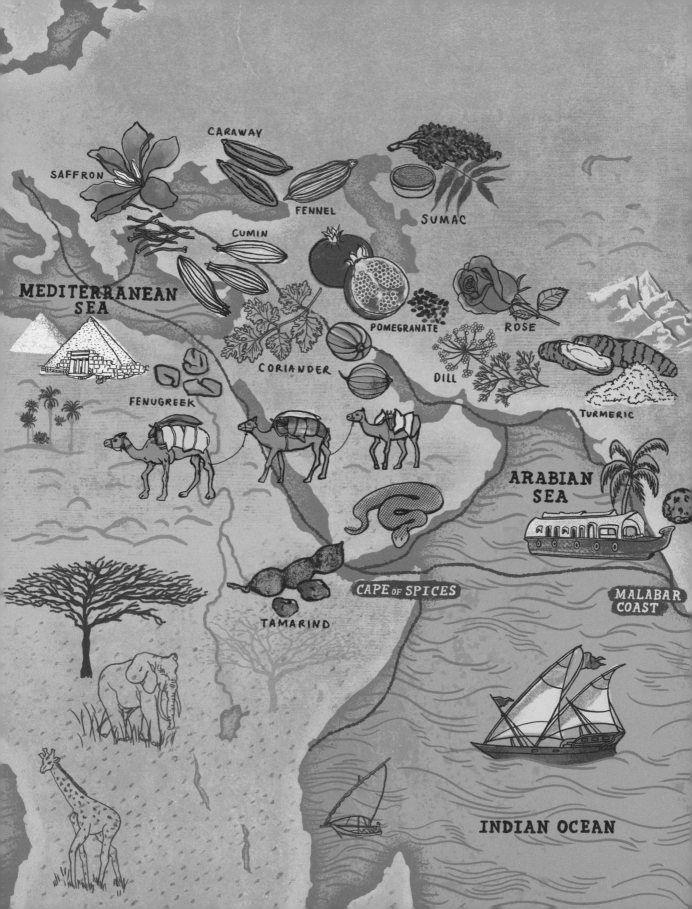